Race, Sex and Gender in Contemporary Art

art is the greatest possible rationalization of our deepest fears, joys, and instincts as human beings. visual artists should seek to explain life metaphorically and poetically... the aesthetic dimension is the carrier of hope

MARTHA MAYER ERLEBACHER 1993

Edward Lucie-Smith

Race, Sex and Gender in Contemporary Art

The Rise of Minority Culture

Art Books International

For Douglas Chowns

Acknowledgements Many of the ideas and arguments which appear in this book were rehearsed and re-rehearsed during a five-week lecture tour of universities and polytechnics in New Zealand, arranged under the auspices of the Queen Elizabeth II Arts Council of New Zealand, with support from the British Council. It was stimulating to deliver these lectures in a country which is bicultural and which also has a long-established feminist tradition. Special thanks are due to Douglas Chowns and Julie Warren, who made the detailed arrangements for this tour. Thanks are also due to Celestine Dars and Susie Green, who very efficiently did the picture-research for the book under great pressure of time; and to my editors Jane Havell (of Art Books International, London) and Ruth Peltason (of Harry N. Abrams, Inc., New York) for many helpful comments and suggestions. Thanks are also due to Rashéed Araeen (London), Marti Koplin (Santa Monica), Annina Nosei (New York), Donna Perret (New Orleans) and Edith Ryan (Wellington, New Zealand) for help with photographs. I would like to thank Martha Mayer Erlebacher not only for the photograph of her painting, but for permission to quote from a personal letter. **E. L-S.**

First published in 1994 by
Art Books International
1 Stewart's Court
220 Stewart's Road
London SW8 4UD

© Edward Lucie-Smith 1994

ISBN 1 874044 06 6

British Cataloguing-in-
Publication Data
A catalogue record for this
book is available from the
British Library

Editor: Jane Havell
Designer: Richard Foenander
Picture Research:
Celestine Dars, Suzanne Green

Typesetting: Spectrum City
Printed in Singapore by
Toppan

Contents

Introduction **6**

1 African American Art **8**

2 The Artistic and Political Background **38**

3 Art as a Substitute Religion **46**

4 Transgressive Art and the Modern Shaman **56**

5 Chicano and Cuban Art **64**

6 Racially Based Art in Britain **76**

7 Minority Sexuality **94**

8 Feminist Art **140**

9 Aboriginal and Maori Art **168**

10 Modern Africa and Asia **186**

Conclusion **205**

Notes **208**
Bibliography **212**
Picture Credits **218**
Index **220**

Introduction

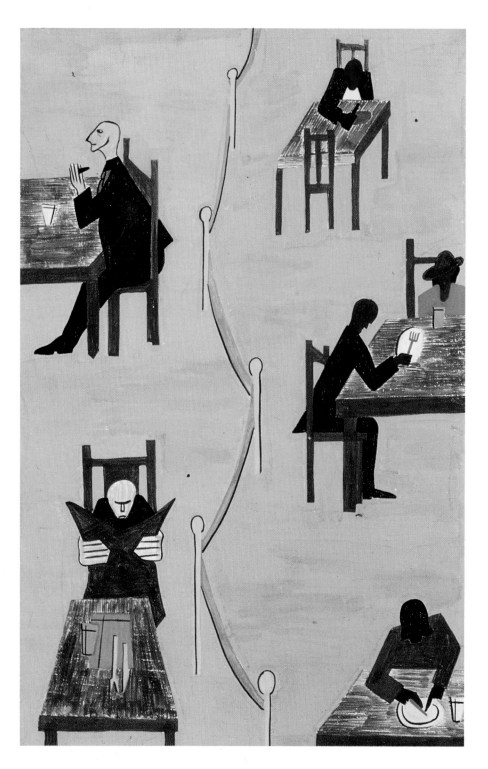

Jacob Lawrence
They Also Found Discrimination, **from the series** ***Migration of the Negro,*** **1940–1**
Tempera on wood, 21¼ x 18in/ 31 x 46cm
Philips Collection, Washington D.C.
One of the most diagrammatic paintings in the series, with connections to African American folk art (see page 20).

The most significant development in the art world of the mid- to late 1980s and the early 1990s was the rise to prominence of minority cultures. What, in this context, do I mean by "a minority"? A minority is essentially a group of people which first recognizes its own separate existence, and is then driven to seek recognition and respect from others. The obvious examples are racial minorities. In the United States, these include people of African American and oriental origin, visibly different from others who surround them. There can also, however, be minorities who identify themselves through a mixture of race and culture – for instance (once again in the United States), those who describe themselves or are described as Latinos or Hispanics. In addition, there are minorities whose "differentness" is not always immediately apparent – those made up of male and female homosexuals. Finally, at the present time, there is one very important and influential "pseudo-minority" – the feminist movement. What I mean by this last term is the grouping whose members, knowing that women are not a minority in numerical terms, nevertheless believes that in terms of empowerment and recognition they are still accorded only minority status.

While the phenomena I am talking about are at their most fully developed in the United States, they can also be seen at work in other countries, particularly in Britain, with its large minority populations of Afro-Caribbeans and immigrants from the nations of the Indian subcontinent: India, Pakistan and Bangladesh.

The rise to prominence of minority art must be seen against the background supplied by the contemporary art world itself. This has been affected by two things. One is a gradual change of attitudes towards museums and museum culture, which has made a particularly strong impact on museums of contemporary art. The museum, once simply a place of entertainment and a repository of knowledge, has increasingly come to be seen as a kind of temple, where members of the public can come into contact with the transcendental or the divine – with aspects of what, in primitive societies, is called *mana*. Museums have a transformative effect on what is shown within their walls, and representatives of minority culture have, in recent years, been quick to seize upon this.

At the same time, avant-garde art retains the need to be "transgressive", as a way of validating itself. If it does not challenge settled perceptions, it loses its cutting-edge credentials. Since other markers of artistic merit – such as quality of workmanship – are now largely disregarded, the issue of priority, generally judged by the extent to which the work of art seems out of step with other works of the same epoch, has become very important. The paradox is that the work of art is no longer seen as something which truly represents its time and is important to it, unless it challenges the norms of that time. Minority-based art fits this formula better than almost any other artistic expression.

1 African American Art

Benny Andrews
Outsider, Inside (***World*** **series),**
1992
Oil and collage on canvas, 37 x
24in/94 x 61cm
Benny Andrews' strongly felt images
continue the tradition established by
Jacob Lawrence and Romare Bearden.

The oldest identifiable minority art, certainly in the English-speaking world, is the art produced by African Americans. This was already struggling to establish a separate identity for itself in the early years of Modernism. Yet, simply because of its long history, this is, of all minority expressions in the visual arts, the one whose workings are most difficult to describe succinctly. Discussion is confused by three factors. One – a barrier which has been erected comparatively recently – is the relentless pursuit of "political correctness". This often leads to a use of language so deliberately obfuscating that it resembles, in its fascination with euphemism, periphrasis and circumlocution, the polite forms of address in old imperial China. One purpose of this constantly shifting terminology seems to be the exclusion of generalist critics such as myself, who readily fall into some newly dug linguistic pit and can then be dismissed as racists.

A second problem is confusion of aims within the art itself, compounded by the fact that the very description African American seems to propose a fixed identity, created by the fact of African American descent. People who describe or see themselves as African Americans frequently have white as well as black blood. Many are also of Native American origin, or have Hispanic or (much more rarely) Asian ancestry.* They come, too, from different parts of the American class system – some from middle-class backgrounds, some from families which are less privileged – and from different parts of the United States. When they make art, these things inevitably affect what they do.

Thirdly, there is the question of communication. It is a truism to say that visual images, like words, are a means of passing ideas and experiences from one person to another. What is often unclear, in the context of the most recent African American art, is whom it primarily addresses. Does it turn to a minority audience, serving as a form of defiance and affirmation? Does it speak to a larger, but still far from universal, group of sympathizers, converts to political correctness, equipped to disentangle meanings, many of which are coded? In this group, there is an increasing tendency to try to move the goal posts, to claim for liberal fellow-travellers a kind of honorary "blackness". Or, as Thelma Golden put it, in one of the catalogue essays for the 1993 Whitney Biennial: "The meaning of whiteness actually encompasses very few people, including many who consider themselves white."[2] This is a form of having one's cake and eating it – of distorting what are already stereotypes until they lose even the approximate meanings they now possess.

Finally, there is the thought, increasingly under siege in supposedly liberal circles, that an identifiably African American art may legitimately

*In an article published in *The Scientist* (the official journal of the American Association of the Advancement of Science) in 1944, it was estimated then that some 80 per cent of African Americans had some white ancestry. The author also noted that "Negro-Indian mixture has occurred, to a greater or lesser extent, throughout America".[1]

address itself to anyone who cares to look. An art which insists that only sympathetic reactions have any validity – and this has been a common tendency in discussions of African American visual imagery – is self-evidently not universal. It is minority in intentions as well as in origin.

Artists of African American descent began to make art long before the aesthetic discovery of Africa made by European Modernists at the beginning of the twentieth century. With the exception of a few folk or craft objects – such as grave-markers, face-pots and walking sticks – the early work fitted into categories provided by white society. Thus we find black "limners" or primitive face-painters at work in the early decades of the nineteenth century, side by side with whites who made the same sort of art, and a little later we discover the landscapes of Robert S. Ducanson (1817–72), which are much in the manner of the artists of the Hudson River School. Though Ducanson had close connections with the Anti-Slavery League, and his second trip to Europe was sponsored by them, there is nothing in the paintings themselves to indicate that the painter was African American.

The most interesting and, in terms of public recognition, the most successful African American artist of the pre-Modernist period was Henry Ossawa Tanner (1859–1937). As the result of a recent retrospective organized by the Philadelphia Museum of Art, there is now a tendency to hail Tanner as the torch-bearer for a new black consciousness. In fact his attitudes towards the African part of his heritage seem to have been ambiguous. Tanner came from a family of achievers. His father was a well-known preacher; his sister, Halle Tanner, was the first woman (not merely the first black woman) ever admitted on examination to practise medicine in the state of Alabama.[3] Tanner himself studied under Thomas Eakins at the Philadelphia Academy of Art, the first person of colour ever to be admitted there. His early work is in Eakins's naturalistic manner, and he was also influenced by another instructor at the Academy, who arrived there after Eakins's dismissal in 1886. Thomas Hovenden (1840–95) produced genre paintings which are often sympathetic and dignified treatments of African Americans. Hovenden's example perhaps helped to inspire what are now Tanner's best-known works, *The Banjo Lesson* (1893) and *The Thankful Poor* (1894). Both document aspects of African American family life, but from a rather sentimental, middle-class standpoint. Had they been painted by a white artist, both works might now be considered mildly racist.

Apart from family portraits, these are almost the only paintings showing African Americans that Tanner produced. In 1891 he went to study in Paris, and by the mid-1890s he had settled there permanently. In 1897 there came an event which changed the direction of his career: he scored a major success at the Salon with his *Raising of Lazarus*, which was promptly bought by the French government for the Musée du Luxembourg. Thereafter Tanner became a specialist in Biblical themes, painting in an academic but also

Henry Ossawa Tanner
An Old Couple Looking at Lincoln, 1892–3
Oil on canvas
National Museum of American Art, Washington, D.C.
One of a small group of genre-scenes featuring African Americans painted by Tanner before he settled permanently in France, and a rare example in his work of a painting with a specific African American message.

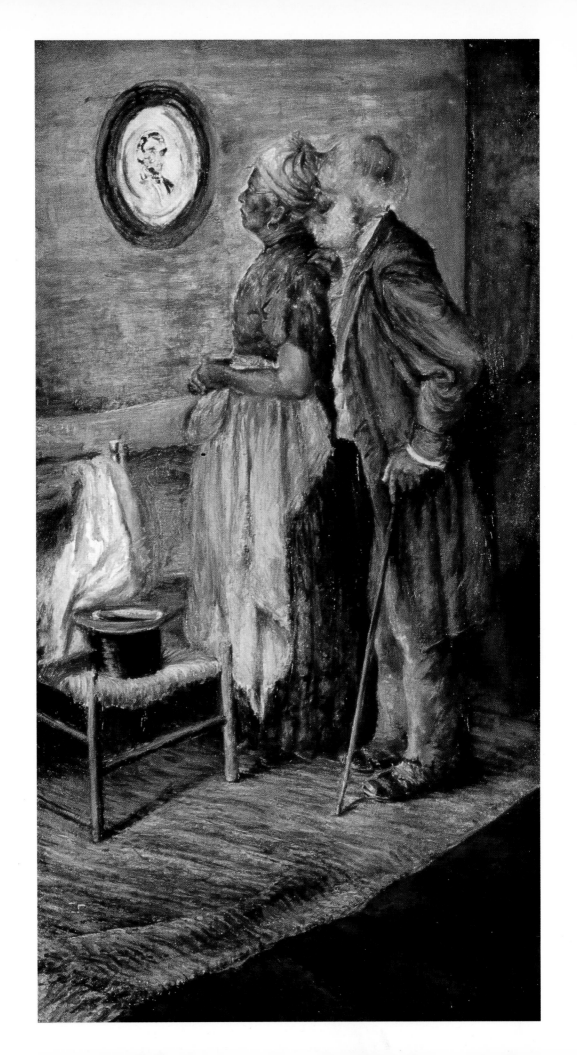

quasi-Symbolist manner which has some relationship to the work of Puvis de Chavannes. The figures who appear in these paintings are the standard Near-Eastern types of academic Biblical illustration. Like many of the conservative painters of the same generation in France, Tanner was eventually overtaken by the Modern Movement and died a forgotten figure. It is probably fair to say that his work would not be the subject of revival today were it not for his ancestry.

We know that, in later life, Tanner's attitudes to his African American heritage were complicated. They are best summarized in his own words, taken from a letter he wrote in 1914 to an enquiring journalist:

. . . Now I am a Negro. Does not the three-quarters of English blood in my veins, which when it flowed in "pure" Anglo-Saxon men and which has in the past done effective and distinguished work in the U.S. – does not this count for anything? Does the one-quarter or one-third of "pure" Negro blood in my veins count for all? I believe it, the Negro blood counts and counts to my advantage – though it has caused me at times a life of great humiliation and sorrow but that it is the source of all my talents (if I have any) I do not believe, any more than I believe it all comes from my English ancestors.[4]

Like Ducanson's work, Tanner's is in fact indistinguishable from that of white contemporaries if we know nothing of the origins of the artist and simply look at the paintings themselves. Both men pursued their careers on the far side of the great divide marked by the birth of the Modern Movement – but this, as we shall see, is not necessarily the reason for their identity of style. They also worked before, or largely before, the discovery of the art of "primitive" (European and tribal) peoples by European artists.

This discovery did not take place in the United States, and the art of tribal Africa was not the first beneficiary. The first avant-garde artist to make substantial borrowings from tribal cultures was Gauguin, whose work forms a bridge between the Symbolist movement and fully developed Modernism. Hand-in-hand with the ultra-refinement of Symbolism, personified by J. K. Huysmans's hero des Esseintes (see Chapter 2), went the cult of the "barbarous". It is this indeed which, by way of Nietzsche, forms a link between Symbolism and its supposed enemy and opposite, Futurism. Gauguin went to the South Seas not so much to discover what was there, as to try to shake off the trappings of the old culture of Europe, which he considered to be effete and exhausted. During his time in Tahiti and the Marquesas he made occasional borrowings from indigenous art, more visible in his occasional pottery and carvings than in his paintings. In the paintings, such borrowings as occurred were strictly for his own purposes. When Gauguin's first series of Tahitian paintings was exhibited in Paris, Camille Pissarro noted sourly that Gauguin (whom he disliked) was "always poaching on someone's ground: now he is pillaging the savages of Oceania".[5]

Paul Gauguin
Carved Coconut-shell
Money-box, c. **1895**
Height 3¼in/8.5cm
Private collection
In addition to making paintings, Gauguin made pottery and carved objects directly inspired by ethnographic originals. The source here is probably Maori carvings seen in a museum in Auckland, New Zealand.

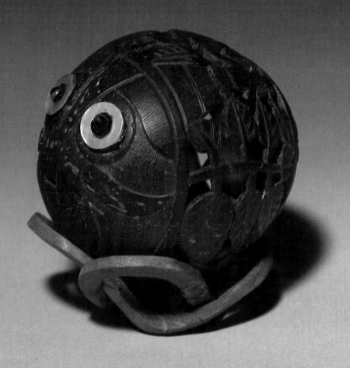

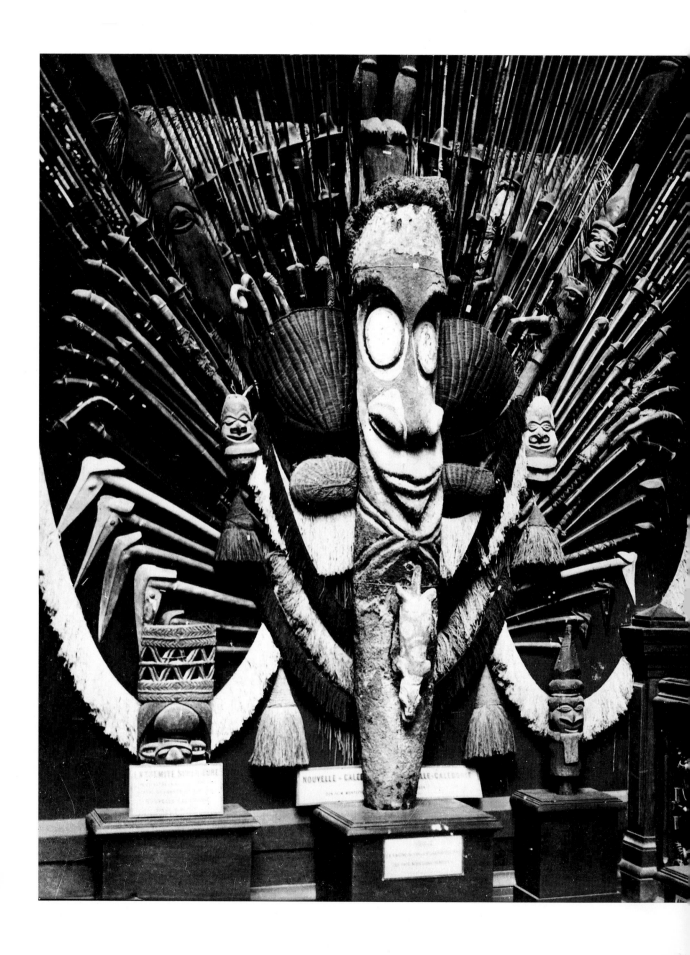

The situation of the next generation of artists to take an interest in primitive art was somewhat different. The artists of Picasso's generation did not travel either to the South Seas or to Africa, and felt no wish to do so. The context in which they encountered African art was one in which it was already cut off from its roots. They found it in the official ethnographical collections and in the curiosity shops of Paris.

It is still sometimes supposed that African objects had been rare and difficult to see before the leaders of the Parisian avant garde began to take an interest in them. This is not the case. Tanner, for example, could easily have seen such things, in the years immediately following his move to Paris, a decade before the official birth of the Modern Movement. From the 1870s onwards the Parisian public had enjoyed greater and greater access to ethnographical material from Africa. A series of temporary exhibitions held during the late 1870s culminated in 1882 with the creation of a permanent Ethnographical Museum at the Trocadero.

Throughout this period, however, there was no questioning of the notion of European superiority. For the French public the new museum was not really concerned with art: it was a scientific and patriotic display. It offered evidence for the validity of European scientific attitudes, and proof of the superiority of European technology compared with anything indigenous to Africa. At the same time, it offered a glimpse of the heroic exploits of French military and colonial officers.

In the 1900s the avant garde was imposing a shift of focus on material that was already familiar. Picasso, for one, did not feel the impact of African art until his own development had already prepared him for it. Contributory to his development was his interest in certain primitive forms of ancient art, notably Iberian sculpture. The work of Cézanne was to form links in Picasso's mind with the formal devices he discovered in African sculpture.

In 1906, when the moment of revelation came, African art struck Picasso in two different and at first sight contradictory ways. First, there was the "shock" or "horror" of something which seemed to transcend civilized experience – the very shock the Symbolists had longed to feel a quarter of a century earlier. Secondly, there was the recognition that African sculpture seemed, despite this, to be what Picasso called *raisonnable*. By this he meant that he found it reductive and ideographic in a way which held together

A late nineteenth-century display at the Ethnographical Museum at the Trocadero, Paris
Devoted to material from New Guinea, it emphasizes the idea of "otherness" and savagery, but also, in the costumed mannequin, attempts to document tribal society in a scientific rather than an aesthetic way.

formally, from the inside out, rather than being dependent on the erratic nature of visual perception.[6] However, it was the emotional power of African art which undoubtedly appealed most. This is reflected in Picasso's well-known remark that his friend and colleague Georges Braque, the co-inventor of Cubism, "did not really understand *art nègre* because he was not superstitious." It was precisely because he wanted to preserve the mystery of the work, for himself and for others, that Picasso took little interest in the ethnographic background.

The rather random collections of African and other tribal objects accumulated by avant-garde artists in the years before World War I blossomed into the more serious and well-informed pursuit of such artefacts which began in Europe in the 1920s and rapidly spread to the United States. For economic reasons, however, the vast majority of the new collectors of African art were white.

For African American artists the newly prestigious art of Africa offered not only an alternative tradition to the existing Graeco-Roman and Judaeo-Christian one (associated with white dominance), but a justification of cultural difference. Paintings began to be made by these artists which paraphrased African forms. A good example is the still life with masks, *Les Fétiches*, painted in 1938 by the African American painter Lois Mailou Jones. This was produced during one of the artist's frequent visits to Paris, and the influence of Picasso is very evident. White domination of the visual arts, thrown out at one door, thus promptly re-entered by another. It was very difficult for Mailou Jones, or any other African American artist following the same track, to escape the effects of Picasso's tyrannous vision of the material they were using.

"Classical" African art, as defined first by European artists, then by the experts and collectors who followed in their wake, also offered a subtler cultural trap. One preoccupation of the new generation of (white) enthusiasts was the idea of "authenticity". For them, the only authentic African object was one which had remained free of any contamination from outside, and particularly from European influence. To a large extent, this demand ran contrary to everything that is now known about the history of Africa. In the pre-colonial era, Africa consisted, not of stable nations or empires in the European or Asiatic sense, but of fluid clusters and groupings of people of the kind we now describe as tribes. These clusters, especially if linked by a single language or related languages, might, from time to time, come together to create larger groupings. They might also, on occasion, be conquered by alien but still African groups, moving in from some other area. In this case a weaker tribe might be reduced by a stronger to a condition of helotry, although continuing to occupy its traditional territory, or driven out altogether. All of the clusters were loosely bound together by the great trade routes which stretched across the continent. These routes were often operated by converts

Lois Mailou Jones
Les Fétiches, **1938**
Oil on canvas, 21 x 25½in/53 x 65cm
National Museum of American Art, Washington, D.C.
This accomplished painting owes much to Picasso's *Les Demoiselles d'Avignon* (1906–7) and especially to the heads of the two figures on the right of the composition, which are based on rather similar African masks.

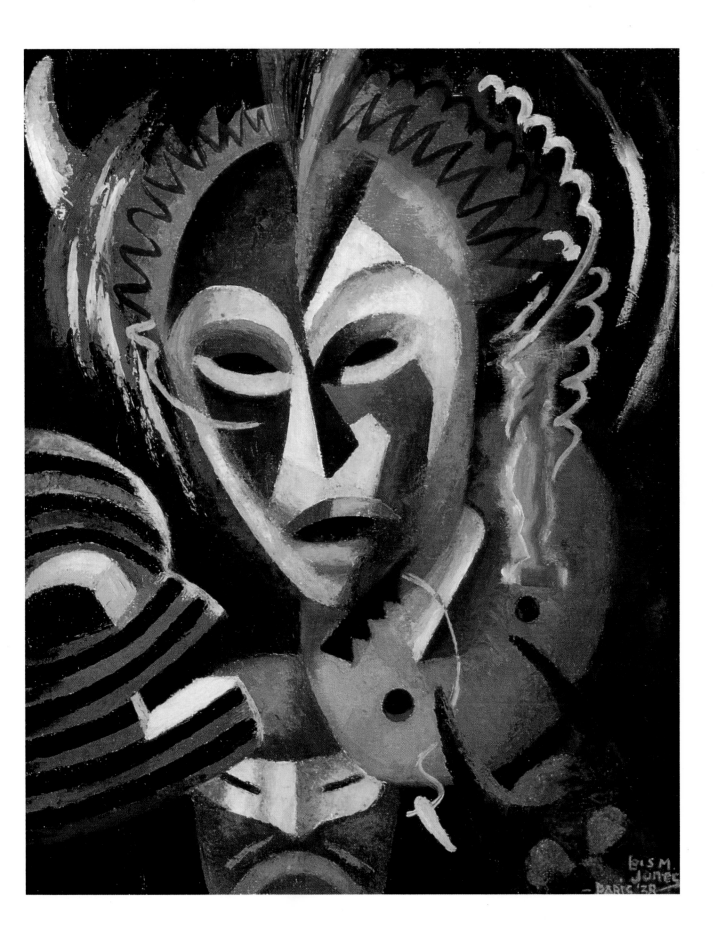

to Islam, and a network of Islamic trading centres existed throughout much of Africa, which was the more influential culturally because Muslim traders tended to be the only literate individuals in a pre-literate society.

Obviously, the natural condition of such a society was change not stasis, though this fact is now hidden from us by the perishable nature of much tribal art. Classical African art of the type coveted by European and North American collectors tends to cover a narrow timespan, perhaps essentially no longer than the period from 1880 to 1930. It represents a particular moment, not the whole span of African culture. The moment itself has been further shaped and edited by European taste. One reason for the repeated failure of African American artists to get to grips with the African cultural heritage is that this heritage is really an artificial construct, adapted to the needs of white aesthetics and white society.

The African past was not the only, or even the leading, preoccupation of a new generation of African American artists. These were affected, not only by the rise of Modernism, but by changes in the nature of African American life. From the 1920s onwards this began to be altered by several factors: profound, underlying causes such as the migration of American blacks from the poverty-stricken rural South to the industrial cities of the North, and more superficial ones, such as the fashion for jazz and its impact on white culture.

The first phase of the change is reflected in the work of the artists of the Harlem Renaissance – Aaron Douglas (1899–1979), Palmer Hayden (1890–1973) and William Henry Johnson (1901–70). Part of the significance of these artists lies in the fact that they were not isolated, but made up the first coherent grouping of African American painters. As such, their work was promoted by white admirers, such as the eccentric millionaire collector Albert Barnes, and by black intellectuals such as Alain Locke, a Harvard-educated philosopher who became a professor at Howard University.

Locke, significantly, was an advocate of the need for African Americans to lay claim to the African tradition in the visual arts, conceived in the form I have just described. This is what he urged in his 1925 essay, "The Legacy of the Ancestral Arts", still regarded as a fundamental document in the history of modern African American art. The artists of the Harlem Renaissance accepted

Palmer Hayden
The Janitor Who Paints, **c. 1937**
Oil on canvas, 39⅛ x 32⅞in/
99 x 83cm
National Museum of American
Art, Washington, D.C.
Palmer Hayden's vignettes of African American life, painted in the late 1930s, have been described as "consciously naïve". In this case the final composition is considerably softened from the original version (revealed by X-rays), in which the artist was "a ludicrous bald man with a bean-shaped head; the baby was a grinning buffoon" (Regenia A. Perry, *Free Within Ourselves: African-American artists in the collection of the National Museum of American Art, 1992, p.89).*

his support, but prudently ignored many of his urgings. They responded to Cubism, to later Art Deco popularizations of Cubism, and (in the case of William H. Johnson) to the naïve paintings made by untutored African Americans which were then coming to notice with the rapidly growing interest in American folk art, which was another aesthetic phenomenon of the period. In the 1930s the Harlem Renaissance artists were thrust aside by another and more impatient generation, with a more finely tuned sense of social concern. Chief among these were Jacob Lawrence (born 1917) and Romare Bearden (1912–88).

Although he was the younger of the two, Lawrence was the first to make an impact. In the late 1930s he began to create paintings linked in narrative series which dealt with black history and black social issues. The earliest are the *Toussaint L'Ouverture* paintings of 1937–8, whose subject is Haiti's struggle for independence from white rule. Though small in scale, these compositions, carried out in tempera on paper, owe much to the work of the Mexican muralists, in particular Orozco. There are, however, many other influences as well, taken from white culture: they include Goya, Pieter Bruegel the Elder, George Grosz, Käthe Kollwitz and the American Jewish social realist William Gropper. Their breadth does credit to the sophistication of an artist then only in his early twenties.

In the later series, Lawrence moved closer to specifically African American experience, dealing with the lives of opponents of slavery such as Frederick Douglass and Harriet Tubman, and then with the *Migration of the Negro*. When the *Migration* panels were first exhibited in December 1941, they won immediate recognition. The series, rather than being privately purchased, was divided between the Philips Collection in Washington, D.C., and the Museum of Modern Art, New York.

Romare Bearden
Sermons: The Walls of Jericho, **1964**
Collage, 11¾ x 9¾in/30 x 25cm
Hirshhorn Museum and Sculpture Garden, Smithsonian Institution, Washington, D.C.
Images from "classical" African art are here mingled with photographic elements, conveying the message that white citadels must capitulate to the accumulated force of the African heritage. Note the falling classical columns at the upper left.

Jacob Lawrence
They Arrived in Pittsburgh, **from the series** *Migration of the Negro*, **1940–1**
Tempera on wood, 12¼ x 18in/ 31 x 46cm
Philips Collection, Washington, D.C.
Lawrence here shows strong similarities with the work of Ben Shahn, the most influential social realist painter of the time in the United States.

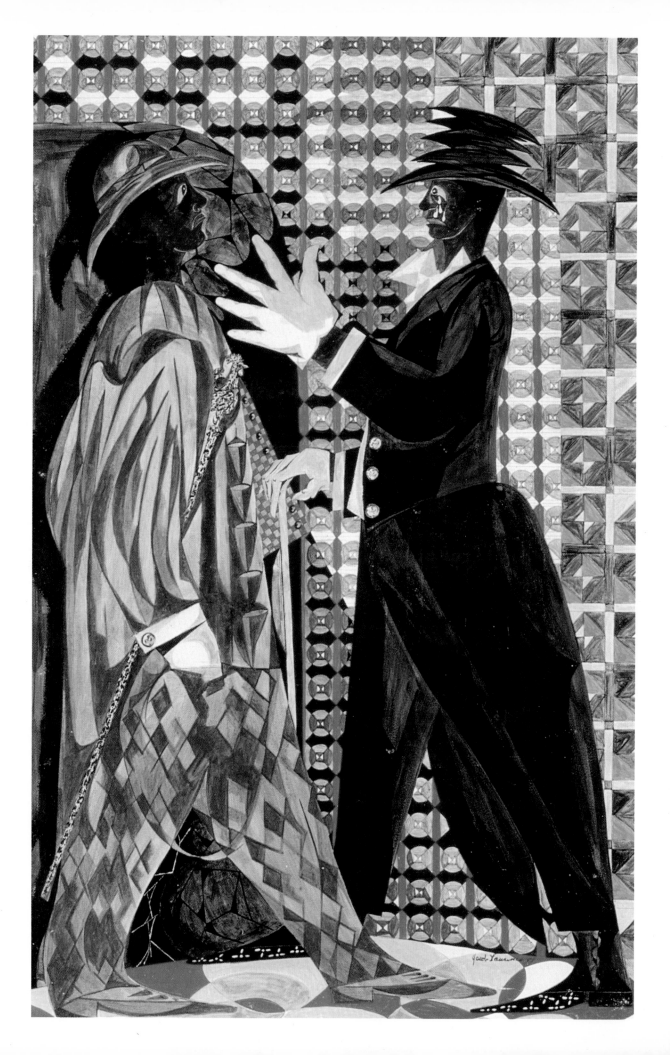

Bearden's work – with its flat, crisply outlined shapes and brilliant colours – has a resemblance to that of Lawrence, although the visual sources are different with, for example, scarcely any influence from Mexican art. Bearden's career was more intermittent than that of his colleague – there were substantial periods when he did not make art – and his contact with European Modernism was much closer: he went to Paris in 1950, and met Braque and Brancusi.

Though the artists of the Harlem Renaissance, and also Lawrence and Bearden, are often cited as direct ancestors of the politically involved African American art which appeared in the 1960s, only Bearden provides a direct link between the two epochs. In 1963 he became one of the founder-members of the Spiral Group, and this involvement led directly to the creation of what are now his best-known works, large-scale paintings and collages showing scenes from African American life. The stylistic sources for these are as varied as those used by Jacob Lawrence – African sculpture, but also Chinese calligraphy, Bosch, Zurbaran and even Mondrian. In this sense Bearden continued a tradition already long established in the work of African American artists: a cultural eclecticism which seemed to reflect an uneasy sense of being caught between two worlds – that of African ethnicity on the one hand, that of mainstream Modernism on the other.

Noticeable about the Harlem Renaissance artists, and also their immediate successors such as Lawrence and Bearden, is the way in which they seem to submit to, and encourage in others, a stereotypical vision of African American life. Palmer Hayden, for example, caricatures black people. Jacob Lawrence, working in the 1940s and 1950s, could produce images which now seem close to insulting their subjects. *The Vaudeville Actors* shows black entertainers, exaggerating ethnic traits for the benefit of a presumably white audience. Today an African American artist would eschew such a scene, unless it was painted in a spirit of savage sarcasm.

The 1960s and the Civil Rights Movement marked a turning point for African American art. The feeling grew that art produced by African Americans must pursue the aim of racial liberation to the exclusion of all else

Jacob Lawrence
The Vaudeville Actors, **1946**
Tempera on wood, 30 x 20in/76 x 51cm
Hirshhorn Museum and Sculpture Garden, Smithsonian Institution, Washington, D.C.
Jacob Lawrence here depicts an aspect of African American life – theatrical performances caricaturing blacks, related to those of white performers acting in "black face" – which would now be considered politically incorrect.

– that is, that it should become primarily an instrument of propaganda, rather than one of individual self-realization and self-expression. One authority on the subject, writing in 1970, defined the situation thus:

Black art is a didactic art form rising from a strong nationalistic base and characterized by its commitment to (a) use the past and its heroes to inspire heroic and revolutionary ideas, (b) use recent political and social events to teach recognition, control and extermination of the "enemy", and (c) to project the future which the nation can expect after the struggle is won.[7]

This programme has little recognizably Modernist about it: the language is that used, from the mid-1930s onwards, by official theoreticians in the Soviet Union to support Socialist Realism.

African American propaganda art of this type took various forms. Some of it was a straightforward denunciation of social injustice – found, for example, in the often brutally effective images produced by Benny Andrews (born 1930). Andrews, however, is much more than a mere propagandist. He is a painter in a line of descent from the American social realist tradition as represented by the work of Ben Shahn, and also has an obvious kinship to the work of Romare Bearden. One of his greatest strengths is his power of direct observation. His figures, often simplified, are nevertheless very convincing in their rendering of individual character.

Other African American art of this period was less convincing. Much was pan-African in inspiration, and attempted to make use of supposedly African symbols, colours and shapes. This suffered from a certain naïveté of approach: it was an art of wish-fulfilment, based on little direct experience of modern Africa, whose art springs from very different roots (see Chapter 10). Among African American artists, ethnic elements continued to be perceived through the filter of long-established western attitudes to African culture, though naturally this fact was strenuously denied at the time and continues to be denied today. Finally, there was a kind of art which acknowledged the situation of African Americans as participants, even if unwilling and disaffected ones, in the contemporary mass culture of the United States.

One of the most inventive and gifted artists in this final category was the California-based Betye Saar (born 1926). Some of Saar's mixed-media

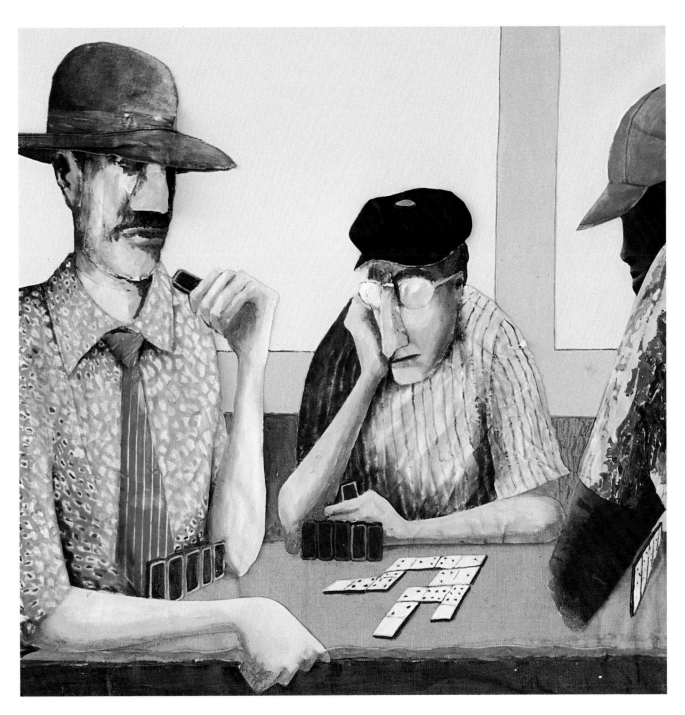

Benny Andrews
New York, New York (World
series), 1992
Oil and collage on canvas, 35 x
35in/89 x 89cm

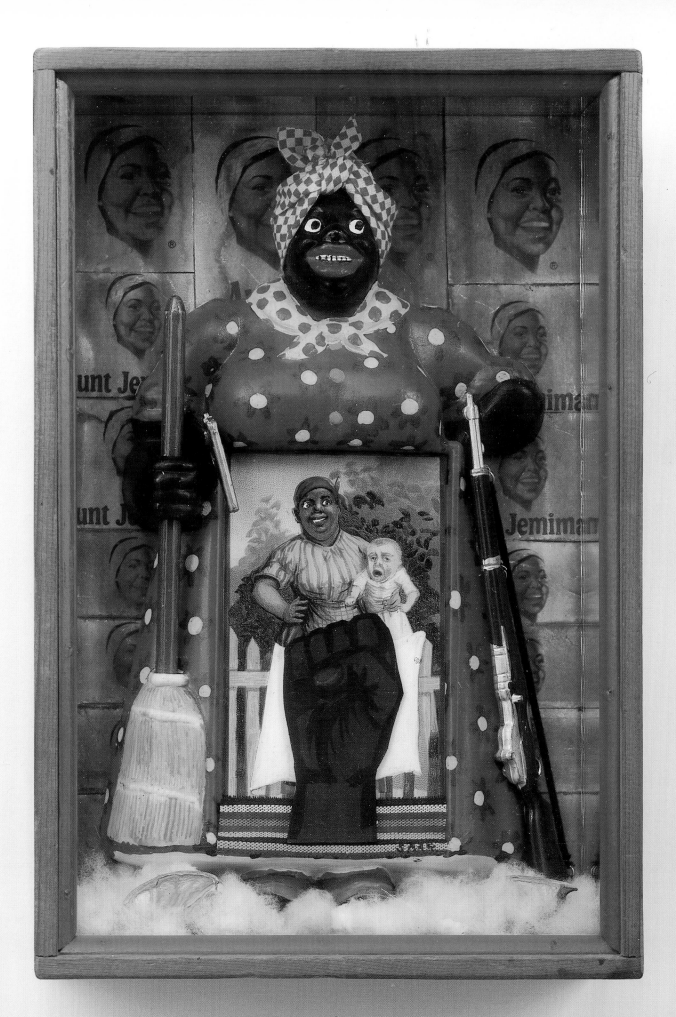

assemblages are attempts to produce modern fetishes combining traditional materials, such as fibre, seeds and beads, with modern technological products, chiefly photographs. These suffer from the inevitable blurring and weakening of effect attached to the circumstances in which they were made. They are would-be ritual objects with no real rituals attached to them. Harder-hitting are works based on derogatory commercial images of African Americans, such as the plump, obsequiously grinning black mammy used as a trademark by the Aunt Jemima range of food products. In one work in the series, *The Liberation of Aunt Jemima* (1972), Jemima is transformed into a gun-toting revolutionary.

Betye Saar's mixed-media pieces in this vein belong to a tradition of appropriation which has grown ever stronger in contemporary American art since the mid-1960s and which has had an especially strong impact on the artistic tradition of feminism (see Chapter 8). This is suitable enough, since the *Aunt Jemima* series is almost as much feminist as it is anti-racist. Like all art works which rely on appropriation, the *Aunt Jemima* series depends for a great part of its effect on the spectator's knowledge of the context. More than this, it is dependent on the firmly established existence of the image or symbol which the artist wants to deconstruct. A comparison can be made here, not with Soviet Socialist Realism, but with the answer to it devised by a group of Russian artists during the brief *perestroika* period presided over by Mikhail Gorbachev. The paintings made by artists in this group, among them Eric Bulatov, were so closely linked to the whole system of official imagery in Russia that the fall of the Communist regime has deprived them of a great part of their meaning, and has transformed them, in a remarkably short space of time, into fossils – historical curiosities.

Even in the turbulent 1960s and 1970s African American artists had a choice: to be visibly political, or to reject politics. Amongst the most prominent of those who took the latter course was Sam Gilliam (born 1933). Gilliam, an abstractionist whose work eschews overt symbolism of any kind, has had to endure frequent accusations of being an Uncle Tom, but has nevertheless persisted quite steadfastly in his chosen course. His paintings are related, not to anything specifically African, but to those by other members of the "Washington Color School", whose members include Morris Louis, Kenneth Noland and Gene Davis. Louis was already dead when Gilliam

Betye Saar
The Liberation of Aunt Jemima,
1972
Mixed media, 11¾ x 8 x
2¾in/29.8 x 20.3 x 6.9cm
University Art Museum, University
of California at Berkeley;
purchased with the aid of funds
from the National Endowment for
the Arts (selected by The
Committee for the Acquisition of
Afro-American Art)
One of the best-known "militant"
images in recent African American art,
this mixed media piece also has
feminist and Pop Art elements.

arrived in Washington in 1962, but the latter's off-stretcher, unsupported canvases, draped and stained, represent an innovative development of techniques pioneered by Louis. Gilliam has always asked to be judged simply as an artist, not as a generic African American painter, and in doing so he implicitly rejects both the advantages and disadvantages of minority status.

The dilemmas which faced African American artists during the 1960s and 1970s are little changed today. One the one hand, there are more and more opportunities to join the mainstream, and work within the parameters this decision imposes. On the other, in a cultural climate which is once again highly political after a period of quiescence during the boom years of the 1980s, there are many calls for artists of African American origin to express solidarity with a community which perceives itself as oppressed and alienated. One important difference between the early 1990s and the late

1960s is that it has become considerably easier for African American artists to see themselves as fully competitive, in terms of recognition and financial success, with those who belong to non-minority groupings.

Two leading sculptors offer indicators of this change in career patterns. One is John Scott (born 1940), who lives and works in New Orleans and is becoming increasingly celebrated nationally (he was recently the recipient of a John D. and Catherine T. MacArthur Foundation grant of $315,000, a so-called "genius award"). Scott is a significant figure for more than one reason. He is an African American artist who lives and works in the South. Hitherto, the African American artists associated with the Modern Movement have tended to live and work either in the industrial cities of the North, or in California; Southern black art has been the work of naïve or untutored artists, not of mainstream ones. Scott is a representative of the move towards increas-

Sam Gilliam
Uguisu, 1986
Acrylic on canvas, enamel and acrylic on aluminium, 101½ x 134 x 9in/257.8 x 340.4 x 3.5cm
A typical off-stretcher work by Gilliam, in the Abstract Expressionist tradition.

John Scott
Breeze Window for Mom, **1988**
Polychrome steel, 61 x 36 x 30in/
154.9 x 91.4 x 76.2cm
Most leading African American artists
live and work in the North; John Scott
is a distinguished sculptor who has
made a major career in the South.

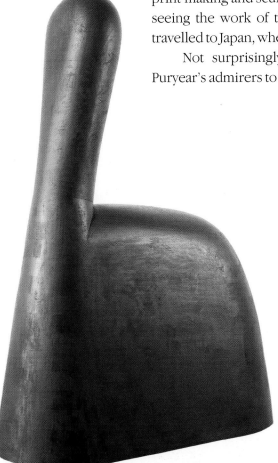

ing regionalization in American art, as well as of the increased prestige of
African American painters and sculptors.

His sculpture is kinetic and, according to his own account, many of his
recent pieces are based on the African legend of the diddley bow – the
hunter's bow which, after the kill, was transformed into an improvized one-
string fiddle and played to appease the spirit of the slain animal. It was
this instrument which supplied the pseudonym of the 1950s black rock 'n'
roll singer-guitarist Bo Diddley (Ellas McDaniel). Scott, however, gained his
knowledge from more academic sources, in the course of researching the
Afro-American Pavilion for the New Orleans World's Fair of 1983, which he
was commissioned to design. Despite this African source of inspiration, his
sculptures remain thoroughly western in form, unimaginable outside a wes-
tern and Modernist context. The element of movement, with different ele-
ments swaying and changing position, derives not from anything African, but
from Scott's contact at a crucial moment in his career with the kinetic sculptor
George Rickey who is in direct line of succession from Alexander Calder.

Martin Puryear (born 1941) is even better known than John Scott. He
was awarded first prize at the São Paulo Bienal of 1989 and in 1991 was the
subject of a major touring retrospective in the United States. Puryear is well
travelled. He is, for example, one of the few major African American artists
with direct experience of Africa. He lived in Sierra Leone for a period as a
member of the Peace Corps. From there he moved to Sweden, studying
print-making and sculpture at the Swedish Royal Academy in Stockholm, and
seeing the work of the master cabinet-maker James Krenov. He has also
travelled to Japan, where he became familiar with Japanese craft aesthetics.

Not surprisingly, strenuous efforts have been made by some of
Puryear's admirers to align what he does with classical African art, for so long

Martin Puryear
Empire's Lurch, **1987**
Painted ponderosa pine, 75 x
48 x 25½in/190.5 x 121.9 x
64.7cm
Private collection
A typical work by one of the most
prominent African American
sculptors in the United States, this
piece shows the influence of
Brancusi far more than that of
"classical" African sculpture.

the beacon of African American aesthetics. A comparison is sometimes suggested between Puryear's smoothly contoured sculptures and traditional African artefacts, such as ceremonial spoons. The artist himself feels that his time in Sweden was more important in the formation of his style. When in Africa, he felt that "though an African American, he as much as anyone of European extraction was an outsider to the customs of the people amongst whom he lived."[8] It was Sweden, and especially Krenov's example, which made him think of ways in which building and furniture-making techniques such as lamination could be used to make sculpture:

At a certain point I just put the building and the art impulse together. I decided that building was a legitimate way to make sculpture, and that it wasn't necessary to work in the traditional methods of carving and casting.[9]

Puryear also has a broad acquaintance with the work of his contemporaries. Moderna Museet in Stockholm, during the 1960s one of the most progressive museums in the world, enabled him to see important exhibitions of work by leading artists such as Claes Oldenburg (1966) and Andy Warhol (1968). It also introduced him to the work of artists then little known in the United States, such as Joseph Beuys and Carl Frederick Reutersward. Visiting the Venice Biennale in 1968, Puryear saw the work of a new generation of American Minimalist artists, and was particularly interested in, and impressed by, Donald Judd.

Clearly, it both diminishes and distorts Puryear's achievement to see him simply as a minority representative or a minority spokesman. In his mature work he sums up many aspects of the twentieth-century sculptural tradition: some of his works have a particular affinity with Brancusi. It seems likely, since he is not a visibly autobiographical artist, and since the figurative element in his work, where it exists, is general rather hermetic, that many of the visitors who encounter Puryear's work in museum collections (in which he is now well represented) remain unaware that the artist is African American unless it is specifically drawn to their attention.

The situation is different in the case of Jean-Michel Basquiat (1960–88). Basquiat enjoyed a meteoric career in the New York art world of the 1980s. Basquiat was black, and certainly not averse to emphasizing his blackness when it suited him. His background, nevertheless, was far from stereotypical for an African American artist. Neither side of his family had long-established roots in the United States (the opposite is the case with the majority of African Americans). Instead, Basquiat was a typical product of the post-World War II

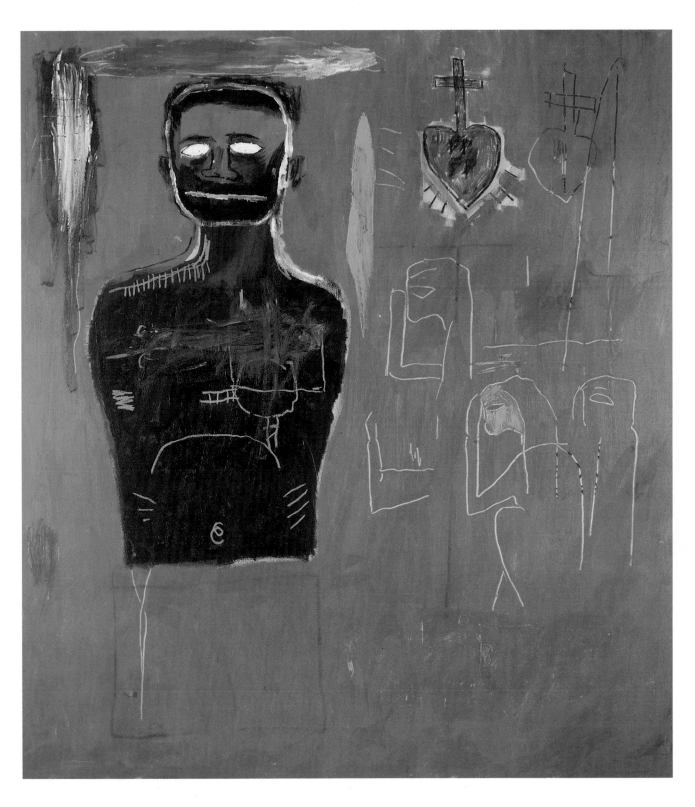

Jean-Michel Basquiat
Untitled, 1984
Acrylic/mixed media on canvas,
26 x 23½in/66 x 60cm
Private collection

New York melting pot. His father, a black middle-class accountant, came from Haiti; his mother, white, was from Puerto Rico.

When Basquiat was eight, his parents separated, and he was thereafter brought up by his father; the family left New York for a while and spent some years in Puerto Rico. Basquiat returned as a rebellious teenager, and was caught up in the graffiti craze then mesmerizing many of his New York contemporaries. Graffiti was, and remains, a contentious topic. The New York middle class felt increasingly threatened by daubed walls and unofficially decorated subway trains. Despite this, the graffiti writers and painters could not be classified by either class or race:

When asked, "What sorts of kids write graffiti?" police officer Kevin Hickey of the New York Transit Police Department's graffiti squad replied, "The type of kids that live in New York City. They range from the ultra-rich to the ultra-poor. There is no general classification of the kids; it's just that a typical New York city kid will write graffiti, if given the opportunity and this is what his friends do."[10]

That is, the craze had to do with opposition between the generations, not with racial or class conflict.

Despite the disapproval of worthies like Mayor Edward Koch – who opined that the elimination of graffiti would have a "positive psychological impact"[11] on subway riders – this new urban phenomenon soon attracted the attention of a New York art world besotted with the idea of youth and always avid for novelty. Basquiat was one of the chief beneficiaries and, of all the graffitists, the one who most successfully managed a transfer of activity to the artistic mainstream. His work was included in the groundbreaking "Times Square Show" of June 1981, which announced the appearance of a new generation of artists. The following February it was featured in the "New York/New Wave" exhibition at P.S.1, Long Island, where fellow exhibitors were Keith Haring, Robert Mapplethorpe and Andy Warhol. His contribution attracted the attention of dealers in New York, Zürich and Milan, and his first solo show took place in Italy, in May of the same year. The first extensive article about Basquiat was published in the American magazine *Artforum* in December 1982. From this time, until his death from a drug overdose six years later at the age of twenty-seven, he was an established New York art world celebrity.

Jean-Michel Basquiat, in collaboration with Andy Warhol
Felix the Cat, **1984–5**
Acrylic on canvas, 9ft 8in x 13ft 3³⁄₄in/2.95 x 4.06m
With characteristic confidence, Basquiat has almost obliterated Warhol's contribution.

Basquiat's output offers a wide range of cultural references, ranging from European traditions (Leonardo da Vinci) to classical African and Pre-Colombian art. There are paintings which allude to African American culture (jazz and blues) and also to black hero figures, such as the boxers Cassius Clay (Muhammad Ali) and Sugar Ray Robinson. However, these form only a small part of the complete list. Basquiat, a great reader with an absorbent mind, was interested in African ideology and conscious of his position as a representative of the African diaspora, but his was not a political temperament. Critics constantly stressed the intuitive, not the analytic, character of his work, as in this comment from the art impresario Jeffrey Deitch (later a major supporter of another artist who made an immediate and sensational impact on the New York art world, Jeffrey Koons):

Basquiat's great strength is his ability to merge his absorption of imagery from the streets, the newspapers and TV with the spiritualism of his Haitian heritage, injecting both into a marvellously intuitive understanding of the language of modern painting.[12]

In no sense can Basquiat be seen as primarily, or in intention, a representative or spokesman of the African American minority. A man with a large ego, and boundless ambition, his measure of success was the kind of celebrity which accrued to Andy Warhol, rather than any consciousness-raising exercise on behalf of fellow African Americans. Warhol, at first suspicious of Basquiat, and perhaps a little afraid of him, eventually became an artistic collaborator. A show of paintings made jointly by the two artists was unveiled at the Tony Shafrazi Gallery in New York in September 1985. Almost nobody liked them, but the logic of the alliance was apparent to most art-world insiders. One comment ran:

Having presided over our era for considerably more than the requisite fifteen minutes, Andy Warhol keeps his star in the ascendancy by tacking it to the rising comets of the moment.[13]

Basquiat's career – and this is also true of the more sober careers of Sam Gilliam, John Scott and Martin Puryear – called into question the inevitable "minority" status of African American art, as opposed to that of the African American community. The long history and by this time huge variety of African American painting and sculpture made it increasingly difficult to force it into neatly political categories. However, as was clearly demonstrated by the 1993 Whitney Biennial exhibition, there has been, and continues to be, a strong impulse to do this. Even the admission tag to the show was an "anti-racist" statement: it read, either as a whole or in part, "I can't imagine ever wanting to be white."

Though the 1993 Whitney Biennial exhibition ranged well beyond the African American tradition, tackling issues of gender as well as those of race, it

was clear from a number of its inclusions that the African American example, in its most "political" form, was something very much in the organizers' thoughts. Among the "artworks" chosen for display were the now celebrated amateur video showing the beating of Rodney Green by a group of white Los Angeles policemen, and a music video by Spike Lee, director of the film biography *Malcolm X*. These inclusions set the tone for an event which implicitly argued, first, that a truly contemporary art should concentrate not on aesthetic issues but on social therapeutics and, second, that the museum was an entirely appropriate – indeed *the* most entirely appropriate – place for such political discourse.

2 The Artistic and Political Background

Natalia Gontcharova
Design for *The Golden Cockerel*,
1914
Gouache
The commission to make designs for
Rimsky-Korsakov's opera was offered to
Gontcharova by the great impresario
Sergei Diaghilev. Her designs represent
the apotheosis of the Russian
"primitivist" style.

The fluctuating fortunes of African American art have to be set against the whole Modernist background, not least because African American Expression, certainly from the 1920s onwards, has to be regarded as a branch of western Modernism, as fundamentally dependent on the European and North American context as all other forms of Modernist activity. Some salient aspects of Modernism in general are worth emphasizing. This first is that the burgeoning avant garde of the early twentieth century was in many respects quite unlike what has succeeded it today. In particular, it was élitist, and looked for support to the private not the public sector. Avant gardists were, at this period, outspokenly hostile to the idea of the museum. The hostility is articulated in the First Futurist Manifesto, published in February 1909:

Museums, cemeteries! . . . Identical, surely in the sinister promiscuity of so many bodies unknown to one another. Museums: public dormitories where one lies forever beside hated or unknown beings. Museums: absurd abbatoirs of painters and sculptors ferociously macerating each other with colour-blows and line-blows, the length of the fought-over walls.[1]

This gives a good idea of conditions of display during the first decade of the twentieth century. Attitudes were very different from those which prevail now, when works of art are often isolated visually and presented as magical or sacred objects.

It was, however, the Futurists, the first fully organized art movement, anxious to show the world a collective image, who began the politicization of avant garde art from which the minority expressions of today were ultimately

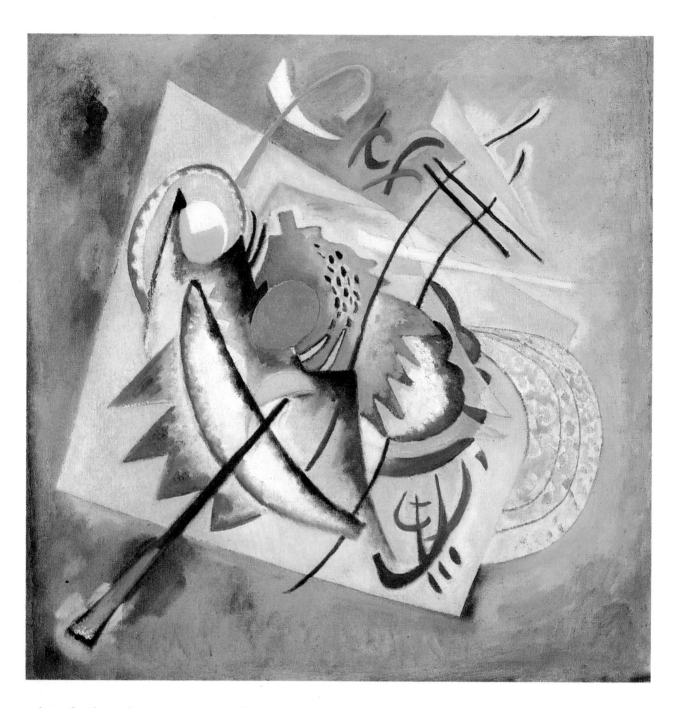

to benefit. Their ideas – the worship of war and masculine strength combined with fervent Italian nationalism – were not so far from those which later went to create Mussolini's Fascism.

The most significant early alliance between avant garde artists and political activism was, however, consummated in Russia. Russian avant gardists, who originally took much of their inspiration from Italian Futurism, discarded the Italian fascination with the radical right and instead allied themselves with the left. The choice was not made immediately. Like the Futurists, the Russian avant garde was, to begin with, nationalist. The mood was set by

Vassily Kandinsky
Red Oval, 1920
Oil on canvas, 28⅛ x 28⅛in/
71.5 x 71.2cm
Solomon R. Guggenheim
Museum, New York
This painting dates from the period of
Kandinsky's closest collaboration with
the new Bolshevik regime. He returned
to Germany in 1921.

the humiliating defeats Russia suffered in her war against Japan of 1904-5.
Hence, for example, the tendency to return to folk-sources – icons and *lubok*,
or folk art prints – found in the work of painters such as Natalia Gontcharova
(1881-1962) and her husband Mikhail Larionov (1882-1964).

It was a second generation of Russian avant gardists who threw them-
selves into the arms of the Bolshevik regime. The new leaders were, from
the first, rather doubtful about the worth of these difficult allies, and were
only persuaded to give a blessing to their experiments in art by the liberal
and cultivated Commissar for Education, Anatoly Lunacharsky. Unlike his col-
leagues, Lunacharsky had been acquainted with a number of avant garde art-
ists during his years of political exile. The most important was Vassily Kan-
dinsky (1866-1944), one of the leaders of the Blaue Reiter, a splinter group
from the main body of German Expressionism, founded in Munich in 1911.
Forced back to Russia by the outbreak of World War I, Kandinsky, who had a
strong pedagogic streak, was willing to give Lunacharsky his help in creating
an artistic programme in tune with the needs of the new regime.

The alliance was a fragile one. Far from sharing the materialism of Bol-
shevik philosophy which was based upon Marx, Kandinsky was a believer
in the mystic doctrines of Mme Blavatsky, a Theosophist and champion of
spiritual values in art. Soon frozen out by younger colleagues, he returned to
Germany, where he became a major figure in the Bauhaus, the leading peda-
gogic institution of its time.

In Russia, younger and more radical artists such as Vladimir Tatlin
(1885-1953) and El Lissitzky (1890-1941) set about mobilizing state help in
order to create art which, in supporting the political aims of Communism,
would also penetrate every aspect of daily life. Art which remained in the
museum did not interest them; they concentrated on the art of the streets. Yet
the alliance between the Communist Party leadership, its new bureaucracy,

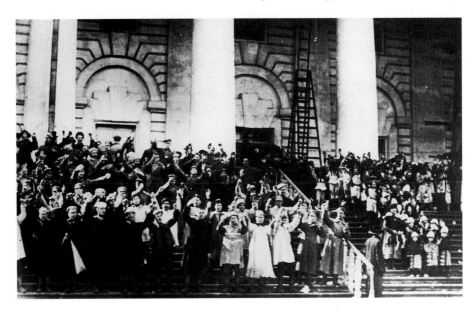

Towards a Worldwide Commune
Mass performance on the steps of
the Stock Exchange Building,
Petrograd, 1920

and the Russian avant garde soon began to fray. By 1925 the Communist Party Central Committee was already calling for an art which would be "comprehensible to millions",[2] with the implication that the avant-garde work produced since 1917 did not fulfil this criterion. In 1932 Stalin disbanded all existing cultural groups, thus emasculating an avant garde which was already rent by internal dissension.

Despite these conflicts, the Russian experiments of the immediate post-revolutionary period implanted the idea that avant-garde art had an intimate connection with left-wing politics, and that it was in some way always a spokesman for radical political ideas. This suited the "transgressive" image which the avant garde had already been at pains to build up. Henceforth there was no doubt in people's minds that art and politics were partners – the idea was embraced by rabid critics of Modernism as well as by its supporters – to the point where abstract art, with no apparent specific content, was frequently denounced as "bolshevik". Throughout the interwar years the Mod-

ernist artists of the European democracies remained generally sympathetic to the views of the left. The Surrealist Movement, in particular, conducted a vigorous though finally abortive courtship of Russian Communism.

The alliance between European artists and left-wing politics intensified in the late 1930s because of the Spanish Civil War. Many leading painters produced works of propaganda – the most celebrated was Picasso's vast canvas *Guernica* (1937). Yet there followed, perhaps surprisingly, a period of comparative quiescence during World War II; it was almost as if events were now too tremendous for artists to attempt a commentary. Only with the beginning of the Cold War did politics once again begin to play a prominent role in art, with Communists pitted against anti-Communists.

In Europe, a large number of intellectuals including celebrated artists allied themselves with the Communist propaganda machine. The Communists' greatest coup, engineered by the poet Louis Aragon (once a founding member of the Surrealist Group but now very much a servant of the

Pablo Picasso
Massacre in Korea, 1951
Oil on wood, 43¼ x 82¾in/110 x 210cm
Musée Picasso, Paris
The most notorious of the propaganda paintings made by Picasso to express his solidarity with the Communist Party.

Party), was to recruit Picasso, who became a declared Communist in 1944 immediately after the Liberation. In an interview given to the American periodical *New Masses* after the announcement, immediately reprinted on the front page of the French Communist daily *L'Humanité*, Picasso stated:

Joining the Communist Party is the logical conclusion of my whole work . . . These years of terrible oppression have proved to me that I should struggle not only with my art but with my whole being. So I went to the Communist Party without the least hesitation, for fundamentally I had been with the party from the very start.[3]

Picasso's drawing of a dove (in origin a pigeon) became the symbol of the Communist-backed Peace Movement, and was soon familiar to people who had never seen any other example of Picasso's art.

In general, however, his relationship with Communism was not a successful one. Both artistic and practical difficulties lay in wait. In January 1951 he produced one of his most ambitious pro-Communist propaganda works, entitled *Massacre in Korea*. Intended as a protest against American military intervention in Korea, its immediate model was Goya's *Third of May*, an outcry against the French occupation of Madrid during the Napoleonic Wars. The painting is in fact a piece of Davidian pastiche, its Modernist mannerisms scarcely concealing an academic, Neo-Classical structure. Before this, Picasso had frequently used Neo-Classical elements in an ironic, parodistic fashion; using them seriously, he seemed to betray the whole of his development.

Even for an artist as eminent as Picasso, it was not always prudent to stray from the paths laid down by Communist orthodoxy. His enthusiasm for

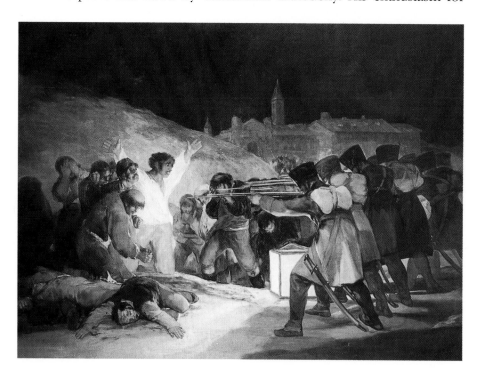

Francisco de Goya
The Execution of Madrilenos on the Third of May, 1814
Oil on canvas, 110¼ x 135¼in/266 x 345cm
Prado Museum, Madrid

the Party had to survive the humiliating response to his portrait of Stalin, produced in great haste on the occasion of the latter's death in 1953. Because of its lack of photographic realism it evoked so many protests that even Picasso's close friend and ally Aragon was momentarily forced to disown him. "Our comrade Picasso", Aragon wrote, "has altogether forgotten the fact that he was first and foremost addressing himself to the worker in mourning, struck by this terrible blow."[4]

The competitive nature of the Cold War meant that cultural manifestations were used as a weapon on both sides. If the Communists gloried in their possession of Picasso, the most celebrated modern artist of the first, pioneering generation, then the American government was anxious to stress the rise to international prominence of Abstract Expressionism.

Where Picasso was an active collaborator with Communism, the role of the American artists of the 1940s and 1950s was almost entirely passive – a strong contrast with the situation in the 1930s when leading American artists such as Stuart Davis had frequently been involved in political debate. The absence of overt political content in Abstract Expressionist paintings proved to be no barrier to their use for political ends. The success of this new American style came to be seen as an important symbol of the rise of the United States to a position of world power, a perception which was encouraged both by US governmental agencies and by their allies in the world of business. As the American critic Max Kozloff pointed out, a parallel was often drawn between the idea that "America was now the sole trustee of the avant-garde 'spirit' and the US government's notion of itself as the sole guarantor of capitalist liberty."[5] This made Abstract Expressionism the subject of bitter political controversy, especially in Latin America where it was vigorously promoted both by American cultural agencies and by corporations with strong business links to the United States. As a result of this, Abstract Expressionism was often construed in Latin America as a planned attack on the home-grown Modernist tradition, represented by artists such as the Mexican mural painters Rivera, Orozco and Siqueiros, with their concern for social issues.

It is ironic that what most effectively put a stop to the exploitation of the new American art for political purposes was not a change in policy but a revolution in art itself. The demotic content of Pop Art, with its emphasis on American commercialism and its apparent scorn for any idealism or transcendental feeling, made it difficult to exploit as Abstract Expressionism had been exploited. It was only later, after a suitable hiatus, that the world-wide success of Pop came to be seen as a continuation, in another guise, of the existing American cultural hegemony.

One other point is worth noting. During the first half of the twentieth century, artists, when they were political, enjoyed a purely client relationship with the causes they supported. They put their art at the service of some greater good, but did not presume to invent that good for themselves.

3 Art as a Substitute Religion

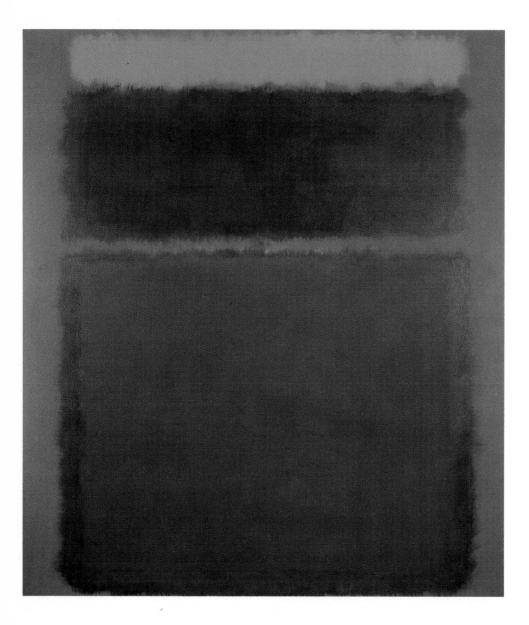

Mark Rothko
***Blue, Orange and Red*, 1961**
Oil on canvas, 91 x 81in/231 x 206cm
Hirshhorn Museum and Sculpture Garden, Smithsonian Institution, Washington, D.C.
A work typical of the abstract paintings to which Rothko wanted spectators to attach a quasi-religious significance.

Contemporary art cannot, of course, be thought of as operating simply in the political sphere contrasted with a formalist, purely aesthetic one. Within the history of twentieth-century Modernism there is another and very different tradition. It is rooted in the tendency to treat art, and especially art which seems difficult or mysterious, as a substitute for religious experience. The pioneer Modernists – and in this connection I have already cited Vassily Kandinsky – were often fascinated by the mystical theories which were prevalent in the late nineteenth century and at the beginning of this one.

Many of these theories came together in the quasi-religion which took the name Theosophy. The Theosophical Society had been founded in New York in 1875. Its leading spirits were Mme Blavatsky (Elena P. Blavatsky, 1831-91) and Henry Steel Olcott (1832-1907). Among its declared aims were to combat materialism and scientific dogmatism, to develop man's latent spiritual powers, and to make available the esoteric teachings of oriental religions, particularly Hinduism and Buddhism. These teaching were formulated in Blavatsky's book *The Secret Doctrine* (1888), subtitled "the synthesis of science, religion and philosophy".

[The] entire process of cosmic and human evolution, according to The Secret Doctrine, *is also the story of divine awakening in which the spirit interacts with matter and comes to know itself through the evolution of consciousness.*[1]

These somewhat cloudy doctrines were sufficient to make Theosophy popular with two generations of intellectuals, and its influence grew rather than waned when Blavatsky and Olcott were replaced by Annie Besant (1847-1933) and Charles W. Leadbeater (1847-1934). Mondrian and Kandinsky were strongly influenced by this system of beliefs, and some of their preoccupations were inherited by the American Abstract Expressionists, who often put forward versions of the idea that their activity was neither formal investigation, nor even primarily aesthetic, but a spiritual quest which they expected others to have the courage to join. Rothko, for example, once declared: "The people who weep before my pictures are having the same religious experience as I did when I painted them."[2]

The tendency to make art into a religion substitute can be linked not only to the esoteric tradition just cited but to ideas put forward by the inventor of psychoanalysis, Sigmund Freud (1856-1939) – even though Freud was, like Marx, a convinced scientific materialist. In one of the most fascinating of his late texts, *Civilization and Its Discontents* (1930), Freud speculates that art can actually become a substitute for religion in a modern society. Nevertheless, the art Freud was thinking of was almost certainly the accumulated store of masterpieces from the whole western European past. Despite his influence over the Surrealists, he neither sympathized with nor understood modern art.

Contemporary art's claim that it provides an effective substitute for religious experience really crystallized with the Abstract Expressionists, as the quotation from Rothko suggests. It was perhaps no coincidence that the birth of this style coincided with a boom in museum building, especially in the United States. New museums were founded, and older ones enlarged or rehoused. The buildings themselves were often the work of leading Modernist architects, so that they and the collections and temporary exhibitions they displayed became complete statements about the workings of the twentieth-century sensibility.

Two examples are the Guggenheim Museum in New York, a late masterpiece by Frank Lloyd Wright, conceived in 1943 but not finally completed until 1960 after Wright's death; and the new, purpose-built, home of the Whitney Museum of American Art, designed by Marcel Breuer, once a prominent figure in the Bauhaus, in 1963-4. The two buildings have significant features in common. Both – and in this they are like Indian temples – were conceived as giant habitable sculptures, statements about the nature of Modernism as its patrons as well as its architects conceived it. Both were outgrown in less than three decades. The Guggenheim has been revamped and has had a new wing

Frank Lloyd Wright
The Solomon R. Guggenheim Museum, New York (from the south)
Designed in 1943 and finally completed in 1960 after Wright's death, the Guggenheim Museum has been described as "functionally indefensible but formally certainly startling" (Fleming, Honour and Pevsner, *The Penguin Dictionary of Architecture*, revised edition, 1982).

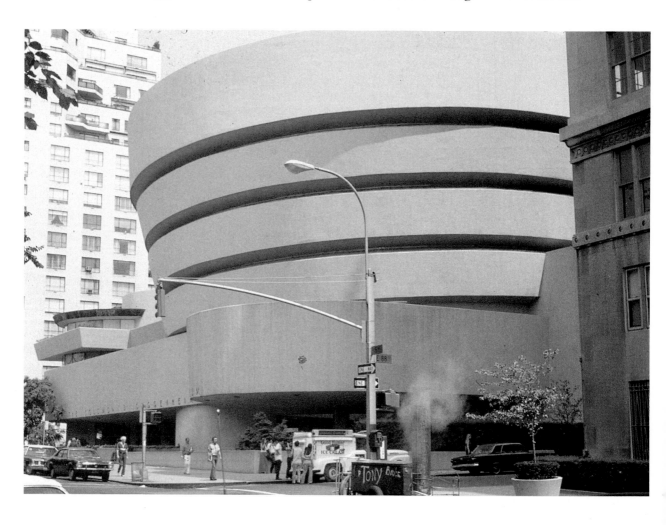

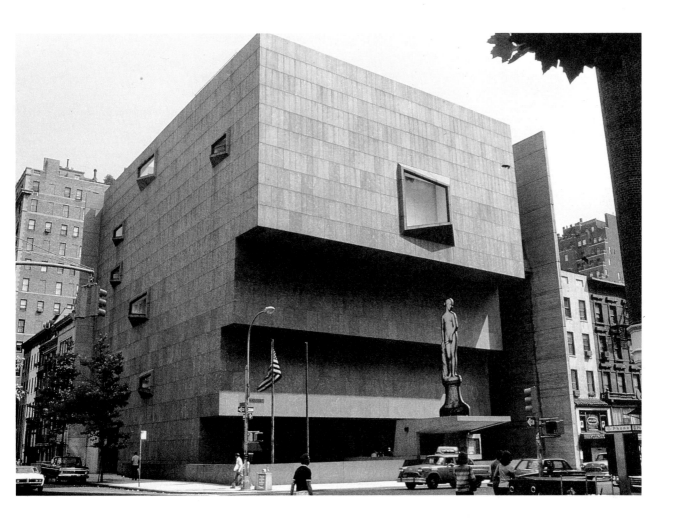

Marcel Breuer
The Whitney Museum of American Art, New York
Designed in 1963-4 by a leading architect connected with the Bauhaus, and completed in 1966, this like the Guggenheim is an early example of the "modern museum as temple".

added; the American architect Michael Graves, a leading exponent of 1980s Post-Modernism, has provided a design for enlarging the Whitney which so far remains unexecuted.

Like the Guggenheim and the Whitney, most of these new or radically transformed institutions were and are concerned with presenting contemporary art. When the museum boom began, it was, among other things, a sign that Modernism was entering the mainstream of modern culture, rather than being an isolated phenomenon of interest only to a small group. In addition, and this is to put things in much cruder terms, contemporary art was what was readily available. It was easier to fill a museum with the products of the artists of the time, or of the immediate past, than to raid the dwindling stocks of pre-twentieth-century art.

The new museums of contemporary art inevitably had a profound effect upon their cultural context. As gathering points and arenas for social display, they rapidly replaced religious buildings, such as churches: they acted as foci for a society which was increasingly secular and therefore uncomfortable with many aspects of revealed religion. Their role was the more effective because it effaced old boundaries. Many denominations could come together

under a museum's roof. In many parts of the United States, for example, museum gala openings and fundraising events took the place of the bustling church socials of the nineteenth century.

At first the rise of the museum seemed to benefit one class in particular, even more than it did contemporary artists. This class had existed as a recognizable intellectual profession or category since the mid-eighteenth century; the French *philosophe* Denis Diderot, leader of the Encyclopedists, admirer of Greuze and denigrator of Boucher, has a good claim to be its true founder. His lengthy commentaries on the annual French Salons, published in Melchior Grimm's *Correspondance littéraire*, which went out to a small but highly influential group of subscribers including Catherine the Great of Russia, have many of the salient characteristics of today's art criticism, among them the tendency of the critic to present himself as a moral arbiter. It is amusing, for example, to find Diderot, in his Salon review of 1767, opining that there might be "a morality special to artists, or rather to art, and that this morality could well go against the grain of everyday morality."[3]

In the new post-World War II situation, there was a profound and important degree of interaction between the critic and the museum. On the one hand, because of the variety of forms in contemporary art, and also very often – as with Rothko – its lack of specific content, it more and more became the task of the museum to define what art was, a function which, theoretically, became removed from the sphere of the critic, though not without arousing some protest from practitioners. The avant garde found itself rapidly absorbed by the very museum culture it had initially rejected with such vehemence, and unable to exist without it.

On the other hand, the museum often allied itself to critics because it needed their dialectical skills as a bridge to the lay public. If the critic was prepared to accept what was in the museum as a "given", there was always a job to be had explaining it. For a new generation of writers about art, contemporary works became the sacred texts which they were called upon to expound, as the preachers of the Middle Ages explained the imagery of the stained glass windows in Chartres and other cathedrals to illiterate or semi-literate pilgrim congregations. For a while at least, as the new mass audience was encouraged by every means possible to come to terms with the "complexities" of contemporary art, artists remained passive and museums seemed to remove themselves from the political arena.

A number of the artistic styles which followed in the footsteps of Abstract Expressionism, among them Post-Painterly Abstraction, Minimal Art and Conceptual Art, confronted the spectator with objects which were formally very simple: their chief quality and the chief barrier they presented to the spectator was a kind of willed blankness. Even the supposed emotion and spirituality, however cloudy and ill-defined, attributed to Abstract Expressionism were no longer present. The spectator, not unnaturally, looked for

Richard Long
Installation view of the artist's retrospective exhibition, *Walking in Circles*
Hayward Gallery, London, 1991
An example of the museum transformed into a sacred space: visible are *River Avon Circle*, *River Avon Mud Hand Circles* and *Magpie Line*.

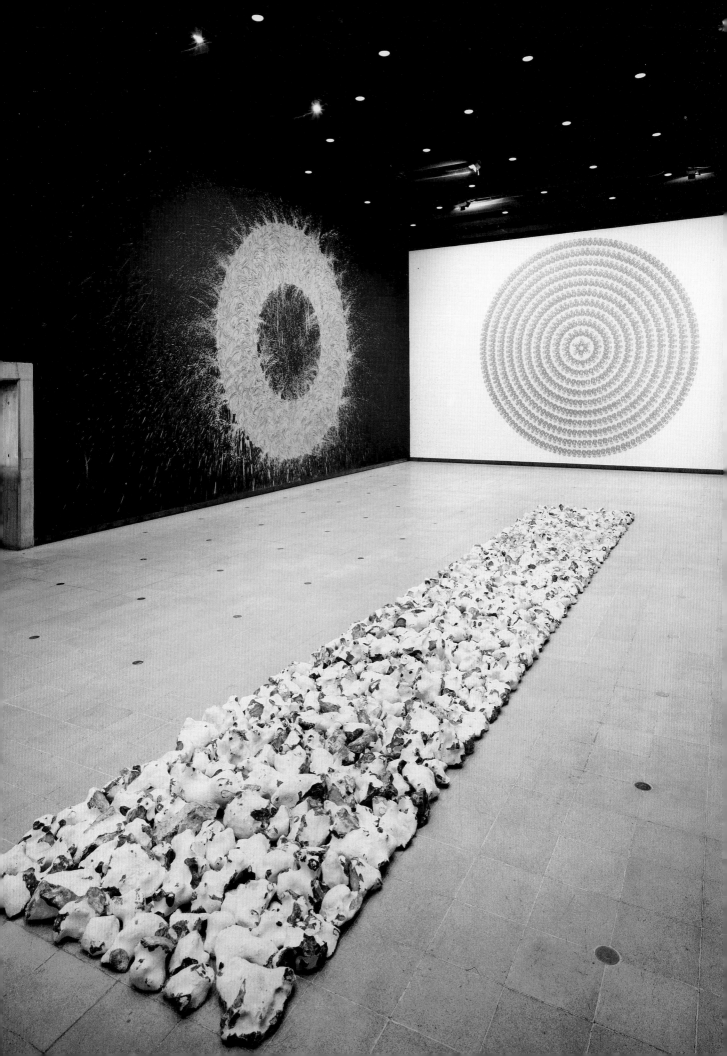

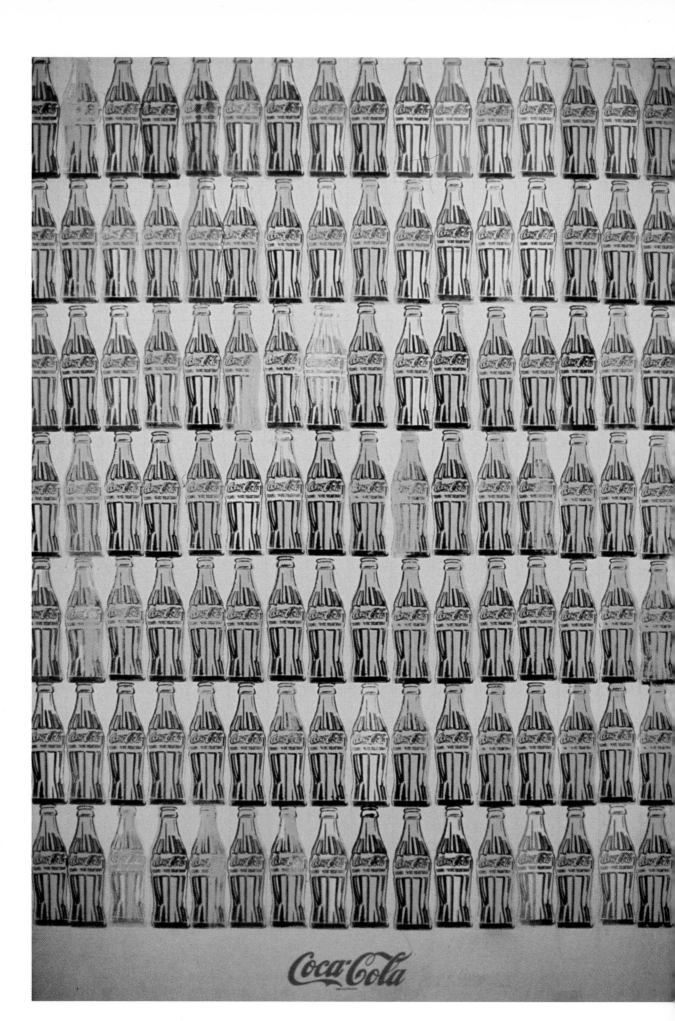

Andy Warhol
Green Coca-Cola Bottles, **1962**
Oil on canvas, 82¾ x 57in/210 x 145cm
Whitney Museum, New York
A classic early Pop work, the repetition of identical forms stressing the links between Pop and Conceptual art.

help in penetrating this shield of resistance. The official explanation, when offered, was frequently to do with the nature of perception. The audience was taught that avant-garde art objects were now essentialy self-referential, and that the truly valid subject for the artist who wanted to be on the cutting edge was the nature of art itself. The audience was adjured to hone its perceptions to catch the subtlest nuances in works which seemed to be visually inert. For this task, it needed the assistance of professional explainers – critics and curators. It often seemed that the more apparently simple the work of art the greater the number of words it generated.

From time to time, challenges or apparent challenges were offered to the reductivist approach. One was the Pop Art of the 1960s. To many ranking critics of the time, Pop seemed like a brutal attempt to overthrow the high seriousness they associated with contemporary manifestations in art (the brief, deeply cynical revolt of Marcel Duchamp and other Dadaists during and just after World War I had been largely forgotten). But in the broad sense Pop Art continued the intellectual status quo. For its participants, the chief interest was less the celebration of mass culture than the analysis of conventions of representation – something which did not take Pop far from the modes of perception enshrined in Minimalism.

The Pop movement did not halt or thwart the continued construction of a self-enclosed, mandarin, culture focused on the activity of the museum, its acolytes and servants which had become such a conspicuous feature in the United States and non-Communist Europe. This mandarin culture was financed in different ways on either side of the Atlantic: in the United States the money came from the private sector, in Europe it was more apt to come from the public one.

Wherever it appeared, this culture displayed certain common features. One was an insistence on the primacy of language over visual stimulation. It often seemed that avant-garde art could not fully exist until the appropriate explanation had been devised to validate it. The explanation – an exegisis of the artist's announced or supposed intention in creating the work – was almost invariably provided by the exhibiting institution, or by someone at least residually connected with it.

Another feature of avant-garde culture, from the time of Abstract Expressionism to around 1970, was a false but confident ecumenism. Contemporary Art, under the aegis of the Modern Movement, was perceived as something unified and universally valid, although manifestations of the Modernist spirit outside the North American or western European spheres still tended to be thought of as "provincial" and inferior. This led to oddities of perception. For example, a western European or North American artist borrowing African forms would, with the example of Picasso very much in mind, be praised for

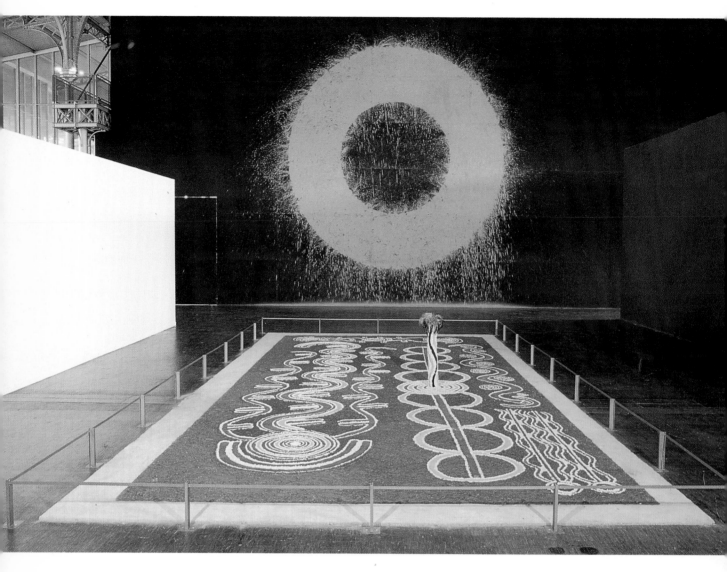

Installation view of *Les Magiciens de la Terre* exhibition Centre Georges Pompidou, Paris, 1989

An ambitious if flawed attempt to show art from "the margins" jointly with, and on the same footing as, contemporary art from the central Modernist tradition.

sophistication and breadth of cultural sympathy. A modern artist from Asia or Africa making obvious use of forms borrowed from the European tradition would, on the other hand, be condemned for diluting his or her heritage.

Despite the fact that it was much less inclusive than it claimed to be, the museum culture of the immediate post-war decades eventually came under severe strain, not because of its obvious intellectual defects, nor the exclusive attitudes of those who created, sustained and directed it, but because of the highly prolific nature of contemporary art. Museums soon found that they could not absorb and display everything they were meant to be responsible for. Against their instincts, they were forced to specialize, generally in the art of their own particular region or catchment area. This tended to call into question all universalist claims, and to speed up the process of regionaliza-tion which has been such an obvious feature of artistic developments during the last decade.

The universalizing impulse died hard, however. At the same time as art seemed to be regionalizing itself, there was greater and greater curiosity about artistic manifestations in regions which until then had counted as secondary or unimportant. More and more exhibitions, for example, were devoted to the art of Latin America, modern Africa, modern India and contemporary Japan. These shows tended to be linked to the exploration of minority cultures, but they also enshrined a contrary impulse: the reassertion of the rights of the centre and its duty to impose its own standards on the periphery. The claim that "all art is one", the central tenet of large-scale survey exhibitions such as *Les Magiciens de la Terre* (Centre Georges Pompidou, Paris, 1989), was still founded on the critical and curatorial establishment's confidence in its own powers to determine what was, and was not, to be thought of as art.

4 Transgressive Art and the Modern Shaman

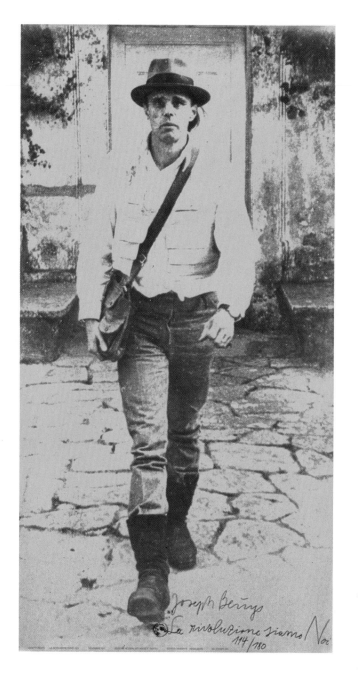

Joseph Beuys
We Are the Revolution, 1972
Silk screen, 75 x 40in/191 x 102cm
Houston Museum of Fine Arts
A self-portrait of the artist in his accustomed costume of jeans, fishing vest and felt hat. The hat, which became a trademark, was originally adopted because of his war wounds.

The absorption of avant-garde art into the mainstream of contemporary culture eventually reached the point where this began to threaten its "traditional" identity. From the beginning of its career, the Modern Movement had in large part defined itself through negatives. In particular, it relied on the fact that it was transgressive in terms of what surrounded it. Whether the avant garde in art was radical right or radical left politically, for instance, was to some extent irrelevant. What mattered was that it should remain radical; that it should continue to oppose conventional bourgeois society. The desire – even the urgent need – of the contemporary artist to reject accepted standards was in part a legacy of the Romantic Movement of the early nineteenth century, from which all Modernism descends. The Romantic artists frequently postured as *âmes maudits*; to be rejected by society was regarded as the necessary guarantee of genius.

Where the twentieth century was concerned, the feeling that art must establish itself by transgressing established norms was greatly reinforced by political events, chief among them the destructive madness of World War I to which the deliberate nihilism of the Dada Movement seemed a fitting reply. The avant garde, however, reckoned without the power of the cultivated bourgeois class to absorb ideas and attitudes apparently completely hostile to it. Nor did it foresee the consequences of its own increasing dependency on museums, and thus on the social and financial structures of which museums of contemporary art were a visible embodiment.

Whereas the first Modernists were, as has already been said, totally alienated from the museum culture of their own time, the situation had changed drastically by the mid-1960s. By this time it was museums which provided avant-garde artists with their most effective platform. Funding for their activities came either from museum sources, or through official and semi-official bodies set up to offer support for the arts. More and more, the kind of work artists produced was predicated on the existence of a museum space ready and willing to receive it – even if, for the most part, it was on a temporary rather than a permanent basis. Environmental works, regarded as the most reliably radical manifestations of contemporary art, were essentially public statements, and the only logical framework for them was the museum or *kunsthalle*, rather than the private home or commercial gallery. The transgressive element, however, strongly emphasized by the artist, was inevitably compromised by the official nature of the setting.

Artists, while instinctively recognizing this fact, usually denied its importance in public, relying on a noisy rhetoric of alienation to conceal the gap between their assumed and their real situation. In doing this, they generally received unstinting help from the museum directors and curators who were their allies. For this there were logical reasons. Museums were conscious, not only of their dependency on the artists of their time as the "engines" which drove the whole enterprise, but of the value of the publicity generated by

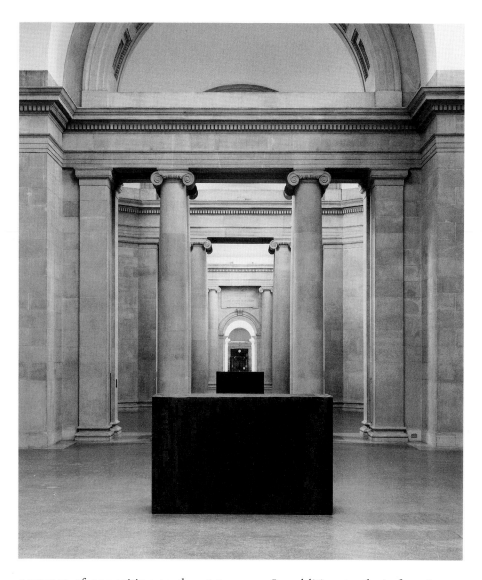

Richard Serra
Weight and Measure, 1992
Installation view, Tate Gallery, London
Forged steel, 68 x 41 x 108½in/1.73 x 1.04 x 2.75m and 60 x 41 x 108½in/1.52 x 1.04 x 2.75m
A classic example of the artist "confronting" a given space.

gestures of opposition to the status quo. In addition to their function as places of worship and pilgrimage, exhibiting institutions were increasingly aware of their position as part of a whole network of popular recreation and entertainment – a function not completely alien to their predecessors, the cathedrals of the Middle Ages. Controversy, so long as it remained within certain bounds, could only increase attendances. Personally sympathetic to the attitudes and aims of the artists whose work they presented, exhibition organizers were able to treat the transgressive element as a justification rather than a stumbling block. It was smoothly absorbed, and became part of their own mission to explain.

In the 1960s, despite the success of Pop Art, artistic controversy generally focused on aesthetic rather than social issues. Minimalism's reductiveness led critics to concentrate, not on unitary forms, but on the effect these made within a given space. Numerous exhibits and displays were based on the idea of "confronting" the architectural volumes of a given

building. Exhibitions of this type are still frequent, although there is now tacit acceptance that the confrontation disturbs no one.

During the past decade and a half, however, there have been increasing signs of a return to non-aesthetic content in avant-garde art. Sometimes the swing has been so drastic that aesthetic issues have been almost entirely displaced. The first sign of a major change in the artistic climate came in the western half of a still-divided Germany, with the appearance of the sculptor Joseph Beuys (1912-86). Beuys brought together elements which had been important in avant-garde culture from its beginnings – both religious factors and political ones – but did so in a new way. Part of the novelty lay in the fact that he manipulated the transformed museum culture with unique adroitness, making it a means of empowerment for the artist himself, rather than for his salaried, bureaucratic interpreters.

Thanks to physically and psychologically traumatic experiences during World War II, when he was rescued and healed by nomadic Tartar tribesmen after crashing his Stuka divebomber in the Crimea, Beuys had come to see his own activity in the world as closely parallel to that of the primitive shaman. "To him," says his biographer, Heiner Stackelhaus, "the shaman was a figure in whom material and spiritual forces could combine."[1] Beuys's art, from the early 1960s onwards, was increasingly a play with " magical" substances, such as felt, honey and fat. The way in which he used these was governed, not by visual effect, but by their place in the rituals enacted by the artist. As his career progressed, Beuys more and more tended to add a political dimension to the purely magical one. Taking advantage of the existing interest in Conceptual Art, Beuys transformed political agitation into a form of artistic activity, designating it Social Sculpture. Metaphorically, he was shaping society itself, just as if this were a block of stone.

Beuys's career as a politician who was also an artist began in 1967. The first step was the foundation of the German student party, in response to the shooting of a student during a demonstration held in West Berlin against the Shah of Iran. Despite this, the main focus of the party's activity was never international events: it was the way in which students were treated by the West German government, and in particular the admissions policy of the Düsseldorf Academy, where Beuys was a professor. Beuys wanted the Academy to admit anyone who wished to come there; the authorities resisted this as impractical. Despite the apparent narrowness of the issue, the party made an enormous amount of noise, thanks largely to the religious aura with which Beuys had already surrounded himself. Opponents at the Academy, helpless in the face of his charismatic appeal, railed against Beuys and his alleged lust for martyrdom – what they described, with some lack of taste, as his "Jesus kitsch".[2]

In 1971, still locked in struggle with the Academy, Beuys broadened the base of his political activities, founding the Organization for Direct

Democracy through Referendum (People's Free Initiative). In his own mind this was less a political party than an anti-party, a challenge to the whole political structure. As one manifesto complained:

Minorities (top officials) . . . dominate unhindered the millions who make up the productive majority of the people. We call that democracy. We consider it to be party dictatorship, pure and simple.[3]

Political discourse now began to play a dominant part in Beuys's activities. At Documenta 5, held in Kassel in 1972 (like previous and subsequent Documentas it was the most ambitious survey of the avant-garde art of its day, giving an immediate imprimatur to any trend it happened to feature), Beuys conducted a hundred days of debate with the members of the international public who visited the show. The room where he held forth was easily the most heavily frequented section of the whole display. He repeated the exercise at Documenta 6 in 1977, as part of what he now called his Free University for Creativity and Interdisciplinary Research.

The significance of Beuys's presence in Kassel was, in art historical

terms, even more complex than might appear at first sight. The Documenta exhibitions had been created as a showcase for free-world values as opposed to those of the Communist bloc. The location of the exhibition was no accident: Kassel was close to the border with the DDR, and the city was somewhat cut off from the rest of West Germany by the vagaries of a rail network and road transportation system inherited from a time when the country was still united. The Marxist elements in Beuys's programme were therefore coloured and to some extent subverted by their setting. Beuys understood this: he was never to be the prisoner, as his predecessors in the 1930s had been, of larger political necessities than his own. Rather, he successfully mediated between rival systems, and seemed to his audience to offer a genuine, art-based alternative to both.

The notion that Joseph Beuys discoursing with all comers on the political and social themes which interested him counted as art was accepted without protest by the wide range of museums and galleries which at this time, and to the end of his life, offered him a forum for his views. Any relics of these occasions – such as the blackboards on which he drew diagrams to illustrate

Anselm Kiefer
The High Priestess/
Zweistromland **(detail), 1985–9**
Book 61, double spread, no. 22
Original photographs mounted on
treated lead, 22 solder-bound
leaves, 29³⁄₄ x 20¹⁄₂ x 4¹⁄₃in/75.5 x 52
x 11cm when closed
Private collection
This unwieldy book hints strongly at the essentially literary nature of Kiefer's inspiration.

his concepts – were piously preserved and often exhibited later as independent artworks. There was no doubt, nevertheless, that Beuys's actual presence and discourse were the primary element of the art "happening", both for himself and for his audiences.

His example – that of someone initiating political action in, and with the aid of, the contemporary art context – bore most immediate fruit in Germany. Yet, surprisingly, his followers reverted to more conventional means of artistic expression. This was true of Beuys's chief heir, Anselm Kiefer (born 1945). An important point of reference in Kiefer's work is the world of the German thinkers and poets of the eighteenth and nineteenth centuries, who belonged to a period when the German lands (as can be seen from Mme de Staël's once-celebrated exploration of German culture, *De l'Allemagne*, published in 1810) were regarded as the most naturally peaceful and progressive region of Europe. Kiefer contrasts this with the trauma of the immediate past, Nazism and World War II.

Not content with alluding to the past, he reverts to it in his chosen means of communication. His most typical products – vast, sombre canvases

Jörg Immendorff
Café Deutschland – Self love doesn't stink, 1983
Oil on canvas, 59 x 78³⁄₄in/150 x 200cm
One of a series of paintings about divided Germany.

steeped in bitumen and other substances – are Modernist only by courtesy. Their nearest equivalents are the dramatic, rhetorical, paintings-as-public-statements produced by artists such as David, Géricault and Delacroix in the Napoleonic and immediately post-Napoleonic epochs. In fact, Kiefer has fallen into the same trap as the one which engulfed Picasso when he painted *Massacre in Korea*. In order to produce art with a sufficiently specific political content, he has been forced to reach back beyond Modernism, and employ devices associated with pre-Modernist painting. The same is true of other German political artists of Kiefer's generation – for example, Jörg Immendorff (born 1945) and his *Café Deutschland* series, meant to symbolize the problems of a still-divided Germany.

Those who learned the lesson of Beuys in a much more fundamental way were artists, not necessarily German, who were representatives of minority groups. These had long been marginalized by the museum system. The very fact that they were members of such groups seemed, to the curators and taste-makers of the 1960s and 1970s, to guarantee their lack of centrality, and therefore their irrelevance to the museum situation.

They got their chance to move towards the centre when Beuys demonstrated the effectiveness of the museum as a political platform, and also the way in which political discourse could be sacralized by the museum context. Beuys never surrendered his claim to be a shaman after he became a politician; the fact that he, and others, designated his political discourse as a form of sculpture reinforced that aura. His listeners and interlocutors, reverently surrounding him in a building such as the Tate Gallery, Britain's national museum of modern art, had the feeling that they were at that moment artistic co-creators, as well as being participants in a rite. The situation was emotionally a very powerful one, and those who stood to benefit by creating similar opportunities for themselves noted its effectiveness. The museum, they saw, could be a megaphone, which greatly increased the audibility of a single voice, or small group of voices.

At the same time, those who controlled museum access – access for participants, not simply the public – began to realize that minority spokespersons were well placed to reinforce the transgressive element which was inexorably draining away from the mainstream avant-garde arts, and in consequence weakening their authority. A minority of whatever sort is, by its very nature, usually in a state of insurrection against what surrounds it.

For museums and for the contemporary art scene in general to identify with the need to empower minorities was also a logical step in a world where the standard, long-accepted groupings of left and right had begun to crumble, but in which contemporary art and its aficionados continued to feel a need, deeply rooted in the whole history of Modernism, to align themselves with some idealistic cause. What the traditional left could no longer offer, minority politics were in a position to supply.

5 Chicano and Cuban Art

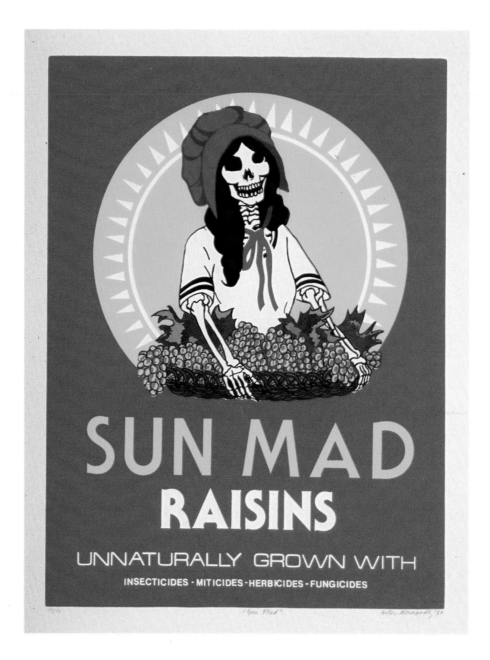

Ester Hernandez
Sun Mad, **1982**
Screenprint, 22 x 17in/55.9 x
43.2cm
This Chicano woman artist uses a
Mexican *calavera* (skeleton figure),
derived from the work of Jose
Guadalupe Posada, in a new, North
American context as an agent of
ecological protest. The poster format
also points to Cuban influence.

A good example of such an idealistic cause, limited in both geographical and cultural scope, and perhaps for that very reason more closely focused on the operation of minority psycho-social dynamics, is the art produced by members of the Chicano community in the West and Southwest of the United States, especially by that part of it settled in Los Angeles. This art has made the now classic transition from being an expression directed only at members of the minority community itself, to being one directed at a much wider audience, though sometimes only in what one might call a "refractive" way – that is, the non-Chicano audience is permitted to eavesdrop on what Chicanos say to one another, and the museum becomes a means to this end. Whereas African American art more and more seems to represent an area of stylistic and ideological confusion, Chicano art offers a model of the ways in which minority artistic expressions are now expected to operate

First, it gives a means of self-identification, presenting Chicano culture and aesthetics as immediately recognizable entities. Second, it serves as a vehicle for political claims. Finally, and somewhat intermittently, it conveys a message and a warning to those who are not Chicanos. Unlike African American art, it has little genuine connection with Modernism. It is Modernist by virtue of the fact that it has now made its way into museums of contemporary art, which have to some extent been forced to redefine their own criteria in order to make room for it.

There are other forms of minority expression in art which operate in a similar way, though few are as direct. Two which immediately come to mind are Japanese American art and contemporary Native American art. None, however, is as complete in its fulfilment of the whole spectrum of aims attributed to art of this type, and none has a history which is equally clear and compact. There are other diferences as well. If one looks at the work of perhaps the best-known Japanese American artist to pursue a strongly political agenda, Masami Teraoka (born 1936), one is struck by the savage irony with which he uses Japanese source-material – in his case *ukioye* prints. He uses the *ukioye* conventions of representation to stress ideas of cultural, social and even sexual difference. All three are present in his *What are you looking at?* of 1992, where a blonde female swimmer clutching a snorkel indignantly confronts a Japanese man she suspects of taking too close an interest in her. Cultural interplay of this degree of complication is absent from Chicano art, which addresses, primarily, its own community, though now, in a second stage of its development, occasionally allowing outsiders to eavesdrop through museum presentation.

What is a Chicano or Chicana? One cannot do better than quote the definition printed in the catalogue of *Chicano Art: Resistance and Affirmation, 1965-1985*, the most important exhibition devoted to the subject which has so far been held:

Masami Teraoka
What are you looking at?, 1992
**Watercolour on paper, 15 x
22³⁄₈in/38 x 56.8cm**
Teraoka uses the conventions of the
nineteenth-century Japanese *ukiyo-e*
print as a way of commenting on
relationships between Caucasians and
Japanese in the context of a Western
society.

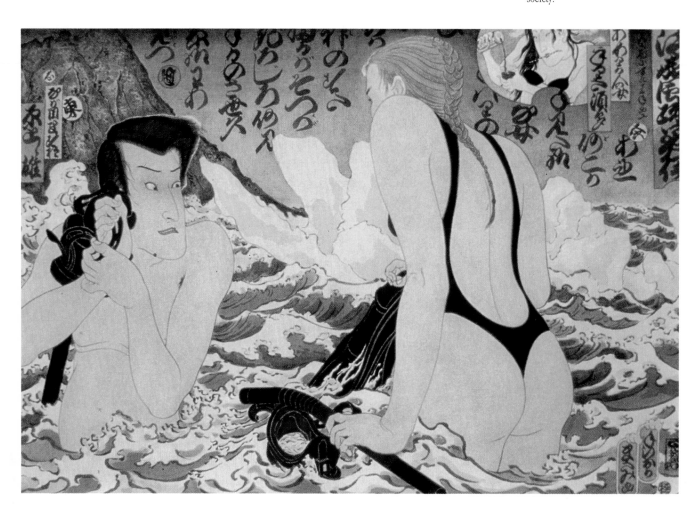

*Term of self-designation for a politicized individual of Mexican descent in the
United States. . . . The term has also been applied specifically to persons active
in the ongoing Chicano Movement.*[1]

Chicanos are found chiefly in the Southwest, in the cities of the Pacific Coast,
and in Chicago and the Great Lakes region. The most important centre for
Chicano artistic activity is Los Angeles.

Chicano art, as an identifiable phenomenon, first made its appearance
in 1965, as part of a community response to labour agitation by the National
Farmworkers' Association, led by Cesar Chavez, which was then struggling to
unionize poorly paid immigrant farmworkers in California and Texas. Soon,
however, it became an urban product, rather than a rural one. It was linked to
protests against police brutality, and against inadequate housing and educa-
tion. It owed much to the nationwide Civil Rights Movement, and to opposi-
tion to the Vietnam War: a disproportionately large number of soldiers of
Latino origin were sent to serve in Vietnam. The first, most politically radical,
phase of Chicano visual expression lasted from 1968 until the mid-1970s. The
second phase stretched from that time until the present.

During the early period, Chicano images were almost entirely com-
munity-oriented. Murals and posters were the most typical form of expres-
sion, and there was no thought of museums or museum culture, not least
because museums of any sort remained remote from the experience of most
Chicanos. The chief sources of inspiration did, nevertheless, have an es-
tablished artistic pedigree: they were Cuban posters and Mexican murals.
Posters from Cuba were made widely available by the publication of a hand-
some picture book featuring them at the beginning of the 1970s. This, *The Art
of Revolution, 1959-1970*, had an introduction by the influential critic Susan
Sontag. Her words probably had minimal impact compared to the illustra-
tions, which were almost poster size, and could be torn out and pinned up.

Even more important were the murals painted between the early 1920s
and the mid-1940s by three leading Mexican artists, Diego Rivera, José
Clemente Orozco and David Alfaro Siqueiros. All three worked in the United
States as well as in Mexico. Their art was, in addition, widely publicized by
exhibitions sponsored by the Mexican government, often aimed specifically
at the Mexican community in the United States. Their most potent attraction,
however, was the effect of years of propaganda which had made the work of
the muralists part of the consciousness of even the poorest and least-
educated Mexicans: it was an embodiment of national consciousness.

Mexican influences of a somewhat humbler sort were also visible in
Chicano visual images. These sprang from the special culture of the *barrios*,
the neighbourhoods inhabited by Mexican immigrants. They included the
wall paintings often found on the walls of *pulquerias* or drinking places; the
chromo-lithographic illustrations found in the popular calendars distributed

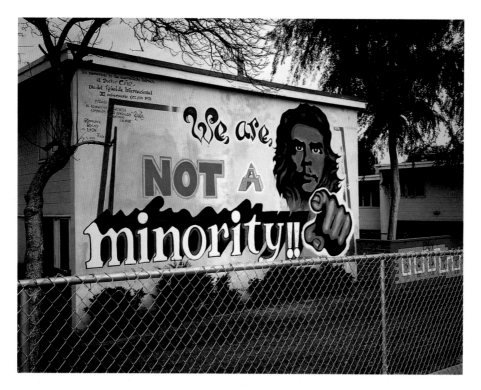

Congresso de Artistas Chicanos en Aztlán (Mario Torero with Zapilote, Rocky, El Lton, Zade)
We Are Not A Minority, 1978
Mural, c. 20 x 30ft/6 x 9m
Estrada Courts Housing Project, East Los Angeles
One of the most celebrated Chicano murals, several times defaced and restored.

by local traders; and images borrowed from the *penitente* art of the Southwest. *Penitente* Brotherhoods are religious confraternities for laymen; one of their preferred symbols is the *Ecce Homo*, or Man of Sorrows. It is in including religious images of this type – not only the *Ecce Homo* but the Virgin of Guadalupe – that Chicano art differs most widely from the official art commissioned by the Mexican government at home, since there the regime was (and is) officially atheist.

Another way in which Chicano art differs widely from purely Mexican art is in its use of source material identified with the culture of the United States. Much of this, too, was of popular origin. Some Chicano visual expression has affinities with Pop Art, drawing as it does on comic strips and popular magazine illustrations. There are scarcely any references to North American "high art" sources, with Andy Warhol perhaps the only exception: his iconic portraits of celebrities seem to have influenced some of the Chicano muralists.

An example can be found in one of the best-known wall paintings of the early period, *We Are Not A Minority* (1978). This features a gigantic head of Che Guevara, killed in Bolivia some ten years previously, plus a huge hand which points accusingly at the viewer. Warhol is here combined with a device borrowed from a World War I recruiting poster. It is a tribute to the continuing effectiveness of the image that it has been twice vandalized since it was painted. The most recent occasion was in 1984, just before the Los Angeles Olympics, when the perpetrators were a Cuban group. Their action served to emphasize the divisions between Latino communities in the United

States, and the divide between immigrant Cubans and Chicanos in particular. Though effective as propaganda, the image has little real claim to aesthetic quality. This is an issue which many supporters of Chicano art would dismiss as irrelevant.

Easel paintings by Chicano artists, a comparatively late development, remain obstinately representational and indeed illustrative in style. A good example is the work of John Valadez (born 1951), who is a graduate of the mural movement. His paintings have deliberate stylistic neutrality, designed to make the point that the thing depicted is infinitely more important than the way in which it is shown.

If Chicano art has any genuine contact with other aspects of the contemporary avant garde, it is through feminism. Chicano culture, like the popular Mexican culture it so largely springs from, is notorious for its swaggering *machismo*. From 1970 onwards, however, feminist caucuses began to make an appearance at national Chicano conferences. The first Chicano feminist artworks appeared in the mid-1970s, close on the heels of the first general upsurge of feminist art. The Virgin of Guadalupe became an image of par-

John Valadez
The Wedding, 1985
Oil pastel on paper,
38¼ x 48½in/97.1 x 123cm
Private collection
The paramountcy of the subject matter is indicated by the near-photographic nature of the actual depiction.

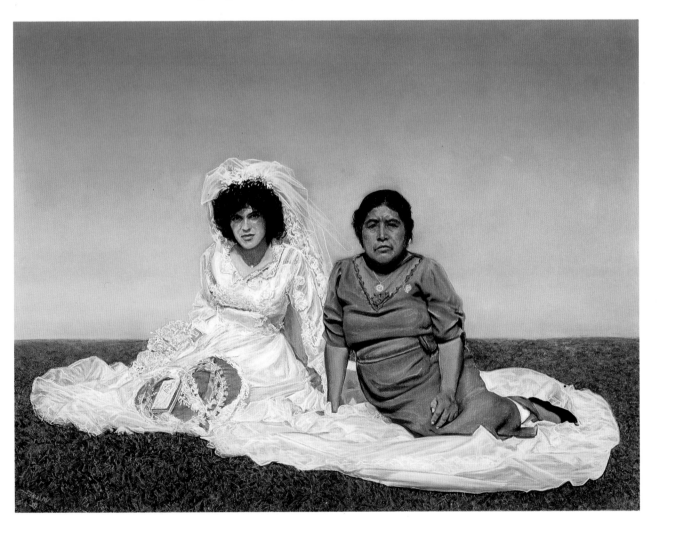

Frida Kahio
The Dream, 1940
Oil on canvas, $29^{1}/_{2}$ x $38^{3}/_{4}$in/74.9
x 98.4cm
Private collection

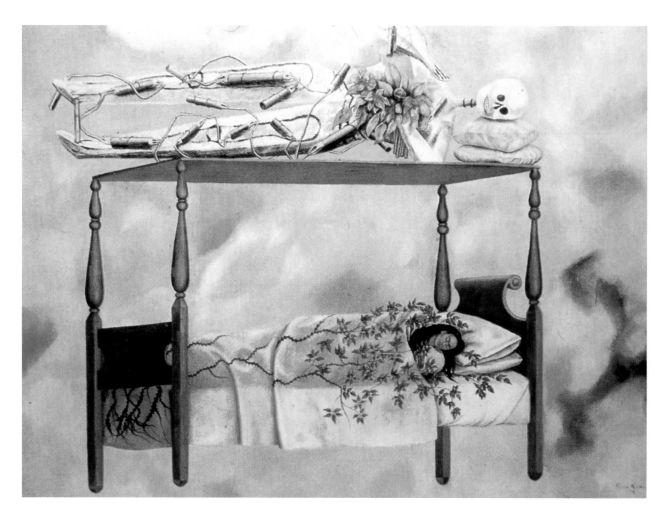

ticular importance for leading women artists like Ester Hernandez (born 1944) and Yolanda M. Lopez (born 1942). So too did the art and personality of Frida Kahlo.

While Chicano art lacks the distancing irony typical of the work of Masami Teraoka, it does display a quality which Chicanos themselves call *rasquashismo*. This is perhaps the most typical and sympathetic trait of the urban Chicano sensibility:

Rasquashismo is a sensibility that is not elevated and serious, but playful and elemental; it finds delight and refinement in what many consider banal and projects an alternative aesthetic – a sort of good bad taste.[2]

Spectacular examples of what is meant by this are supplied by the automobiles as artworks made by Larry Fuente. Using old tail-fin Cadillacs and other examples of the "baroque" automobile styling of the 1950s and 1960s as his armatures, Fuente encrusts them with incongruous materials of all kinds, ranging from plastic beads and jewels to toys and thrift-shop china ornaments. These automobiles make direct reference to Mexican church decoration, and also, at the other end of the cultural spectrum, to "low riders" – lovingly customized automobiles and motor-cycles which feature at meets and exhibitions attracting thousands of fans of a type very different from the museum-going public. Fuente's creations are simultaneously exuberant and cool – they participate directly in the culture of the *barrio*, but at the same time make a comment on it.

When Chicano art moves in this direction it is very different from other manifestations of Latino art in the United States. The most coherent Hispanic or Latino group, apart from the Chicanos, is that of the Cubans, now as thickly settled in Florida and the Southeast as Chicanos in California and the Southwest. The main survey of Cuban art-in-exile during the 1980s – *Outside Cuba: Fuera de Cuba*, mounted in 1987-9 by Rutgers University, New Jersey, and the

Larry Fuente
Liberty, 1983
1967 Cadillac with mixed media
An exuberant example of Chicano taste.

University of Miami – offered a very different set of attitudes from those encapsulated in recent surveys of Chicano art. The first sentence of the first catalogue essay, "The Inevitable Exile of Artists" by Ileana Fuentes-Perez, struck the dominant note:

This exhibition is about the reappearance of Cuban art in many distant landscapes, and this essay, in particular, focuses on the causes of this phenomenon, a government's attempt to bring the cultural life of a nation under its absolute jurisdiction.[3]

The reference, far from being to the situation of Cuban artists as part of a minority within the United States, is to their situation vis-à-vis the country they have been forced to abandon. Miami, where most artists of Cuban origin in the United States now live and work, is seen both as a "backdrop for the recapturing of traditions and cultural mores"[4] and as a forum for the exchange of information concerning the art of all Latin American countries. The youngest artists in the show have spent most of their lives in the United States,

Luis Cruz Azaceta
Question of Color, **1972**
Acrylic on unstretched canvas,
10ft x 11ft 8in/3.05 x 3.56m
Private collection
This early work by Cruz Azaceta shows the influence of Abstract Expressionism, but nevertheless still hints at a political agenda. His later works are figurative expressionist in style.

Wifredo Lam
Overture to Eleggua, **1955**
Oil on canvas, 42 x 35in/106.6 x
88.9cm
Eleggua is one of the gods of African
origin included in the Santeria
pantheon.

but all were born in Cuba. Those who left in adolescence rather than in early childhood still have vivid memories of the Castro regime. This is Mario Bencomo, born in Pinar del Rio in 1953, who finally left Cuba in 1968:

At school we were taught about a god named Fidel; it was part of the indoctrination. My family never supported Battista or Castro. As I grew older, I realized that I didn't want to remain in Cuba. I still feel anxious about being able to travel, to come and go as I please; it stems from the terrible fear of being unable to leave Cuba.[5]

Cuban artists now living in America are mostly of middle-class origin, and this too has had an effect on their attitudes. While they, like Chicanos,

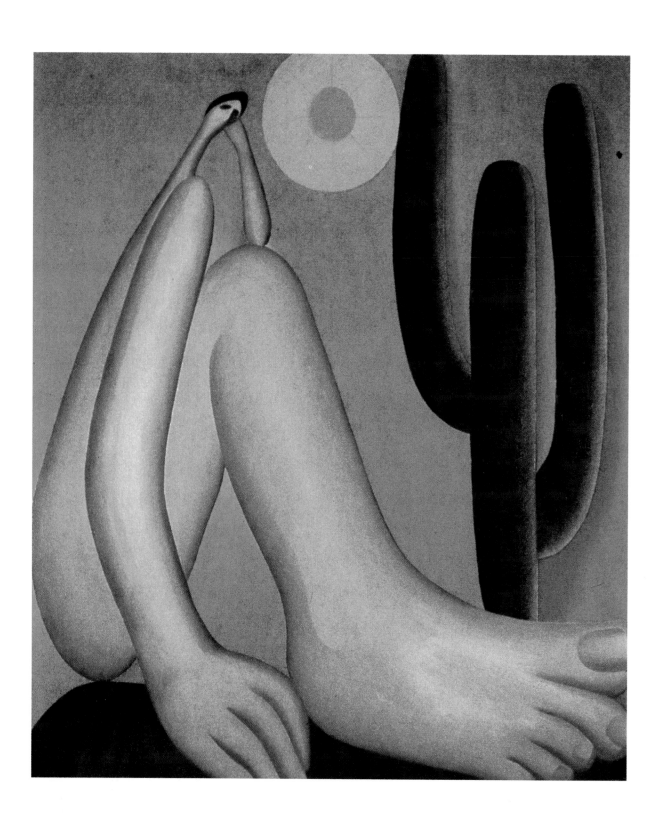

Tarsila do Amarai
Abaporu, 1928
Oil on canvas, 33½ x 28¾in/85 x
73cm
Private collection

perceive themselves as being part of a community which has its own set of cultural traditions, they do not think of their situation as being one in which they are inevitably belittled and besieged. Some painters of Cuban origin, such as Luis Cruz Azaceta (born 1942) have made the breakthrough into the New York mainstream, and are shown in major commercial galleries on the same footing as other highly successful artists. Azaceta's work shows a combination of Latin American and Neo-Expressionist elements.

A comparison of *Outside Cuba: Fuera de Cuba* with the various exhibitions which have recently showcased Chicano art reveals not only a much greater variety of style but a sharply reduced interest in overtly political content. The Cuban tradition, while it exists, is less fixed and not so firmly ethnic and nationalist. The greatest of the Cuban Modernists, Wifredo Lam (1902-82) spent nearly all of his working life outside Cuba, and was closely associated with the Paris-based Surrealist Movement. While he attempted to interpret aspects of Cuban culture in his work, notably what Cubans had inherited from Africa (his godmother was a black healer and sorceress who followed the old African ways), he became essentially a European artist. His work is free of the nationalism which typifies the Mexican muralists.

The search for a specific national identity was never as pronounced in Cuban art as it became in Mexico, and has not been inherited by the Cuban painters and sculptors who now live and work in Miami. Seeing themselves as Latin Americans as much as they are Cubans, and perhaps rejecting Lam because of his sympathy with the Castro regime, they have not – or not yet – developed the kind of combative minority consciousness which distinguishes Chicano art. Nor does militant feminism seem to have made much of an impact on the work of women artists from the Cuban emigré community. One reason may be the long-established success of women artists within the framework of Latin American art. Among painters, some of the greatest names are those of women: not only Frida Kahlo, but Maria Izquierdo (Mexico), Tarsila do Amaral (Brazil), Tilsa Tschuya (Peru), Amela Pelaez (Cuba) and Maria Luisa Pacheco (Bolivia).

The contrast between the two immigrant Latino groups is an instructive one. It demonstrates that what is now rather imprecisely called "minority art" does not necessarily arise just because a definable minority exists. In the case of immigrant Cubans now in the United States such an art may appear, even if it has not as yet done so. However, it will appear only under two quite strict conditions. First, their cultural focus will have to shift from the Cuba which they have left to the country in which they now live; second, they will have to feel that they are being subjected to serious social and political discrimination within the larger framework that holds them, the United States itself.

6 Racially Based Art in Britain

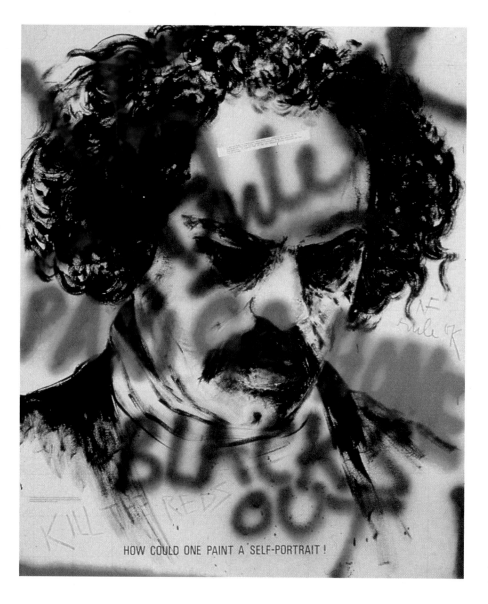

HOW COULD ONE PAINT A SELF-PORTRAIT !

Rasheed Araeen
How Could One Paint a Self-Portrait?, 1978–9
The self-portrait is obliterated by racist and political graffiti.

The history of art in Britain based upon racial origin and racial difference is briefer and less complex than that of art of this type in the United States. It is also different in other, important respects, to a degree as yet unadmitted by leading protagonists in the United Kingdom.

The largest and most ambitious exhibition of art of this type so far held in Britain was *The Other Story*, shown at the Hayward Gallery in London in 1989-90, and afterwards in Wolverhampton and Manchester (both cities with large immigrant communities). It was curated by Rasheed Araeen, a well-known Pakistani-born artist, editor of the magazine *Third Text*, and a noted campaigner for greater recognition for artists from the Third World. The blanket description Araeen chose for participants was "Afro-Asian", and the artists chosen came not only from the Indian subcontinent and the Caribbean, but from China, Japan, West Africa and the Lebanon.

Essentially, however, nearly all "minority art" made in Britain falls into one of two categories; either it is made by artists from the Indian subcontinent, or by men and women of Afro-Caribbean origin. These two areas between them have supplied the vast majority of the non-European immigrant population which flowed into Britain after World War II, and vastly changed the nature of British society as a result. Despite attempts to lump the two groups together by promoting what in Britain is still called "black art", what they produce is radically different, for excellent historical reasons.

During the nineteenth century, as Araeen points out in his introduction to *The Other Story*, Indian art was often cited by philosophers such as Hegel and art critics such as Ruskin as the epitome of decadence. He cites a passage from one of Ruskin's lectures which is worth quoting again:

I can put the relation of Greek to all other art, in this function, before you, in easily compared and remembered examples ... Here, on the right ... is an Indian bull, colossal, elaborately carved, which you may take as a sufficient type of the bad art of all the earth. Faulty in form, dead in heart, and loaded with wealth externally. We will not ask the date of this; it may rest in the eternal obscurity of evil art, everywhere and forever. Now, beside this colossal bull, here is a bit of Daedalus-work, enlarged from a coin not bigger than a shilling: look at the two together, and you ought to know, henceforthward, what Greek art means to the end of your day.[1]

In the late twentieth century, however, the situation is different. We have accepted the notion of a plurality of cultures, and the Indian subcontinent is universally recognized as the seat of a succession of great civilizations, with architecture and art inspired by three of the world's major religions, Hinduism, Buddhism and Islam. This fact gives Indian artists, even those cut off from their roots, a certain innate self-confidence; they have something to contribute to the west as well as something (perhaps) to learn. The work of

the Indian, Pakistani and Bangladeshi artists shown in *The Other Story* was surprisingly unpolemical, despite the nature of the framework within which it was presented. There was a wide variety of style, and very often, as in the case of the Punjabi-born Balraj Khanna (born 1940), the balance between east and west was so delicate that the spectator found it difficult to decide which of these had made the greater contribution – there was a seamless stylistic join.

What makes Khanna an "outsider", in any viable sense of that sometimes misused term, is the fact that he does not paint in one of the currently established British styles. Not for him the rather aggressive, socially conscious figuration of the new Glasgow School, nor the conceptual and environmental work produced under the influence of Goldsmiths' College in London. Khanna's delicate traceries have led to comparisons with the work of Miró, but even here the resemblance is not very close. In the terms set by the current art scene in Britain his work is entirely *sui generis,* and probably this is true in Indian terms as well. Khanna has all the marks of an artist who has matured in isolation. The one thing he has in common with the other Indian artists included in the show is that all were born abroad, and came to Britain as adults, and generally as fully mature artists, with their training already behind them. Part of their struggle has been a struggle to adjust to a new society and cultural context.

Before the great tide of Indian immigration had fully begun to flow, the outsider status of the Indian artist could be an advantage rather than a handicap in Britain. During the 1950s, for example, two painters of Indian origin were prominent in London – Francis Newton Souza (born 1924) and the late Avinash Chandra (1931–92). Araeen seems to attribute their failure to sustain initially brilliant artistic reputations to simple prejudice, but the situation was surely more complicated. Both artists are figurative expressionists; both make use of imagery drawn from traditional Indian sources, ranging from Khaligat bazaar paintings to Tantric diagrams. And both suffered from the backlash against overtly emotional, densely textured painting triggered by the rise, first of Pop Art, then of various types of Minimalism.

In addition, both artists abandoned London for New York at a crucial moment in their careers – Chandra in 1965 (he returned in 1971) and Souza in 1967. The break in continuity delivered a fatal blow to what had, until then, been rising reputations. In 1962, for example, Chandra was the subject of a film made for Britain's then most prestigious arts television programme, *Monitor.* Souza was British representative in the Guggenheim International Award in 1958, and in 1962 the respected critic Edwin Mullins published

Balraj Khanna
Regatta, 1991
Oil on canvas, 72 x 144in/
182.8 x 365.7cm
Khanna's work is neither specifically Indian nor specifically European.

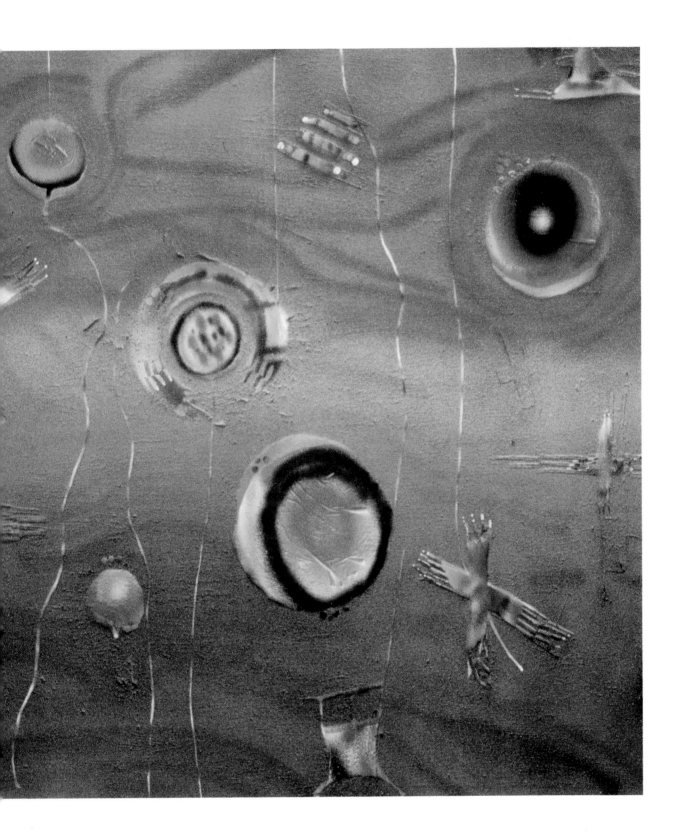

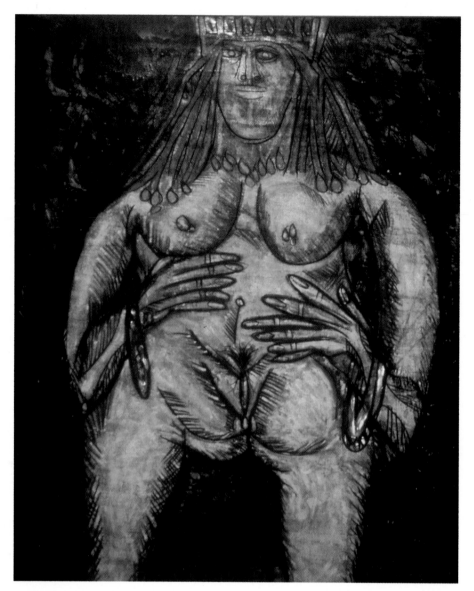

F.N. Souza
The Goddess Kali, **1962**
In this typically Expressionist work the
artist equates Kali, the Hindu goddess
of sex and death, with the Western
tradition represented by Willem de
Kooning's *Women*.

Avinash Chandra
Untitled, **1961**
**Oil on canvas, 36 x 28in/91.4 x
71cm**
Chandra combines obviously Indian (in
this case Tantric) elements with
European technique and presentation.

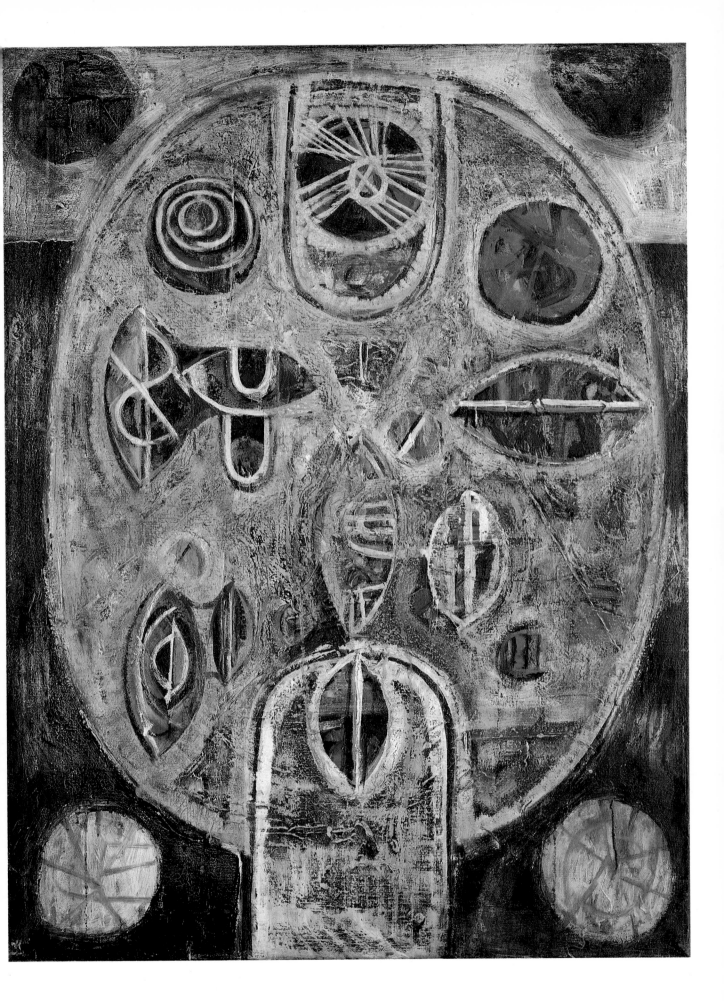

Avinash Chandra
Untitled, **1987**
Ink and watercolour
Inspired by Indian miniature painting, this work is also influenced by British Neo-Romantics such as Graham Sutherland and Paul Nash.

a monograph about him. After his move to America he never completely vanished from sight. In India he is now one of the best-known modern artists – there were major retrospectives in Delhi and Bombay in 1987.

There are now other artists in Britain, of Indian or partly Indian origin, who have achieved the kind of acceptance which once seemed to be within the grasp of Chandra and Souza. The best-known are both sculptors –Anish Kapoor (born 1954) and Dhruva Mistry (born 1957). Significantly, neither of these was represented in *The Other Story*. Kapoor, in particular, is insistent that he wants to be recognized, not as a representative of any aspect of Indian culture (even though he in fact holds an Indian passport), but as a fully international artist, whose work would be viable in any context. He is now in the collections of museums of contemporary art throughout the world, and was the British representative in the Venice Biennale of 1992. Perhaps embittered by Kapoor's rejection of the Hayward Gallery show, Rasheed Araeen has postulated that it is the exotic and sexual aspects of his work which conform to stereotyped expectations of otherness, and thus supply an explanation for his widespread success.

Matters are more complicated than this. Though born in India, of Indian and Iraqi-Jewish parentage, Kapoor was not brought up there. After a period

in Israel on a kibbutz, Kapoor spent his youth in Britain. A brief return to India, in 1979, was the beginning of a process of "learning how to be Indian".[2] Essentially his art is a bringing together of modern European and age-old Indian ideas, influenced by C.G. Jung's theory of archetypes. A particular influence has been the hermetic, mystical art of Tantrism, which makes use of mysterious abstract and semi-abstract symbols whose forms are echoed in many of Kapoor's sculptures. Kapoor himself says:

I take an alchemical view of matter as being in a state of flux, progressing towards the spiritual. As an artist one is helping along.[3]

This, of course, fits in well with the situation already outlined, where the museum of contemporary art exercises one of its primary functions as a repository for objects which are thought to be filled with *mana*.

These are already persuasive reasons for Kapoor's rise to fame. There are others in addition. One is that Kapoor has become the beneficiary of a situation which, despite angry denials by some, is genuinely more tolerant

Dhruva Mistry
Diagram of an Object (second state), 1990
Bronze
Mistry combines vestigial Indian imagery with ideas derived from Picasso and Julio Gonzalez. His earlier work was more specifically Indian.

and more multi-cultural than it has ever been. Another is that Kapoor's use of Jung and Tantrism has found an interface with one of the most important prevailing avant-garde styles. In his hands, Indian mysticism becomes an extension of western Minimalism. He also benefits from the generally paradoxical situation of the avant garde, where what claims to be radical and experimental serves as a form of official art. Kapoor's sculptures, in addition to being repositories of *mana*, are, like other Minimal works, activators of museum spaces. In both guises, it is the museum context which supplies them with much of their authority.

Yet there are artists from the Indian subcontinent, including all those chosen by Araeen, who suffer from their situation between two worlds just as much as Kapoor, on his side, seems to benefit from it. Araeen himself, who appears as artist as well as curator, is the only one who purveys direct political messages. The rest are all abstract artists making work with non-specific content. In most cases it would be impossible to guess that the artist was in fact of Indian origin, unless one looked at his name. A few, notably the Pakistani-born Iqbal Geoffrey (born 1939) use elements – in Geoffrey's case forms derived from Islamic calligraphy or images taken from Pakistani movie posters – which are demonstrably exotic, while producing art which is basically western in format.

Geoffrey is a classic case of an artist who inhabits several cultures but seems fully at home in none. The implication to be drawn from Araeen's discussion of his work and from the artist's own remarks in the catalogue is that he owes a certain lack of success to ingrained British racism. The barrier to accepting this assertion at face value is the nature of the work itself – not its lack of quality (Geoffrey is often a sensitive and attractive painter), but the stylistic choices made by the artist. The main influence is the American Abstract Expressionist Robert Motherwell, and his kind of American-derived Abstract Expressionism has never succeeded in making a secure place for itself on the British art scene, no matter what the origin of the artist. These are goods being offered in the wrong market. Understandably, Geoffrey himself does not see matters in this light. In 1984 he accused the National Gallery in London of racial discrimination when it rejected his application for the post of artist-in-residence, and took the dispute before an industrial tribunal. He lost, but the case enjoyed widespread publicity, including television coverage.

The situation of Afro-Caribbean artists in Britain is very different from that of immigrants from the Indian subcontinent, and is likely to be different from that of British-born artists of Indian origin (surprisingly, *The Other Story* featured none from this category, though there is an increasing number of British Indian students in British art schools). The difference is the product of both a cultural and a sociological gap.

An Indian artist may feel at a disadvantage in British society, because of undoubted racial prejudice. He or she is nevertheless almost certainly in

Iqbal Geoffrey
But the King had no Clothesline
Collage photocopy, detail from a larger work including clothespeg, safety pin and string, 16½ x 11¾in/41.8 x 29.7cm

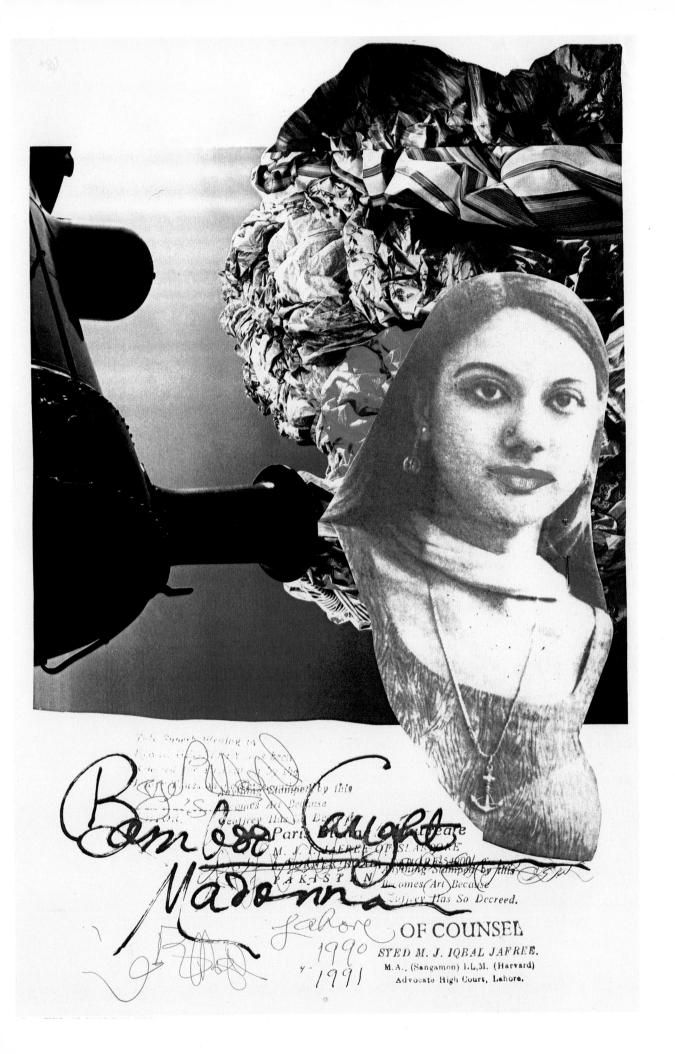

Bam boo Caught

Madonna

Lahore
1990
1991

OF COUNSEL
SYED M. J. IQBAL JAFREE.
M.A., (Sangamon) LL.M. (Harvard)
Advocate High Court, Lahore.

possession of a full set of cultural references, derived from the subcontinent itself. Museum collections, notably those in the Victoria & Albert Museum and the British Museum, emphasize the depth, the range and the sheer variety of classical Indian civilizations. These collections, largely built up in the colonial period, are now arranged and interpreted in ways which stress Indian-European parity, and there are many signs of sensitivity to the feelings of Indian visitors. An Afro-Caribbean in Britain is without these advantages. He or she is doubly displaced – first the violent rupture imposed by slavery, which brought Africans to the West Indies in large numbers, and at the same time deprived them of most elements of their traditional culture; then a second displacement to an unwelcoming white society, which accommodates Afro-Caribbeans only as an underclass. It is not surprising that Afro-Caribbeans have tended to lack the typical Indian aspiration towards material and cultural betterment within the framework of British society. An Afro-Caribbean artist in Britain has to overcome even greater barriers of class and racial prejudice than his or her Indian counterpart. In addition, there is the crucial difficulty of answering the question: "Who am I?"

The straightforward response is for the artist to see himself as being still, essentially, an African. This was the reaction of Ronald Moody (1900-84). Jamaican-born, Moody came to Britain in 1923, to study dentistry. Switching to sculpture, he had the sort of restless, unfulfilled career also typical of many African American artists born during the earlier years of the century. He went to Paris in the mid-1930s, worked and exhibited there until World War II, then was forced to escape to Britain by the German occupation of France. He exhibited often with the Royal Society of Portrait Sculptors, and at the annual Summer Exhibitions of the Royal Academy (then at its most thoroughly alienated from the Modernist art scene). His one-man shows were at distinctly minor commercial galleries, and the awards and other forms of recognition which came to him tended to emphasize his position as a minority spokesman – one was the Minority Rights Award in Britain of 1981. His sculpture tends to be simultaneously Africanizing and academic, and there is more than a hint of self-doubt in some of his ruminations upon art:

There is a great deal of uncertainty because of the times in which we live, the throwing overboard of things and not knowing where to go. Anything is permissible in art but it all depends on whether you think that art has anything to do with life ... In the past art was always part of the community; it always had a function, but now it tends to be divorced from that. I do feel that someday it will be once more integrated into society.[4]

Moody's work is meaningful more in historical than in purely aesthetic terms. It marks a first stage in a process of liberation and self-recognition.

The next stage in the process is represented by the work of the Guyanan artist Frank Bowling (born 1936). Bowling's story is essentially one of

Ronald Moody
John the Baptist, 1936
Carved wood
Tate Gallery, London
Moody, the doyen of Afro-Caribbean
sculptors in Britain, here combines
European academic and African
elements.

promise unfulfilled, or only partially fulfilled. Unlike Moody, he was never an outsider in the British art world. Having come to Britain from Guyana while still in his teens, he studied at two of the most prestigious British art schools, the Slade School of Fine Art and the Royal College of Art, from 1959 to 1962, departing from the RCA with a silver medal and a travelling scholarship. That is, he was a noted and notable figure among young artists in London at one of the moments when the British art scene was at its most exciting: the end of the 1950s and the beginning of the 1960s saw the birth of British Pop Art, when David Hockney, R.B. Kitaj and Peter Blake were starting their careers.

In 1966 Bowling departed for New York, where he stayed for ten years, holding two Guggenheim Memorial Foundation Fellowships and exhibiting frequently in both public and private spaces – he was, for example, included in the 1951 Whitney Museum show, "Contemporary Black Artists in America". In 1977, soon after his return to London, he held a semi-retrospective at the

Acme Gallery, and in 1986 another semi-retrospective at the Serpentine Gallery in London, a prestigious space operated by the Arts Council. In most artists' terms this record would represent a respectable level of acceptance. Bowling, however, clearly does not feel this:

I wasn't allowed to be a Pop artist because of their preoccupation with what was Pop. Mine was to do with political things in the Third World. I chose my own themes ... because this was where my feeling was. So I was isolated. It was a racist thing anyway, the whole thing ...[5]

This statement makes the rather large assumption that the Pop movement was defined entirely by the artists concerned, rather than by the artists in conjunction with the critics, curators, collectors and the public at large. And again: "I left because I found England impossible to deal with in terms of my own ability as an ambitious artist."[6] Bowling begs the question of why so many English-based artists suddenly headed for the United States at that time, and why so few of them made a success there. He, with his two Guggenheim Fellowships, did better than most. A particular hurt during the 1960s was Bowling's exclusion from the "New Generation" exhibition held at the Whitechapel Art Gallery in 1964, which set the agenda for British painting for the best part of a decade: a version of Pop opposed to a version of American Post-Painterly Abstraction. But this was the result of a decision made by one curator.

Bowling's work does not fully bear out his complaints. He is an extremely eclectic artist, and clearly one who is easily influenced. In the course of his career, his work has veered from Francis Bacon, to Jasper Johns, to Jules Olitski. Always technically skilful, he lacks individuality. The absence of a

Eddie Chambers
How Much Longer . . ., 1983
Mixed media, 8 x 4ft/2.4 x 1.2m
Sheffield City Museums and Art Galleries
An attack on the involvement of British banks with South Africa.

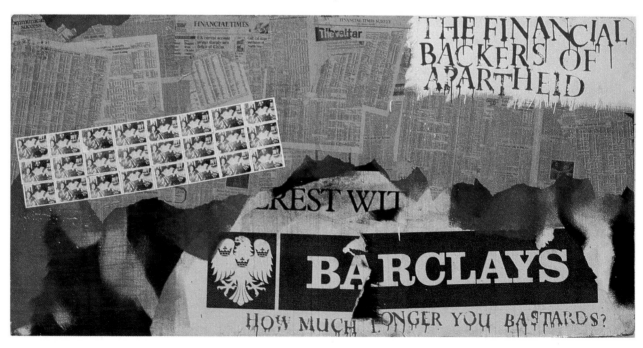

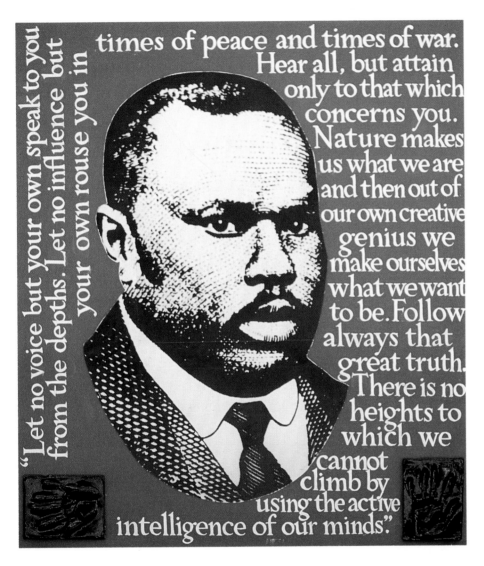

"Let no voice but your own speak to you from the depths. Let no influence but your own rouse you in

Eddie Chambers
Untitled, 1988
Mixed media, 4 x 5ft/1.2 x 1.5m
Collection of the artist
This features a portrait of the Jamaican leader Marcus Garvey, one of the founders of the Pan-Africanist movement, with quotations from his work.

definite, recalcitrant, artistic personality seems itself to mirror one aspect of recent Afro-Caribbean culture: engaged in a perpetual search for role models, it is uncertain whether to claim to be essentially African, or for the most part western European. Bowling chose the second option, despite his intermittent preoccupation with Third World themes. In search of success, he saw the official art worlds of London and New York as the only possible arena in which to operate.

A new generation of Afro-Caribbean artists, born in Britain, is producing a very different sort of work – cruder, more violent, openly militant. Two of the best-known protagonists are Eddie Chambers (born 1960 in Wolverhampton) and Keith Piper (born 1960 in Birmingham), who are also close personal associates. They first met when attending Lanchester Polytechnic, and throughout their careers they have been energetic organizers, devoting considerable time and energy to promoting radical black art in addition to being practising artists.

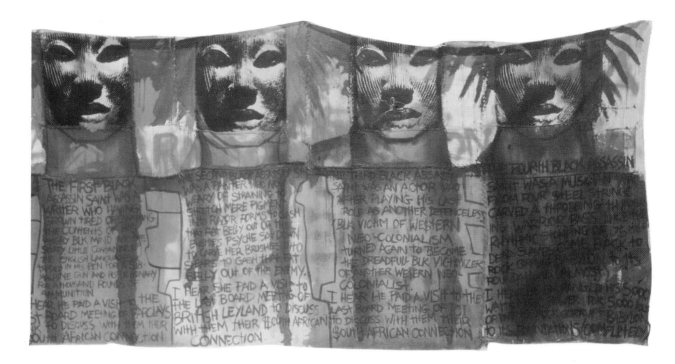

Keith Piper
***The Black Assassin Saints**, 1982*
Acrylic on unstretched canvas,
6 x 12ft/1.8 x 3.6m

Chambers has often been preoccupied with black history. However, in much of his early work he turns to America, rather than looking at events in the West Indies or in Britain. He has also, as Betye Saar did in America before him, tried to deconstruct black stereotypes, using examples taken from the supermarket shelf. Where Saar focused on Aunt Jemima, Chambers focused on the equivalent British trademark, the gollywog long used as a symbol on Robertson's jam. He did not have to search far to find targets for savage irony – for example, the response made by Robertson's marketing manager to protests about the continued use of the symbol: "Golly is part of our national tradition. An attack on it is an attack on part of British culture".[7]

Keith Piper has also been heavily influenced by America, particularly by the writings of black American militants such as Eldridge Cleaver and Huey Newton. In addition, he has looked at events in South Africa. Despite, or even because of, these multiple perspectives, he seems uncertain what his precise frame of reference ought to be. Is it the British community at large, or is it only blacks within that community?

The task of radicalization within any particular community demands measures specific to the needs of that community, and it is members of that community who are best equipped to judge and furnish those needs.[8]

The problem here, and indeed one of the basic difficulties for Afro-Caribbean artists in general, is that members of the target community are for the most part poor, working-class, educationally deprived and with no tradition of visiting cultural institutions. For example, there are remarkably few art galleries of any sort in the English-speaking West Indies; the only one of any

stature is the National Gallery of Jamaica, fairly recently founded. An audience of this type is unlikely to find contemporary artworks, of whatever sort, an efficient channel for ideas and meanings relevant to itself. Radical Afro-Caribbean artists too often seem reduced to the cry: "This is what I would be saying, if the people I really want to talk to were in fact listening to me." The audience for such art, in fact rather than fantasy, is apt to be largely composed of members of the white liberal bourgeoisie – always the most reliable supporters of all avant-garde cultural enterprises.

A new phenomenon in the Britain of the 1990s is greatly increased promotion of "minority" art by official cultural agencies. The question of the audience is likely to be the most difficult aspect of this enterprise. Is it enough simply to promote work by Asian and Afro-Caribbean artists within existing frameworks? If their work is shown in this way, will it reach its preferred public? If, on the other hand, it is not shown within these frameworks, but in new ones, specially devised, with a major effort to reach social groups who do not attend exhibitions of contemporary art, will this amount to a new, updated form of marginalization?

One very conspicious aspect of Chambers' and Piper's work is constant references, both overt and covert, to aspects of sexuality. Their art, rather than being about the life-experience of the whole Afro-Caribbean community, tends to concentrate on that of young Afro-Caribbean males and, beyond this,

Keith Piper
Exotic Signs, 1993
Mixed media installation with 2 video projections, 8 slide projectors and a 20 x 30ft/6 x 9m timber and muslin construction Gallery Theesalon, Arnhem, The Netherlands, commissioned as part of Sonsbeek 93

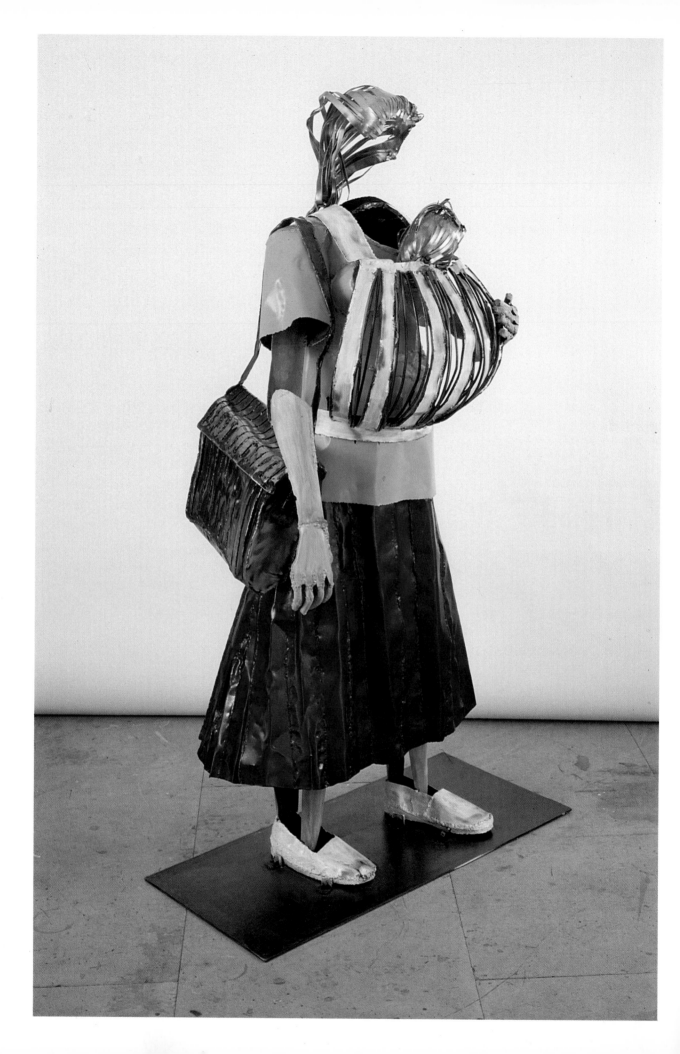

Sokari Douglas Camp
Lady with Pouch
Painted forged iron
Typical of the sharply observed
representations made by this
Nigerian-born artist of people seen in
London's streets and markets.

on that of all men of African descent who form part of a black minority within a white society. A recurring image is that of the black male as the embodiment of physical potency who, as a result, is automatically feared and hated by anyone not of his skin colour.

It is interesting to turn from this to the artworks made by another young Afro-Caribbean artist, this time a woman –Sonia Boyce (born 1962). In this case I cannot do better than borrow Rasheed Araeen's capsule description:

She sees the family as a microcosm of society, which one needs but which also oppresses. Through this ambivalence she expresses the complexity of the personal relationships within and without her own family, and while dealing with desires and anxieties she re-inscribes herself in a domestic space which is a site of survival as well as of struggle.[9]

Boyce is probably the first artist to try and deal with Afro-Caribbean life in Britain from a female point of view. This is important in itself, but also important because of aspects of Afro-Caribbean history and sociology. Under slavery, the child, to the extent that he or she was not simply the property of a master, was the property of the mother. The whole institution of slavery was opposed to the pair-bonding of male and female for encroaching upon the master's rights. As a result, Afro-Caribbean family life remains informally matrilineal. Households are often households of women – mother, daughter, granddaughter – in which men may or may not be conceded rights. The male may be violent, unpredictable, physically dominating, but even in these circumstances he remains external, at the periphery, not the core of the house. At the same time, however, black women remain even more economically disadvantaged than black men. In the economic structure, and almost inevitably in the class structure, they remain at the bottom of the heap. The unwed black teenage mother, without male support, has become an Afro-Caribbean stereotype in Britain, just as it has become a stereotype among African Americans in the United States. This is the type of material which Boyce chooses to deal with. Interestingly, she is able to do so without rhetoric.

Another artist, also black and female, whose work expresses similar attitudes is the young Nigerian sculptor Sokari Douglas Camp (born 1958). Her welded iron sculptures are witty observations on things she sees around her – she lives and works in a district of London which has a rich ethnic mixture. Sometimes we may surmise that the individuals she represents are black; sometimes her technique allows her to leave the racial element quite unspecific, while still giving a lively rendition of the character of the person shown. Whereas much militant black art, made on both sides of the Atlantic, will survive if it survives at all only with the status of a political and sociological relic, the work of Boyce and Douglas Camp embraces ideas and values which go beyond politics.

7 Minority Sexuality

John Kirby
Two Men Running Away, 1987
Oil on canvas, 36 x 24in/91.4 x 60.9cm
Despite the female clothing, the gender of the figures is obvious. Transvestism is a frequent theme in Kirby's work.

ex has always been a weapon of the avant garde, and sexual imagery has been one of the quickest and directest means open to any artist who wanted to establish his or her credentials as a transgressor against established bourgeois value systems. Raw sexual aggression, for example, is very much part of the impact made by Picasso's *Demoiselles d'Avignon* (1906–7). Today, when we are accustomed to Picasso's stylistic innovations, this sexual content can still disturb and shock us.

Picasso continued to be obsessed by sexual themes throughout his career. In old age, he focused on the violence inherent in much sexual activity, and also on themes of voyeurism and sexual impotence. These ideas recur in the celebrated series of 347 prints which Picasso made in an enormous burst of creative energy between 16 May and 5 October 1968, when he was in his late eighties. A frequently repeated subject is an erotic scene where a young artist (distinguished as such by a beret, palette and brushes) copulates with a young woman, and is spied upon by an old man. Sometimes the old man is shown wearing a fool's cap.

At the time when these prints were made, Pop Art was still very much in the public eye, though it had already passed its creative peak. Among the images Pop borrowed from mass culture were pin-ups from girlie magazines. One artist who made a speciality of paintings based on these was the Californian Mel Ramos (born 1935). Even more directly erotic were the paintings in the *Great American Nude* series by Tom Wesselmann (born 1931), with sexual characteristics deliberately emphasized, and all traces of individuality equally deliberately expunged. So too were many works by the

Pablo Picasso
The Voyeur, **Plate 311, from the**
347 Series, **1968**
Etching
Private collection
A pair of youthful lovers, one identified as a painter by his palette and brushes, are spied on by an old man. This motif, several times repeated in the series, represents Picasso's enraged reaction to the restrictions of age on the life of the senses.

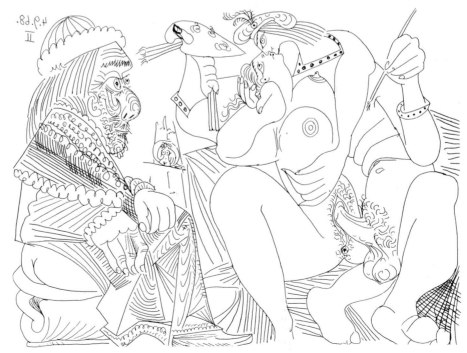

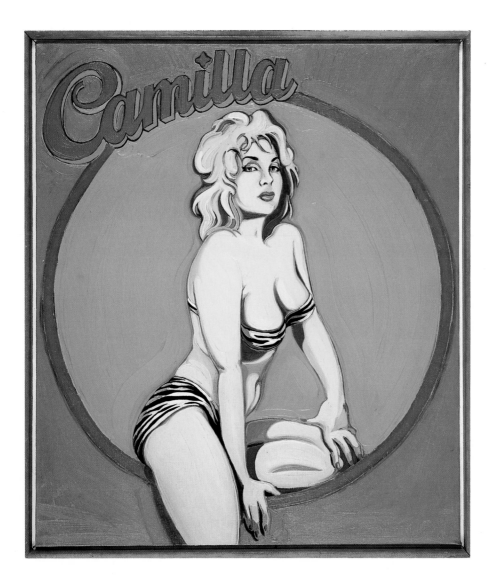

Mel Ramos
Camilla, Queen of the Jungle Empire, **1963**
Oil on canvas, 30 x 26⅛in/76.2 x 66.3cm
This painting exemplifies the interest taken by Pop artists in the imagery of the pin-up.

Tom Wesselmann
Great American Nude No. 70, **1965**
Oil on canvas, 75 x 66in/ 190.5 x 167.5cm
Private collection
Another example of the degree to which the artistic climate has changed since the mid-1960s. In today's "politically correct" terms, the image is unacceptable, since it turns its subject into a purely sexual object.

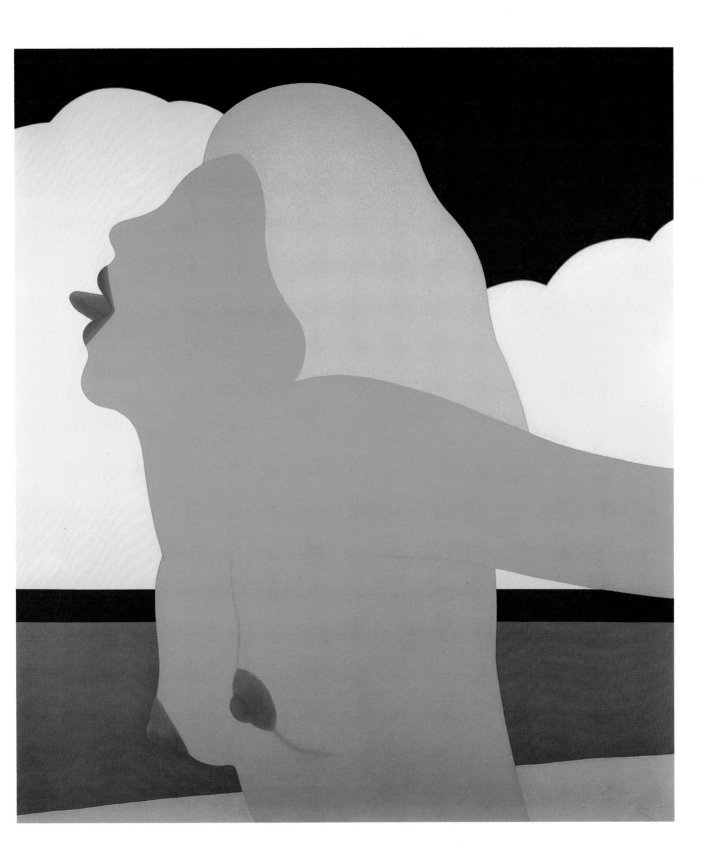

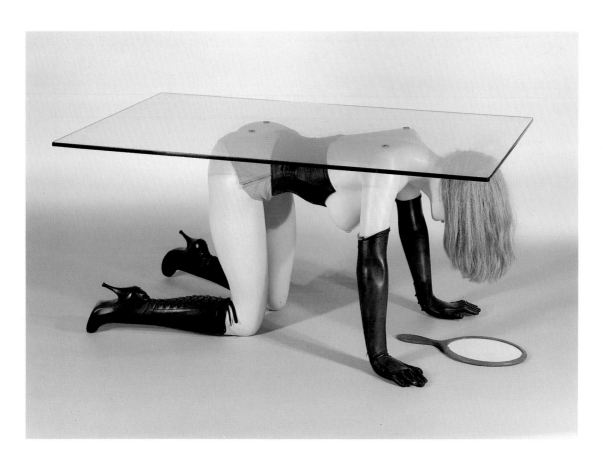

Allen Jones
Table Sculpture, 1969
Mixed media: acrylic, fibreglass,
leather, glass
This fetishistic Super-Realist sculpture
aroused feminist protests when
re-exhibited in the late 1970s.

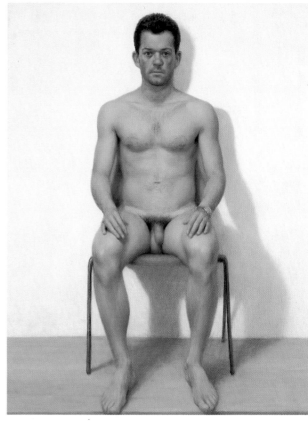

Harry Holland
Triptych, 1984: **Panel 1, Phil;**
Panel 2, Ess; Panel 3, Sue
Oil on canvas, each panel
47¼ x 35½in/120 x 90cm
Glyn Vivian Art Gallery, Swansea
These very directly seen nudes have
caused offence because of their
unidealized, portrait-like nature.

British artist Allen Jones (born 1937). Jones's paintings often feature mildly fetishistic trappings, such as garter belts and high-heeled shoes. His most notorious creations, however, were three-dimensional: a series of sculptures which transformed women dressed in scanty leather costumes into items of furniture: a chair, a table, even a hatstand. These sculptures were later to become a focus for feminist demonstrations. That is, rather than following the usual pattern of transgressive art objects and losing potency as they became more familiar, they seemed more, rather than less, offensive to at least part of the audience with the passage of time.

Today, few artists deal confidently either with the female nude or with sexual images of a heterosexual kind. Lucian Freud's unsparingly depicted female nudes are more acceptable than the glamorization of the subject still common in the 1960s, but when, in 1984, the British painter Harry Holland (born 1941) painted a *Triptych* featuring three realistic nudes, one male and two female, it was the full frontal presentation of the females which caused problems with exhibition organizers. On one occasion at least the work had to be withdrawn from view because of protests. The geriatric couples of the French painter Jean Rustin (born 1928) may horrify us with their vision of humankind, but their version of the erotic relationship is in some surprising fashion more acceptable than that offered by, for example, Jeff Koons (born 1955).

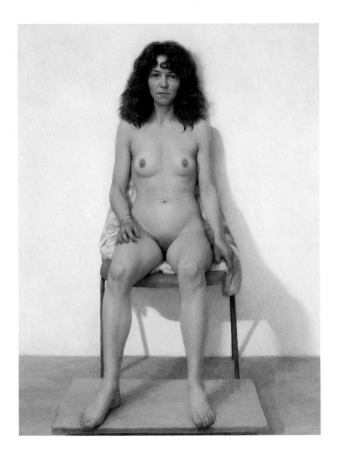
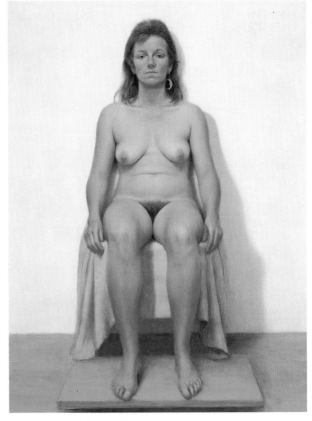

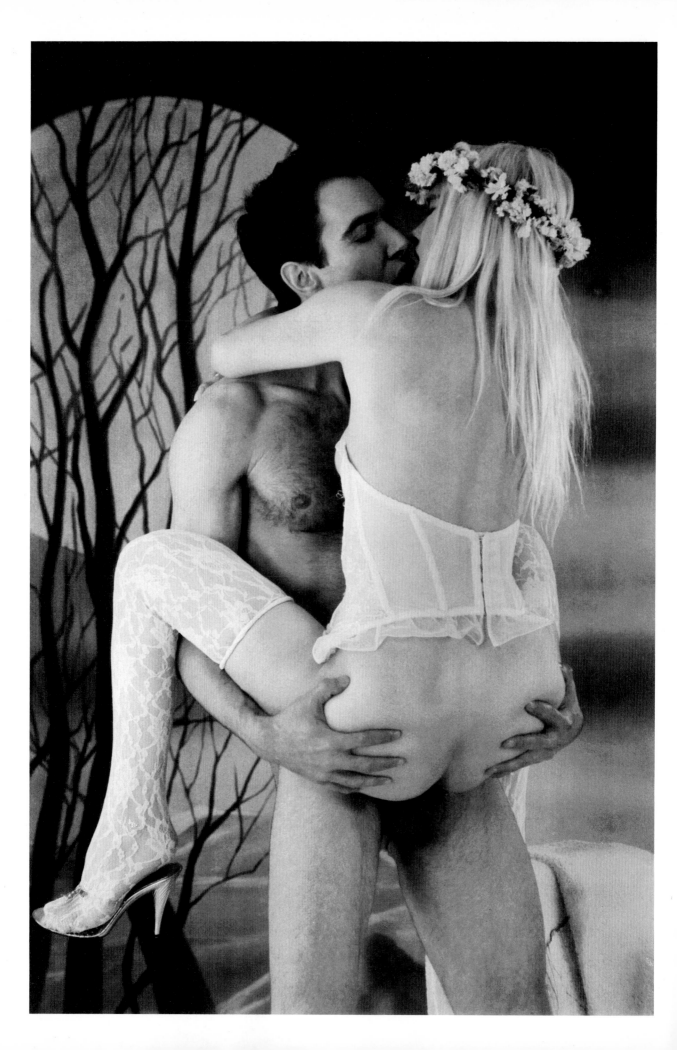

Jeff Koons
Wolfman (Close-Up), 1991
Silkscreened oil inks on canvas,
90 x 60in/228.6 x 152.4cm
One of a series of erotic images
featuring Jeff Koons and his wife Ilona
Staller.

Koons's sculptures and large-scale dye-transfer photographs of himself coupling with his wife Ilona Staller, the star of pornographic films and ex-member of the Italian parliament known as La Cicciolina ("The Little Pinchable One"), are an apparent contradiction of everything I have just written. Blatantly erotic, and undoubtedly heterosexual in theme, they are versions of imagery found in hard-core sex magazines. As such, they are linked to, though much more explicit than, the pin-ups of the 1960s, which are products of the same urban mass culture. They have played a substantial part in establishing Koons's now worldwide celebrity.

Various explanations – some might call them excuses – have been offered for this series of works by Koons. John Caldwell, curator of the major Koons retrospective organized by the San Francisco Museum of Modern Art at the end of 1992, opined that the images in question "look like pornography yet refuse to function in the way that pornography does."[1] He adds:

Koons has taken the fun out of voyeurism and left in its place an objective, blank record of sex without pleasure, disconnected from its sources in our psyches.[2]

However, it seems as if the artist himself would not wholly agree with this. On another page of the same catalogue Koons offers the statement:

To me Cicciolina is the Eternal Virgin. She's able to remove guilt and shame from her life, and because of this she is a great liberator.[3]

We should ask ourselves, not only what Koons's erotic imagery consists of, but how it functions within a particular context. His artworks, and especially the photographs (which are more graphic than the sculptures), are staged in such a way as to remind the viewer that this is "fantasy" – the paradox being that the fantasy has really been enacted for the camera. Details such as the backgrounds, and the few scraps of clothing Ilona Staller wears, are chosen to reinforce this, and the message is further heightened by glamour lighting of a kind commonly borrowed by pornographers from movie stills cameramen. Part of the message, therefore, is that these erotic acts exist only in a kind of never-never land which is entirely detached from any realm the viewer may inhabit. Yet this is contradicted by the nature of some of the acts shown. In one image, Koons penetrates Ilona Staller anally: not only is this an example of "unsafe" sex, but it implies sado-masochistic domination of the female by the male. Staller's demeanour, however, signals cooperation and enjoyment. She is clearly a consenting party.

An image of this sort is specifically calculated to offend, not so much the old bourgeoisie (now so battered by the everyday outrageousness of the avant garde that it hardly reacts to any image, however extreme) but feminists, and particularly the anti-pornography wing of American feminism led by Andrea Dworkin. In terms of contemporary relevance, Koons's debate

Pierre et Gilles
Le Garçon Papillon (Kevin),
1993
Painted photograph
Like Jeff Koons, Pierre et Gilles
manipulate mass market imagery in
order to make subversive comments on
contemporary culture. The "fairytale"
Butterfly Boy, a degenerated version of
the kind of image to be found in a
Victorian children's book (filtered

through the "psychedelic" sensibility
typical of the 1970s) is here given a
homoerotic overtone. The young man
in a posing strap is a close cousin of
the photographs which fascinated the
young David Hockney in *Physique
Pictorial*. The image appeals to two
quite different audiences, one which is
not in the know about its sexual
overtones, and one which is keenly
aware of them.

with feminism is the least understood but also perhaps the most important aspect of his work. His art is at its most genuinely transgressive when seen in relationship with feminist theory. One proof of this is the way in which the erotic duos with Ilona Staller have provoked hostile reinterpretation of his earlier works.

A case in point is the porcelain sculpture *Fait d'hiver* (1988) from the "Banality" series. This shows a "cute" pig, or piglet, wreathed in flowers, with a barrel under its neck, and accompanied by two penguins, which is approaching a prostrate female figure, lying in what is apparently snow. The figure is fully clothed, but sliced through the top of the torso, so we see only the head, bust and one detached hand. This piece has been seen as anti-female: the pig is a "male chauvinist" pig; the woman's figure has been sliced through as an act of violence. In fact, this seems to be a piece of reading in. Another sculpture in the same series featuring a similar pig is called *Ushering in Banality*: it is very clear that the pig is the emblem of the banal, its gender (hardly emphasized) being irrelevant. In *Fait d'hiver* it becomes an emblem of succour, like the more traditional St Bernard dog. The slicing through of the female figure seems to be a matter of practical convenience: without this the sculpture would be impossibly long and thin. Such slicings are a matter of frequent occurrence in Western European art, such as the Renaissance half-length figures of the Virgin and Child from the della Robbia workshop. Koons, with his instinct for provocation, must be delighted by reactions of this kind from feminists. Correspondingly, it is an important part of the Cicciolina photographs that they enter into dialogue with the feminist climate surrounding them, both by exaggerating voyeuristic elements, and by playing on the spectator's knowledge that the female participant, a willing collaborator, is the artist's wife. The image becomes an ironic parody of everything that Andrea Dworkin and her supporters find distasteful.

Despite Koons's enormous success, it has, nevertheless, become more and more difficult for avant-garde art to find a place for erotic heterosexual images, especially if these are in any way hedonistic. One solution to the problem is that adopted by Pierre et Gilles, a pair of contemporary French artists who have abandoned both their dates of birth and their surnames. This duo – Pierre originally a photographer, and Gilles a painter and illustrator – produce photobased artworks which owe something to Koons, but perhaps even more to the longer established British duo, Gilbert & George. Their method of dealing with eroticism is to push it not only in the direction of kitsch, as Koons does, but also of camp, the form of high-style exaggeration borrowed by the homosexual underground from the world of the theatre. Their work is slyly suggestive, rather than directly erotic. They give even apparently heterosexual representations a homoerotic edge.

The rise to prominence of openly homosexual art, as a component within the avant garde, has often been attributed to the tragedy of the

AIDS epidemic. Such images are supposedly in some way validated by the catastrophe which has befallen the gay community. Gay art, like art which protests against racial discrimination, is now something which contrives to put itself beyond the reach of criticism because it is essentially an art of victims. This, to put it mildly, is an oversimplification.

It has always been recognized that the male homosexual component is important to the whole development of western European art. A number of major figures in this tradition are known to have been homosexual or bisexual, and their sexual orientation unquestionably affected their work (Leonardo and Michelangelo are cases in point). One persistent influence was the practice of working from the model. Artists were trained by drawing the nude and, until comparatively recent times, the male model was more often used than the female one. The whole academic tradition, first codified in the Carracci studio at the beginning of the seventeenth century, and recodified by Jacques-Louis David and his disciples at the beginning of the nineteenth, has a homoerotic undertone. It is interesting to compare the drawing by Léon Cogniet (1794–1880) illustrated here to recent drawings of the male nude by the openly gay Californian artist Don Bachardy (born 1934). In the latter the mood is more romantic and the draughtsmanship less firm, but essentially both artists are trying to do the same thing.

Modernism, which abandoned the academic method, was often accused by its original opponents of being a hotbed of deviant sexuality, just as it was often accused of an indissoluble alliance with left-wing politics. Yet few, if any, major Modernist artists of the first generation were known homosexuals, and I cannot immediately think of any whose sexual preference coloured their

Don Bachardy
Bob Newman, 1985
Ink on paper
The portrait-like nature of the drawing tends to emphasize its homoerotic content, when compared with a typical nineteenth-century academic drawing of a male nude.

Léon Cogniet
Academic Study of a Male Nude,
c. 1815
Black chalk on grey paper, 22³⁄₄ x 16¹⁄₂in/57.7 x 41.9cm
Cogniet entered the Ecole des Beaux-Arts in Paris in 1812, as a pupil of the leading Neo-Classical painter Pierre-Narcisse Guérin (1774–1833), who was also the teacher of Géricault.

Bob Newman Tue 15 - '65

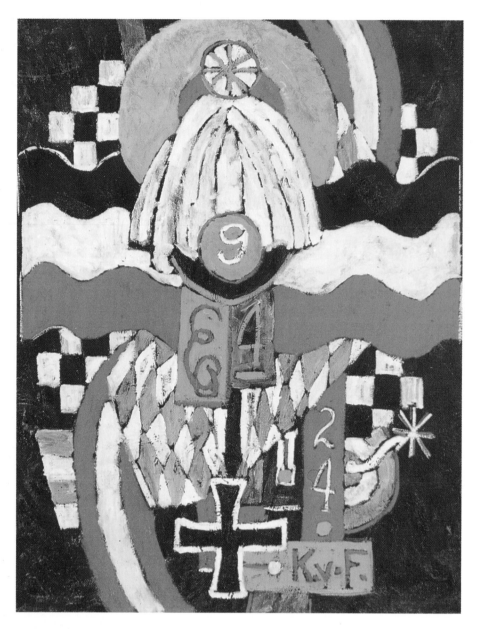

Marsden Hartley
Painting No. 47, Berlin, c. 1915
Oil on canvas, 39¼ x 31½in/99.6 x 80cm
Hirshhorn Museum and Sculpture Garden, Smithsonian Institution, Washington, D.C.
This painting is one of a series using military emblems, inspired by the artist's love affair with a young German officer.

art. Perhaps the nearest any Modernist works come to being openly "gay" is a group of paintings produced by the American Marsden Hartley (1878–1943) during a period in Germany at the beginning of World War I. Hartley was in love with a German officer, and the paintings are brilliant still lifes based on German military emblems. Even here, however, one has to know the story behind Hartley's imagery to understand its significance.

Inevitably, a number of leading twentieth-century artists have been homosexuals. It has been alleged, for instance, that denial of his true sexual orientation lay at the root of Jackson Pollock's drinking, which finally destroyed his life. Steven Naifeh and Gregory White Smith, authors of an authoritative biography, refer to "Jackson's forays into the gay demimonde".[4] If they occurred, these had no visible impact on his art.

Paul Cadmus
Night in Bologna, 1958
Tempera on wood, 50¾ x 35¼in/128.8 x 89.5cm
National Museum of American Art, Washington, D.C.
A typical example of Cadmus's Magic Realism, this painting is notable for its emphasis on both homoerotic and narrative content.

Francis Bacon
Two Figures in the Grass, 1954
Oil on canvas, 59³⁄₄ x 46in/152 x
117cm
Private collection
One of Bacon's most explicitly
homosexual scenes.

Other artists openly declared their sexual preference, and their work does seem linked to homosexual themes. One is the American Magic Realist Paul Cadmus (born 1904). Cadmus's most candidly homosexual image dates from fairly late in his career. *Night in Bologna* (1958) is a narrative of sexual frustration. It shows a lonely Italian soldier wandering the town. He is looking over his shoulder at a girl – a whore still on duty, though it is obviously late at night. The girl, in turn, is vainly trying to pick up a lonely tourist, whose attention is hungrily fixed on the soldier. The real theme of the painting is sexual otherness, exclusion from the "normal" world. Obvious homosexual allusions can also be found in the work of the British artist Francis Bacon. An example is *Two Figures in the Grass* (1954), for which the probable source is an image made by the Victorian experimental photographer Edweard Muybridge from a sequence showing two men wrestling, but the change of setting makes it seem that they are making love. Bacon, although open about his homosexuality at a time when homosexual acts were a criminal offence in Britain, never willingly discussed the subject matter of paintings such as this: the spectator is left to draw his or her own conclusions. The atmosphere of the painting, like that of most of Bacon's work, is full of fear and tension.

The artist who made homosexuality in art a discussable subject, rather than something to be whispered about in corners, was undoubtedly David Hockney (born 1937). Quite a number of Hockney's early paintings were celebrations of the gay lifestyle. At first rather tentative in their acknowledge-ment of his focus of sexual interest, they rapidly became more matter-of-fact. Some were based on images Hockney had culled from the magazine *Physique Pictorial* – a more amateurish as well as a more prudent predeces-sor of the gay "skin" magazines which were to flourish in the 1970s and 1980s. Particularly important was the candid celebration of homosexual love to be found in his illustrations of 1966 to poems by the Greek C. P. Cavafy. These were published in book form in 1967 and the images widely circulated.

Hockney's work had a major impact on a gay scene which was becoming aggressively conscious of its own special identity. It did not at first lead to the appearance of a large number of Hockney imitators in the mainstream art world but, especially in the United States, it encouraged the appearance of small, openly gay, galleries which were adjuncts to the bars, bathhouses and specialist clothing shops which were the visible aspect of the new homosexual culture. These galleries, usually located in the gay ghettoes of New York and San Francisco, did not enjoy much if any credibility with museum curators and established critics, something which is not wholly surprising when one considers how far apart they remained – in atmosphere, style and location – from the rest of the contemporary art world. (Stompers, in New York, shared premises with a fetishist bootstore.)

For the most part, these galleries showcased two kinds of artist: beginners, desperate for a showing and not afraid to accept the homosexual

David Hockney
Man Taking a Shower in Beverly Hills, **1964**
Acrylic on canvas, 65³⁄₄ x 65³⁄₄in/
167 x 167cm
Typical of a group of "domestic" scenes
painted by Hockney in the 1960s, often
based on material found in the
magazine *Physique Pictorial*. (Covers
for the magazine were sometimes
drawn by Tom of Finland.)

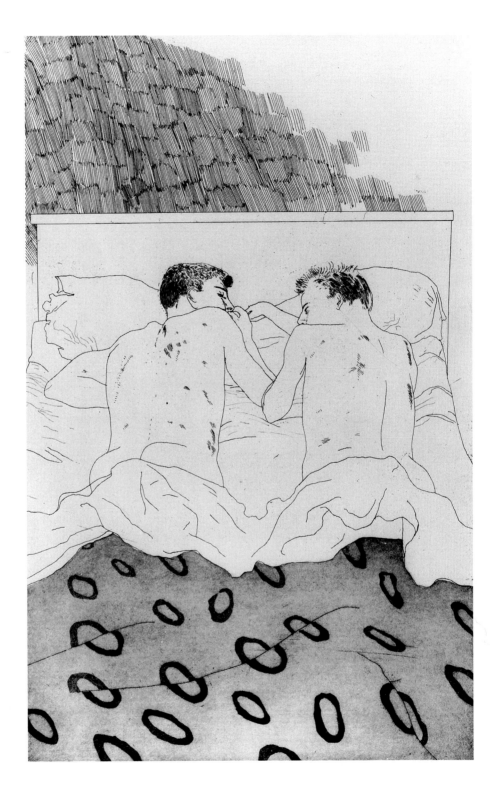

David Hockney
Two Boys Aged 23 and 24, 1966
Etching and aquatint on copper,
14^1/$_4$ x 9in/36 x 23cm
An illustration to *Fourteen Poems from*
C.P. Cavafy, translated by Nikos
Stangos and Stephen Spender, 1966.

identification which came with the venue, and, second, the corpus of erotic illustrators who supplied an increasing number of gay periodicals. These now found a market for their original drawings, in addition to being able to sell images for reproduction. Sometimes skilful and imaginative, these drawings differed from most of the avant-garde art of the 1970s not merely because they were invariably figurative, but because of the inevitable stress on narrative as well as erotic content.

Probably the most skilful of these illustrators, and certainly the most sought after, was Tom of Finland (Touko Laaksonen, 1920–91). Trained in Helsinki as an illustrator and advertising designer, Tom of Finland was first published in an American magazine (the cover of *Physique Pictorial*) in 1957. Eventually, in addition to his other illustrative work, he created a series of erotic booklets under the title *Kake*. "Kake" is the Finnish word for butch, and the series showcased Tom's typical heroes – men in uniform, in working dress such as dungarees or in motorcyclist's leathers. These helped to change the image – well known up to this time – of the gay man as someone limp-wristed and effeminate.

Tom had his first gallery show in 1973 in Hamburg, and his original drawings thereafter attracted the attention of collectors. By 1978, when he paid his first visit to the United States, he was an underground celebrity, soon in contact with the then just emergent Robert Mapplethorpe, and later with Andy Warhol. In 1986 a Tom of Finland Foundaton was set up to preserve and document his work and that of other gay erotic artists.

Because of its subject matter, Tom's work forms a kind of bridge to the second phase of gay art, which had a very different character from that produced by David Hockney. Robert Mapplethorpe (1946–89) emerged on the New York art scene at a time especially propitious to the kind of imagery with which he became associated – the imagery not only of homosexuality but of sado-masochism, which can be found, though generally in much milder form, in many of Tom of Finland's drawings.

In the New York of the late 1970s S&M had become chic. Clubs like the Mineshaft, the Ramrod and the Eagle's Nest were gossiped about by those who were not homosexual. The world at large was given a glimpse of the milder forms of activity in some of these clubs in the 1980 film *Cruising*. Books on the topic had started to appear from mainstream publishers. The most accessible was *Hard Corps: Studies in Leather and Sado-Masochism*, which was published as a Dutton paperback in 1977 with a text by Michael Grumley and photographs by Ed Gallucci. Some of Gallucci's photographs, of men in leather outfits, have a close resemblance to images which Mapplethorpe himself was to make available two years later.

By this time Mapplethorpe was already a well-known junior member of the New York avant garde, and one of the leading figures in the movement which was finally to give photography the same status as other forms of fine

Tom of Finland
Untitled, 1962
An early example of the artist's fully developed style as an erotic illustrator, produced five years after his first cover design for an American magazine.

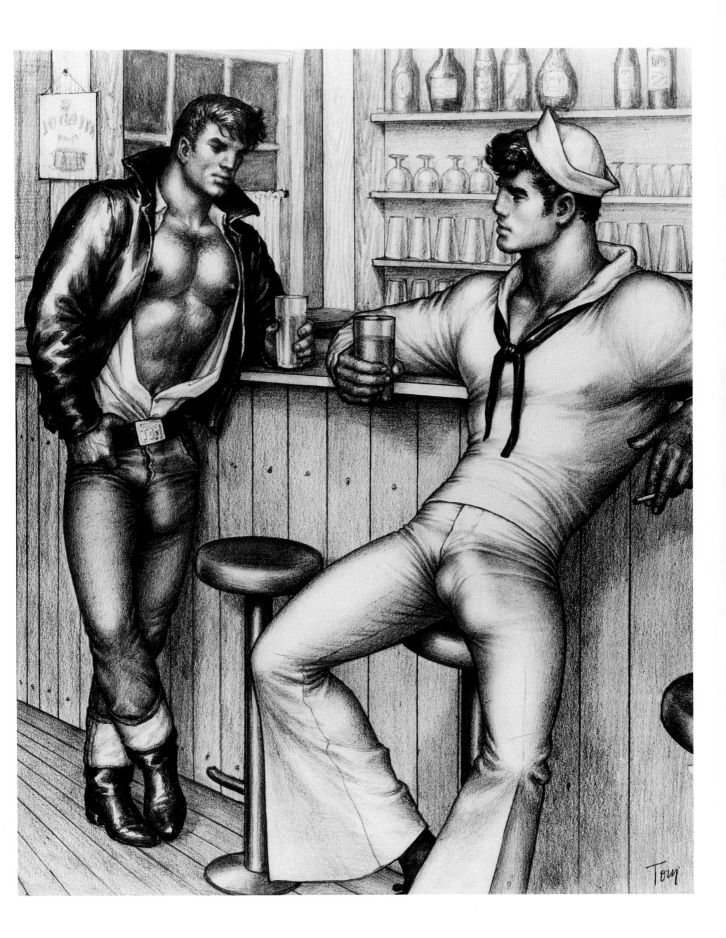

Robert Mapplethorpe
Phillip Prideau, 1979
Photograph
Estate of Robert Mapplethorpe
From the *Black Males* series, this image
carries to extremes Mapplethorpe's
tendency to turn human beings into
objects.

art. Far from being an isolated figure, Mapplethorpe stood at the confluence of several streams of artistic development. Through his lover and mentor Sam Wagstaff he had access to the finest collection of vintage photography ever formed in the United States. In particular, he absorbed the influence of the nineteenth-century photographers of the male nude who used the camera to preserve aspects of the old academic tradition. He also learned about then still-neglected turn-of-the-century pictorialists, such as F. Holland Day, and about the work of George Platt Lynes, once an associate of Paul Cadmus.

At the same time, Mapplethorpe had easy access to the circle around Andy Warhol, who was also gay, but unwilling to express it very openly in painting. Warhol remained suspicious of Mapplethorpe as a potential rival, but the latter soon grasped Warhol's techniques for manipulating the inter-mingled social and artistic worlds of New York, a milieu where to express shock was to seem uncool, and where people's greatest fear was exclusion from what was new and fashionable. He was also in touch with the hardcore world of S&M, through the clubs he frequented and through his connection with the San Francisco-based magazine *Drummer*. The then editor, Jack Fritscher, was for a time one of Mapplethorpe's lovers, and got him to make a striking cover for one issue.

Mapplethorpe's mature style, exemplified by the *Black Males* portfolio of the early 1980s, is a potent amalgam of all these influences, and of others besides. For example, his photographs of black men often owe much to the revival of the taste for Art Deco. In his most typical images, Mapplethorpe reduces the human body – the black male human body – to the condition of an object. He has a number of ways of doing this. Sometimes he concentrates on body parts, rather than the body as a whole: the most famous example of this is *Man in Polyester Suit* (1980), in which an enormous black penis, semi-tumescent, protrudes from the fly of a man who remains anonymous because the photograph is cropped across the torso and at mid-thigh. In another, equally telling photograph, *Phillip Prideau* (1979), the subject crouches on top of a tall pedestal as if his body was a rare art object such as a precious Chinese vase.

It is interesting to compare Mapplethorpe's photographs of blacks with the paintings of similar subjects made by the German Neo-Expressionist painter Rainer Fetting (born 1949). Fetting was Mapplethorpe's near-contemporary, and was well acquainted with the gay subculture of New York in the late 1970s and early 1980s: in 1978–9 he studied there on a scholarship from the Deutscher Akademischer Austauschdienst (DAAD). Mapplethorpe's blacks are stylized, but only within the limits of what the camera will allow. The spectator is constantly aware of the tension between what the photographer chooses to show, and what is "really" there. Fetting's sweepingly painted nudes, romantically subjective reactions to the subject-matter, paradoxically seem less, rather than more, manipulative.

The racism of Mapplethorpe's approach to his subjects aroused little, if any, comment during the artist's lifetime or immediately after his death. During his years of fame, attention was concentrated on his heroic struggle against AIDS. After his death, it focused on the censorship controversy following the cancellation of a touring exhibition at the Corcoran Gallery of Art in Washington, and the subsequent prosecution for obscenity when the same exhibition was put on view at the Contemporary Arts Center in Cincinnati. Racism has, however, been the theme of some more recent criticism, notably a rather weak conceptual artwork shown in the Whitney Biennial of 1993. The artist, Glenn Ligon (born 1960) appropriated some of Mapplethorpe's images from *Black Males* and appended written commentaries, usually feeble or facetious, and sometimes both. His shrewdest hit was the following:

Mapplethorpe's relation to Warhol includes an ability to mirror the desires and prejudices of his spectators, to make them see what they do not want to see.[5]

One can unravel this remark by looking at Mapplethorpe's relationship to the idea of the "beautiful", which has something important to tell us about recent gay art in general. Mapplethorpe is one of the few avant-garde artists of recent years who has tried to get to grips with the idea of beauty in its traditional, pre-Modernist sense. It appears as clearly and obviously in his photographs of flowers as in his pictures of naked black men; indeed, a suggestion is conveyed through composition, lighting and the whole approach to the image that there is an equivalence between the two kinds of subject. Mapplethorpe very shrewdly used the flowers to validate other aspects of his activity, and vice versa. A nervous patron could buy his photographs of flowers with a clear conscience, knowing that their avant-garde status was guaranteed by the existence of Mapplethorpe's darker work. A photographer who made nothing but images of flowers or the fashionable portraits in which Mapplethorpe also specialized would never have risen to such giddy heights of avant-garde acceptance. The flowers, with their purity of approach, in turn seemed to validate Mapplethorpe's way of portraying the male nude.

Rainer Fetting
Desmond Sitting, 1985
Acrylic on canvas, 86½ x 70¾in/ 220 x 180cm
Fetting's studies of blacks are the equivalent in paint of Mapplethorpe's photographs in the *Black Males* series.

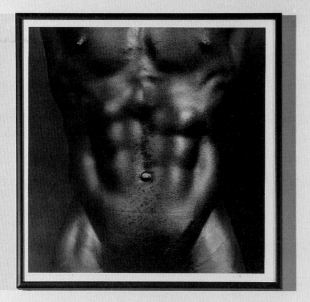

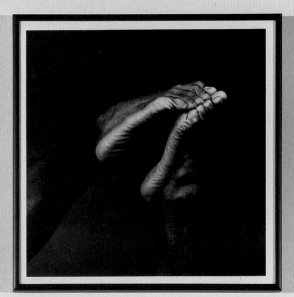

It is the way that black people are marked as black (are not just "people") in representation that has made it relatively easy to analyse their representation, whereas white people—not there as a category and everywhere everything as a fact—are difficult, if not impossible, to analyse qua white. The subject seems to fall apart in your hands as soon as you begin.

—Richard Dyer

Mapplethorpe appropriates the conventions of porn's racialized codes of representation, and by abstracting its stereotypes into "art," he makes racism's phantasms of desire respectable. The use of glossy photographic textures and surfaces serves to highlight the visible difference of black skin: Coupled with the use of porn conventions in body posture, framing devices like cropping, and the fragmentation of bodies into details, his work reveals an underlying fetishism.

—Isaac Julien and Kobena Mercer

What one's imagination makes of other people is dictated, of course, by the laws of one's own personality and it is one of the ironies of black-white relations that, by means of what the white man imagines the black man to be, the black man is enabled to know who the white man is.

—James Baldwin

It is not that Mapplethorpe is unaware of the political implica-tions of a white man shooting physically magnificent black men, and such implicit tensions lend a piquancy to these pictures. But the stereotypes are transcended by a potent mood of celebration and sex, in which the artist reacts towards his subject with as much feeling as the camera allows.

—Alan Hollinghurst

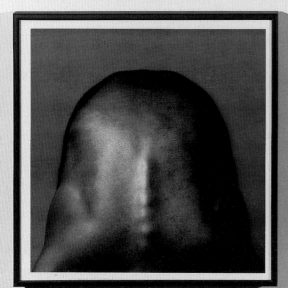

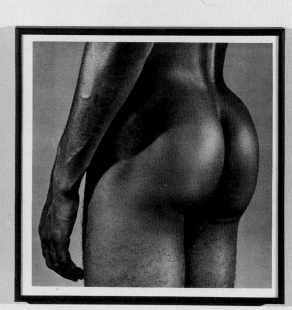

Visual hedonism was made easier for Mapplethorpe because his means of expression was the camera. Beautiful images produced by photographic means retain a validity in our culture not so easily accorded to "beautiful" paintings or "beautiful" sculptures, which are often dismissed as academic. Where conceptual and environmental works are concerned, beauty in any commonly accepted sense is usually an irrelevance: neither artist nor spectators are in search of it. One reason may be that photography by its very nature retains stronger links with ordinary, non-specialist ways of seeing the world than other means of expression used by avant-garde artists (the one exception to this is video, itself a medium closely related to photography). In particular, the photograph is one of the most potent tools available to the advertising industry – always, for obvious reasons, concerned with feel-good images and the portrayal of feel-good situations.

Mapplethorpe's most obvious successors as glamorizers of the male nude are two other photographers, Bruce Weber (born 1946) and Herb Ritts (born 1952). Both have worked very successfully for major advertisers. Weber, in advertising photographs made for Calvin Klein, "sold" homoerotic images very successfully to a mass public which most people might have assumed was inclined to resist such material. In 1991 Ritts published an elegant picture book featuring two male lovers entitled *Duo* (Twin Palms Press, with royalties donated to the American Foundation for AIDS Research). This, much more than any of Mapplethorpe's images, tries to sell the idea of male–male erotic bonding to a mainstream audience and does so by what are, in photographic terms at least, purely traditional terms. These beautifully composed embraces are (once again) in debt to movie stills photography.

By its very nature, however, most gay art speaks not only for, but to, a minority, distinguished from the rest by sexual preference. The themes of sex, beauty and pleasure are intertwined in this art to an extent unknown in other forms of contemporary expression. Today, gay artists have much less inhibition in celebrating the male than heterosexual male artists have in doing the same thing for the female. There has been a reversal of taboos.

Much imagery in gay art is concerned with recognition and celebration. Good examples are the paintings in the "Rodeo Pantheon" series by the New Mexican artist Delmas Howe (born 1935). Born and brought up in the Southwest, some of Howe's earliest memories are of visits to the rodeo, and of erotic feelings associated with the participants and the spectators. He is keenly aware of the erotic connotations both of the typical rodeo events of

Glenn Ligon
Notes on the Margin of the
Black Book, 1993
Whitney Museum, New York

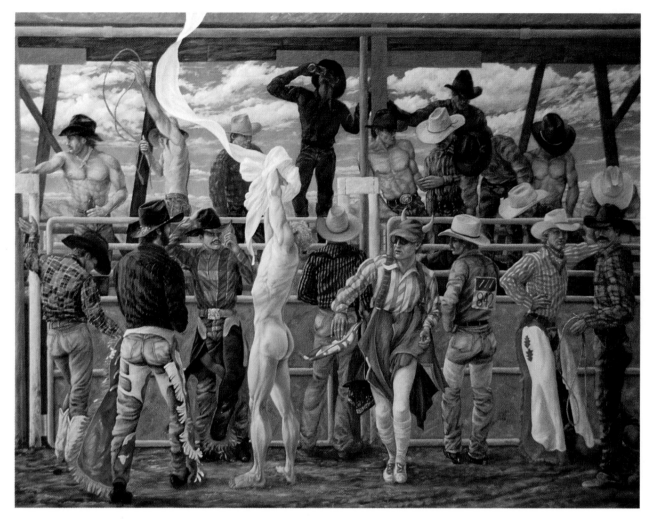

bull-riding and bronco-busting, and of the costumes worn by the participants – boots, tight shirts and jeans, chaps which frame the crotch and buttocks, large silver trophy buckles which call attention to the genitals. Seeing the rodeo as a mythical event, a modern reflection of episodes enacted in classic Greek myths, he combines realistic depiction with elements borrowed from Greek art. His rodeos are invaded by Greek gods, visiting the world of mortals incognito. The gods, always depicted nude, remain invisible to the mortals who surround them. The images thus have a slight self-contradictory air: they are at once celebrations of the beauty and power of the male, and emblems of homosexual invisibility and fear of disclosure. What would happen if the presence of the gods became known to the swaggering rodeo performers? The compositions of Delmas Howe are heavily influenced by the Neo-Classicism of the early nineteenth century. His figures are often arranged in flat bands or friezes reminiscent of the method of organization used by David and his followers. Classical influence is equally strong in the work of other gay artists, almost to the point of an outright rejection of the whole Modernist ethos.

Delmas Howe
Hero I – The Birth
Oil on canvas, 76 x 58in/193 x 147.3cm
The apparition of the nude classical hero remains unnoticed by the participants in a modern rodeo.

Ricardo Cinalli
Hercules Farnese, **1984**
Pastel on tissue paper layers, 12ft 5½in x 12ft 5½in/3.8 x 3.8m
Private collection
Cinalli increases the erotic impact of his interpretation of a famous Roman sculpture by choosing a low viewpoint and by making it disproportionately large for the space.

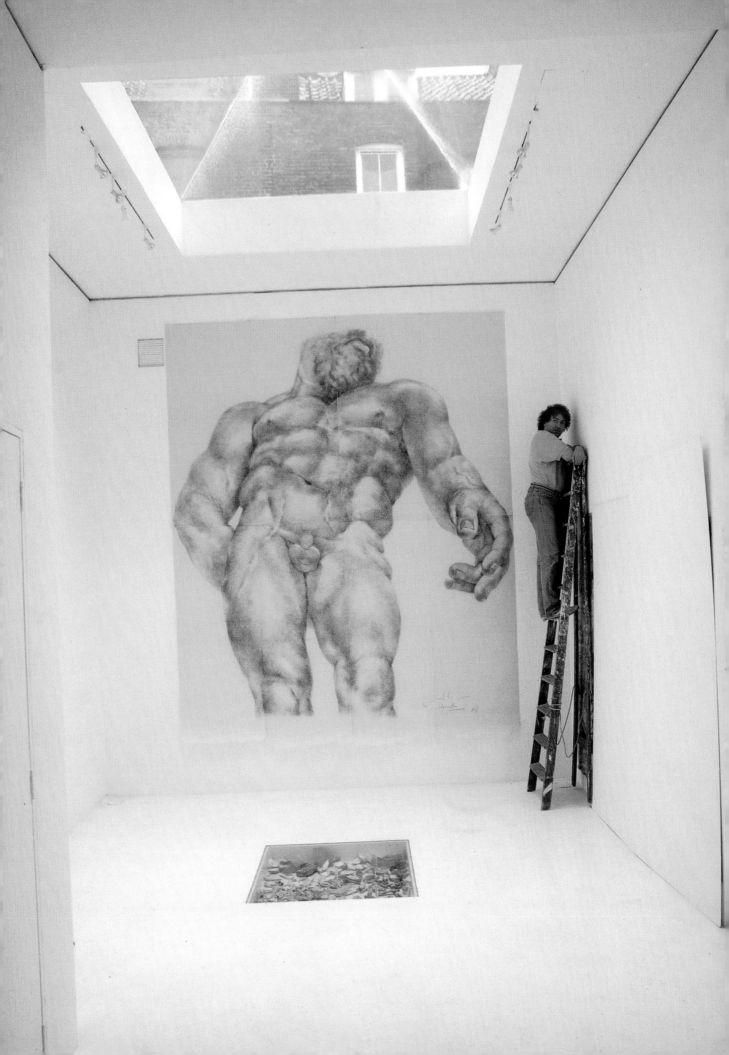

George Dureau
John Simpson, 1987
Photograph
This portrait of a one-legged man shows Dureau's sly use of references to classical art in order to reinforce contemporary meanings.

For example, the work of the young Argentinian painter Ricardo Cinalli (born 1948) makes use of classical mythology, though usually in a more direct way. Cinalli's image of the *Hercules Farnese* (1984), derived from a celebrated Roman statue, is inflected in such a way as to emphasize and exaggerate the idea of dominant masculinity which the sculpture already presents. In particular, Cinalli adroitly manipulates the actual point of view of the spectator, so that the demi-god seems to tower over the viewer. The eye travels directly to his genitals, in this case not hidden by a figleaf. One source for Cinalli's treatment of the image may be a print by the Dutch Mannerist engraver Hendrick Gotzius (1558–1617), which exaggerates the scale and dominance of the Hercules Farnese using rather similar artistic means.

Strong Neo-Classical influence in gay-oriented art is particularly marked in the work of George Dureau (born 1930). Dureau is a New Orleans painter–photographer whose photographs were amongst Mapplethorpe's most important influences. He differs from Mapplethorpe, however, in a number of important respects. One is that his images of male nudes (a large proportion of which are black) are concerned with the personalities of the sitters, in a fashion that Mapplethorpe seldom allowed himself to be. A second difference is that Dureau's sitters, rather than being perfect physical specimens, are physically challenged – either crippled or stunted (Dureau has a fascination with "little people"). He insists that the dignity of these cripples and dwarfs is recognized – that as human beings they are fully equal to the able-bodied.

George Dureau
Wrestling Satyrs, **1991**
Oil on paper
An example of the way in which Dureau adapts his own photographs – in this case of two dwarfs – to create "classical" compositions.

David Pearce
Torso, 1992
This painting shows how Pearce deliberately "wounds", then "heals", his canvas in order to reinforce a sado-masochistic subtext.

There is an additional element. Clearly, Dureau finds his subjects erotic – not despite, but because of their physical defects. One of his ways of expressing this is to pose them like fragments of classical sculpture: one photograph of a muscular but legless man carries echoes of the Belvedere Torso, stylistically a cousin of the Hercules Farnese.

Dureau first began to make photographs as preliminary studies for paintings in which photographic realism is then discarded. His subjects are transformed into beings drawn from Greek and Roman mythology, equipped with satyrs' legs or tritons' tails. As with Delmas Howe, the result is not wholly reassuring. The intention is to celebrate difference, but the classical carnival Dureau conjures up carries with it an indefinable taint of unease. There is, in Dureau's genuine respect and affection for his subjects, still a hint of something sadistic.

The association between gay art and sado-masochistic feeling has already been touched on. This troubles the audience, and clearly troubles homosexual artists as well. The British painter David Pearce (born 1949) makes two entirely different kinds of work. The paintings in one category, signed with a pseudonym, are addressed specifically to sado-masochists and

David Pearce (working as Don Fletcher)
Andy
A realist sado-masochistic depiction made for a specialized market.

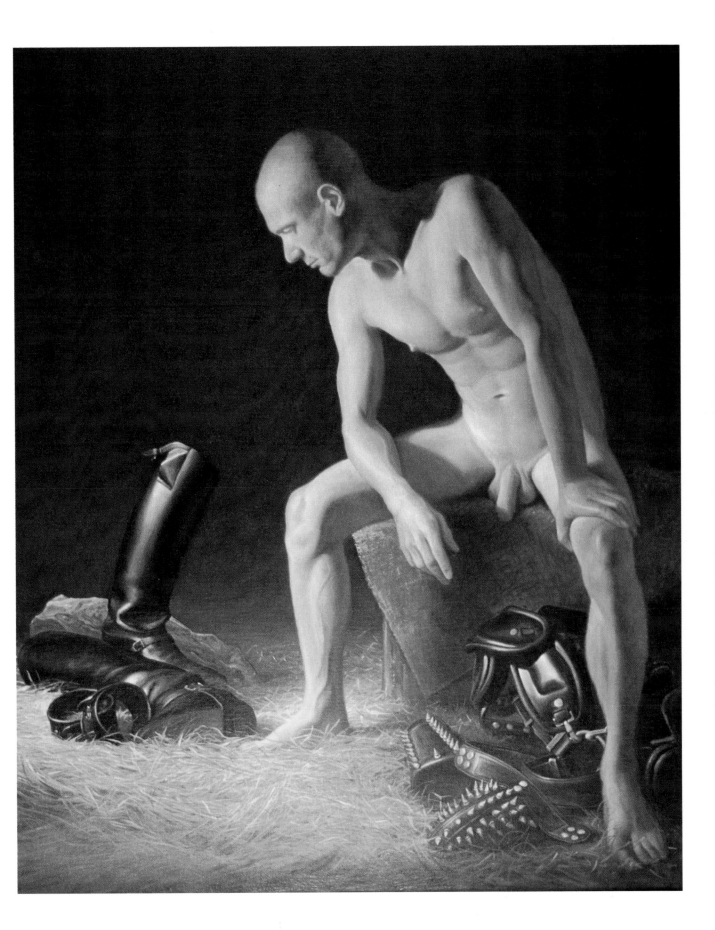

are meticulously realistic. The paintings in the other category, exhibited under his own name, are elaborately coded, and deal with the same subject in a different, more analytical way. For example, the canvases themselves are slashed – i.e. wounded – then stitched or laced together again.

Sometimes, but not always, the association between sex, pain and death routinely found in gay art seems historically conditioned. Granted the notorious machismo of Latin American society, it is perhaps surprising to discover that a number of well-established, and openly homosexual, artists come from Latin America, though not all of them continue to reside there. Equally surprising is the fact that their work finds a ready acceptance amongst their compatriots; in this sense, it has less minority identification than similar work done by North American or British artists.

The most forthright, and probably the best known, Latin American painter of this type is Luis Caballero (born 1947), a Colombian resident in Paris who exhibits regularly in his own country as well as in France, Belgium and the United States. He belongs to a generation of Latin American artists of all sexual persuasions who have been greatly influenced by Francis Bacon: Bacon's work made a sensational impact in the Vth São Paulo Bienal of 1959. Caballero also belongs to a generation of Colombians who were brought up during "La Violencia", the cruel civil war which broke out in 1949 and continued until 1958, killing at least 250,000 people. His work draws on a wide variety of source material, both "high" and "low". Sources include seventeenth-century Spanish religious paintings, and colonial versions of these; the etchings of Goya; the bloody photographs of murders and political assassinations regularly published in Colombian newspapers, and hardcore homosexual pornography.

Once he passed through the phase of being under Bacon's spell, Caballero chose to return to the pre-Modernist tradition. As a draughtsman from the life he is the rival of many nineteenth-century academic masters. His imagery is disturbing because of its ambiguity; the male figures, often seen only in fragments, may be making love, or in their death throes, or in mortal combat. Some poses seem to be based on images found in Goya's *Disasters of War*: prints in this series show mutilated corpses hanging from trees, or impaled on branches. Other works pay tribute to martyrdoms and depositions by Spanish baroque artists such as Jusepe Ribera and Francisco Ribalta.

Another thing Caballero has in common with Mapplethorpe (in addition to a fascination with sado-masochism) is the echo of Catholicism to be detected in his work. This echo also sounds, though more faintly, in the paintings of the British artist Michael Leonard (born 1933). Leonard depicts female and, more frequently, male nudes, as well as still lifes. Very few of his paintings bear a directly homosexual interpretation, but an exception is *Vanitas* (1991), a languorously reclining male nude with a skull half-concealed in the crook of his arm.

Luis Caballero
Untitled, 1990
Red chalk on paper, 41¼ x 29½in/105 x 75cm
An example of Caballero's ability to suggest both eroticism and violence without depicting them.

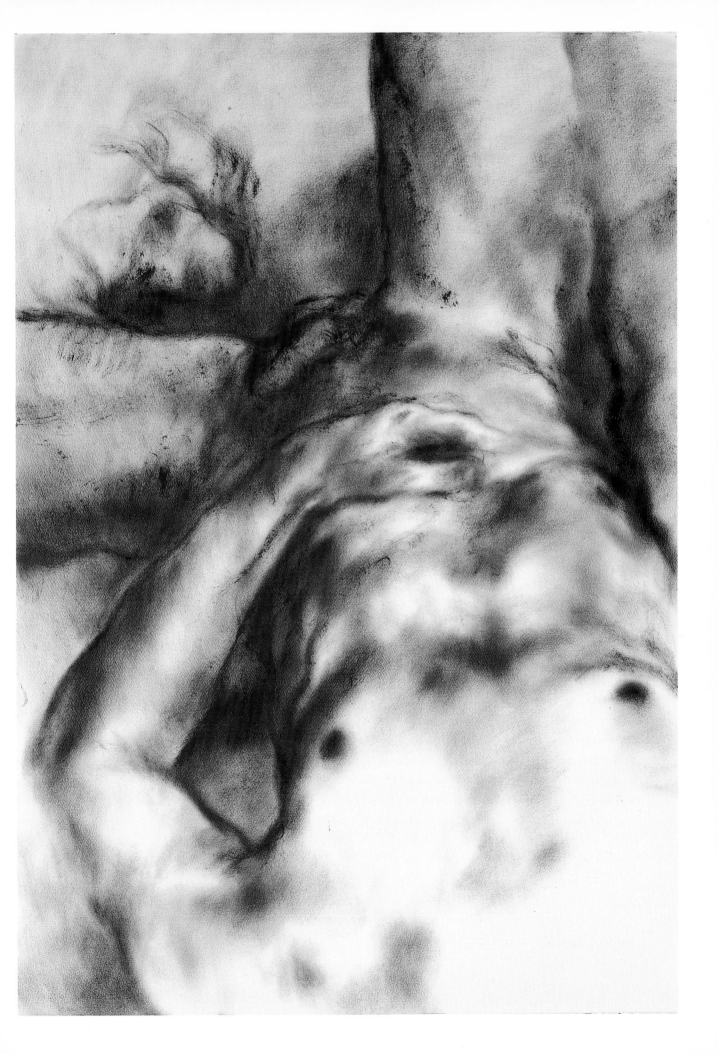

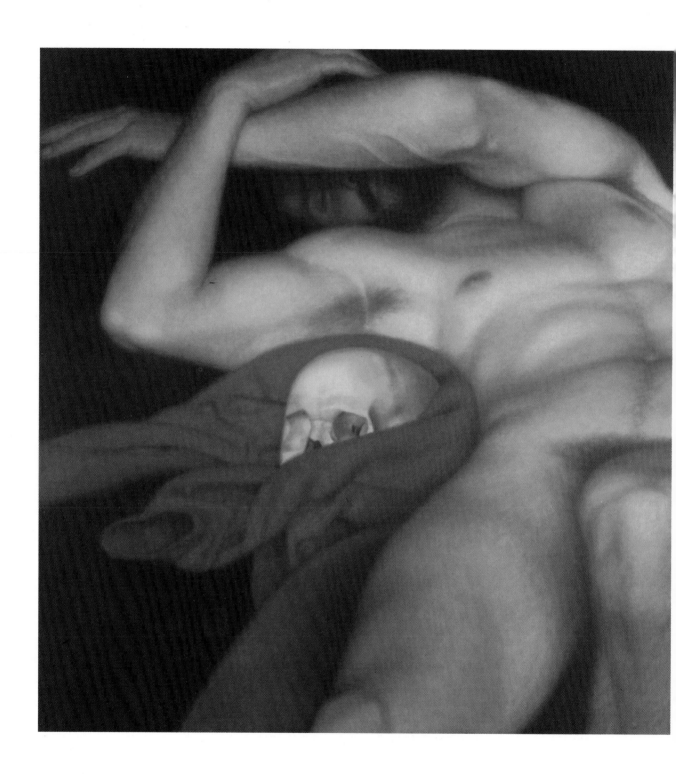

Michael Leonard
Vanitas, **1991**
Alkyd oil on masonite, 32 x 30½in/81.2 x 77.4cm
This moving image makes use of half-concealed Christian symbolism to refer to the effects of the AIDS epidemic.

The painting has a number of significant characteristics. For example, it is fairly obviously inspired by religious art, like so much of Caballero's work: its not-so-remote ancestor is Mantegna's *Dead Christ* in the Brera, where the figure is, like this one, seen in forced perspective, *sotto in su*. Here, however, it is obviously not dead, and perhaps not even asleep, since the body is not completely relaxed. The position of the arms, one intertwined with the other, indicates the kind of drowsy contentment which follows intercourse. *Vanitas* can be read as a lament for the havoc wrought by the AIDS epidemic. AIDS, perhaps more than anything else, has changed public attitudes to homosexual art. Though little, if anything, in Mapplethorpe's work seems to refer directly to AIDS (his late self-portraits, in which it is possible to detect the progress of the illness, are perhaps the only exceptions), his prestige, in the closing years of his life, was undoubtedly linked to the fact that he was known to be a victim. A similar prestige attached to the later work of Keith Haring (1958–90), made when he was known to be ill. Yet here, too, the allusions are not obvious. When Haring portrayed skeletons, in a painting made the year before his death, the title tells us that it was intended as a homage to the Belgian artist James Ensor. Haring's characteristic style, his somewhat inflexible handwriting derived from the world of graffiti and the strip-cartoon, made it difficult for him to create anything with tragic resonance. In a New York art world severely hit by the disease, the effort to commemorate and mourn was left to artists other than Mapplethorpe and Haring.

Of these, the person most closely associated with the campaign against the disease and the fiercest polemicist on behalf of related causes was David Wojnarowicz (1954–92), himself a victim. Wojnarowicz's work, acclaimed by important critics such as Lucy R. Lippard, is extremely difficult to judge in isolation. Unlike the work of the homosexual artists so far discussed, it is so involuted, so densely coded, that it is easy to miss its significance. His importance lies more in his efforts as a campaigner than in his works of art: he writes more eloquently than he paints. His searing book *Close to the Knives* (1991), a compendium of autobiography and polemics, contains remarkably little about art. When Wojnarowicz does write about artistic activity, he posits that there is such a close equivalence between art and life that they are inseparable:

David Wojnarowicz
Untitled, 1984
**Spray paint on masonite, 48 x
48in/122 x 122cm**

*Each painting, film, sculpture or page of writing I make represents to me a
particular moment in the history of my body on this planet, in america. There-
fore each photograph, film, sculpture and page of writing I make has built
into it a particular frame of mind that only I can be sure of knowing, given
that I have always felt alienated in this country and have lived with the sensa-
tion of being an observer of my own life as it occurs.*[6]

Several strands are twined together in this quotation. One is the alienation of
a traditionally romantic *âme maudit*: omit the mentions of film, photography
and the United States and this might sound like a passage from Rimbaud's
Une Saison en Enfer. In addition, there is a Joseph Beuys-like confidence that
the artist and the work are one, not distinguishable entities. Finally, the con-
fession of subjectivity is so extreme that it amounts to a declaration of creative
impotence: not only is the work of art inseparable from the personality of the
artist, it can only disclose its fullest meaning to the person who makes it. What
one sees in Wojnarowicz's art is the incompatibility between avant-garde
procedures and effective propaganda. The same point is also demonstrated,
though in an entirely different fashion, by Chicano art (see Chapter 5).

Two more American artists, with recent major reputations, need to be mentioned in this connection. One is Ross Bleckner (born 1949), whose "Trophy" paintings, featuring cups and chalices, are designed to be read as AIDS memorials. One, *8122+ As of January 1986* (1986), actually takes its title from the number of people in America who had died from AIDS at the time of its completion. Bleckner acknowledges that "the fact of AIDS"[8] is an important part of the background to his work. At the same time, however, he says this about his art in general:

Essentially I'm degrading the sublime. I want my paintings to attempt a belief and a sincerity which I, as an artist, don't necessarily feel, and certainly don't feel continuously.[7]

It is not surprising, therefore, to find that the "Trophy" paintings have a certain elusiveness. The message they deliver could easily be missed by a spectator not completely familiar with the context.

The same can be said, with even more emphasis, about the work of Robert Gober (born 1954). Gober's most typical products are sculptures of lifelike legs, or pairs of legs, which project from the wall of the gallery or room in which they are displayed at some unexpected point: say, just above

David Wojnarowicz
***Just a Little Bit of the Tin Drum Mentality*, 1984**
Paint and collage on canvas

Patrick Angus
All the Love in the World, **1987**
Acrylic on canvas, 22 x 18¼in/
56 x 46cm
A vignette of contemporary New York
low life, with a homosexual strip show
as setting.

the skirting. The gallery may be lined with a wallpaper designed by the artist himself, showing, for example, a white man sleeping and a black man hanging from a tree. The combination of images generates a powerful sense of unease, but this unease is unspecific – we do not know what generates it in the artist himself. If we know that Gober is an openly gay man, living and working in New York, then we may perhaps speculate that the threat of AIDS is one of the things which generates this climate of feeling, and encourages him to try and communicate it to an audience.

In effect, the most direct and touching art generated by the AIDS epidemic has been nostalgic rather than propagandist. The work of Patrick Angus (1953-92), another casualty, is at the opposite extreme from that of Wojnarowicz, though they were contemporaries. The difference is the more striking because both artists emerged from the same milieu: the bars, bathhouses and sleazy erotic cinemas of New York. Wojnarowicz, for a time a male prostitute, records his experiences with disgust and self-hatred; Patrick Angus envelops the same scenes with a Bonnard-like glow. His paintings, not surprisingly, are admired by Hockney, who has bought several; there is a genuine affinity between some of Angus's more domestic scenes and Hockney's matter-of-fact records of homosexual life of the 1970s.

Derek Lawson
A Salon discussion Between the
Young Men of Avignon and a
Crucifixion (detail), **1987–93**
Oil on canvas, two panels, each
72 x 72in/182.8 x 182.8cm
An ironic parody of Picasso's *Les
Demoiselles d'Avignon* (1906–7),
which highlights the blatantly erotic
content of the earlier work.

Where Angus's more ambitious work is concerned, he can be compared both with Bonnard (filtered through the Bay Area Figuration of Richard Diebenkorn and Elmer Bischoff) for style, and with Toulouse-Lautrec for material. Angus paints, just as Lautrec once did, an urban night world, louche and dangerous. He brings to it a personal intensity born of a consciousness, not only of the special character of the milieu, but its fragile ephemerality. Like most of the gay male artists considered in this chapter, Angus is radical in content but essentially conservative in manner.

Naturally, some homosexual artists are dissatisfied with this conservatism: they want to be up-to-the-minute in terms of the current structures and strategies of contemporary art in addition to being frank about their commitment to gay liberation. One is the British painter Derek Lawson (born 1952) who, in a statement issued in connection with his solo exhibition "Queer Nudes" says that:

Artistic Correctness makes certain demands. No painter can currently confine himself to "sensitive" or "expressive" mark making. No artist can claim sincerity of intention or make any claims about intentionality which are not ironic questionings. Sensuality per se is inadequate unless part of a discourse; sexuality is inevitably drawn into a discussion about what a culture will permit.[8]

Lawson's solution is a version of the now well-established technique of appropriation. Known images – for example Picasso's *Demoiselles d'Avignon* (with which this chapter began) – are changed to give them new meanings. Picasso's "young ladies" become young men with rampant erections, and Picasso's version of sexuality is thereby both distanced and called into doubt.

One artist, at least, has turned from the question of gay sexuality to the related problem of gender, thus providing a link with feminist art, whose central preoccupation this tends to be. The British painter John Kirby (born 1949) makes work which is figurative and intensely autobiographical. Nearly all the protagonists in his paintings, which have strong narrative overtones, appear to have a physical resemblance to himself; some are directly identified as surrogates by means of small details, such as the presence of a tattoo which is identical with one Kirby has on his own upper arm.

His paintings do not represent overtly sexual acts, nor can they be read as celebrations of male beauty. They are often meditations on the way in which gay men disguise themselves, and on their ambiguous reactions to their own sexuality. A favourite theme is transvestism, men in the clothing of the opposite sex. In *Two Men Running Away* (1987) the figures are obviously masculine, however feminine their actions, giving a strange pathos to their apparent terror. The picture asks questions rather than provides answers. Why are they frightened? What are they running away from? Is it knowledge of

Gustave Courbet
Le Sommeil, 1866
Oil on canvas, 53 x 78¾in/135 x
200cm
Musée du Petit Palais, Paris

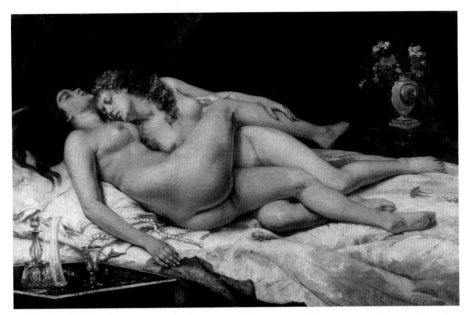

their own tastes and fantasies? Kirby meditates on his chosen themes, but he does not preach.

There remains one important question, so far left dormant. I have written a great deal about the art of gay men: what about the art of gay women? Is there an identifiably lesbian art? It is often asserted that such an art "must" exist. The answer is that, if it does, the more it tends to dissolve as one pursues it. The reason may perhaps be summed up in something said by the feminist critic Joyce Fernandes, in her essay "Sex into Sexuality":

Lesbians are invisible in the visual arts not only as women but as gay women [because] it is nearly impossible to represent lesbianism in a way that cannot be co-opted by the dominant (and inimical) heterosexual culture.[9]

Lesbian representations have always had a well-established place in heterosexual erotica. One of the best-known examples is Gustave Courbet's superb painting *Le Sommeil* (1866), painted for a male (Turkish) patron.

Any insistence that there must be a lesbian art to match the gay male art I have discussed in some detail springs in part from the knowledge that there are certainly a number of contemporary lesbian artists. Yet does their sexual orientation play a significant role in their work? Even where the artist is unequivocally "out" and wants her sexual orientation to be known to everyone, it is not necessarily her main subject matter. Nancy Fried's most moving sculptures are about her reactions to cancer surgery and loss of a breast. Betsy Damon's striking performance piece of the mid-1970s, *The 7000 Year Old Woman*, is about the experience of being female rather than same-sex oriented. On this subject it is fair to let her speak for herself:

I usually think of myself as part scientist and part magician, with certain skills that sometimes make art. Neither feminism nor lesbianism determine the

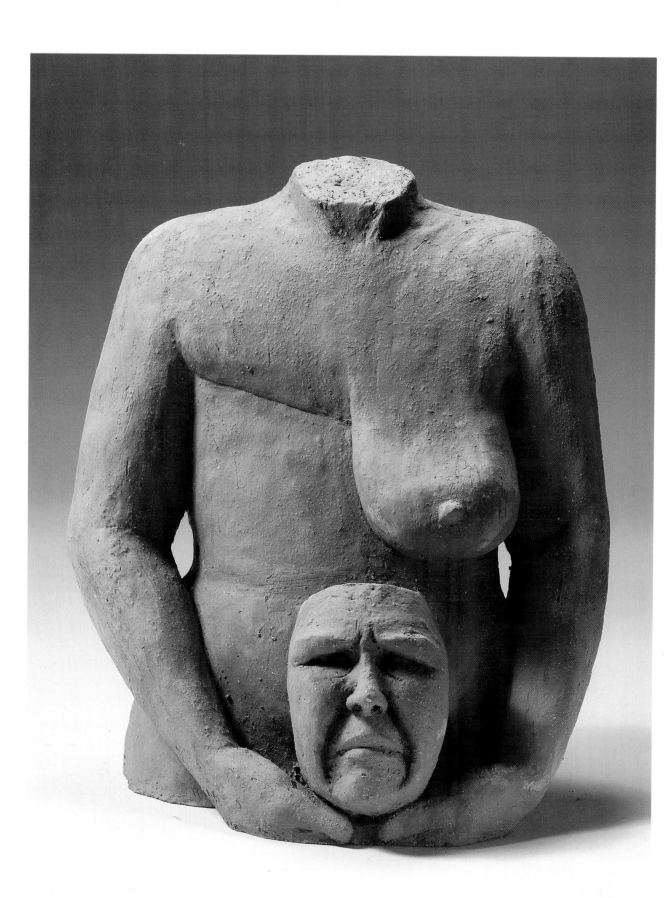

Nancy Fried
Self-Portrait, 1989
Black clay, 10½ x 9½ x 8in/
26.6 x 24.1 x 20.3cm

form and content of my work yet it was only with the security of the former and coming to terms with the latter (the muse) that my life and art began to be uniquely and overtly me.[10]

This quotation comes from a 1977 issue of the magazine *Heresies*, which was devoted to lesbian art and artists. It remains to this day the chief, indeed almost the only, contemporary treatment of the subject. It does not offer a long listing of names.

From the mid-1980s until the time of writing there has been a striking scarcity of publications on this subject. This is not simply my own impression. In the issue of *Women Artists' News* for Spring/Summer 1990, Lourdes Kanou noted that "to date no books have been devoted exclusively to the theme of art created by lesbians".[11] The computer catalogue of the Victoria & Albert Museum Library (Britain's National Art Library), covering books published or acquired since 1985, offers just three titles under "lesbianism". All are books of photographs, devoted to the theme of lesbian self-recognition, and only one is the work of a single photographer, Della Grace (born 1957). Grace's *Love Bites*, published in 1991, is a personal record of the connection between lesbianism and sado-masochism. The muted reception given to the book on publication was almost certainly motivated by the political "incorrectness" of

Della Grace
Photograph from *Love Bites*,
1991
Mapplethorpe translated into lesbian terms.

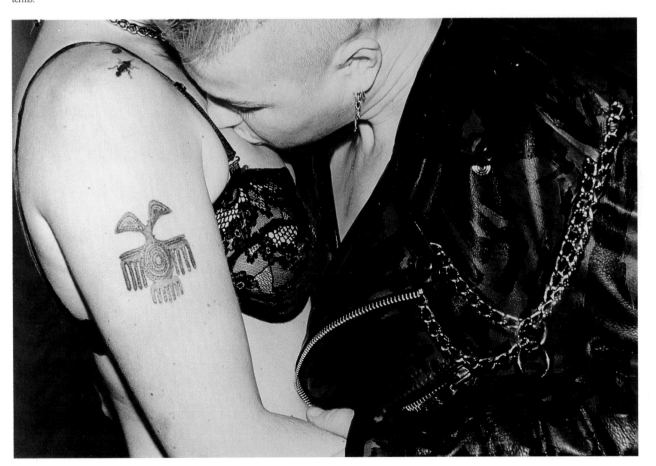

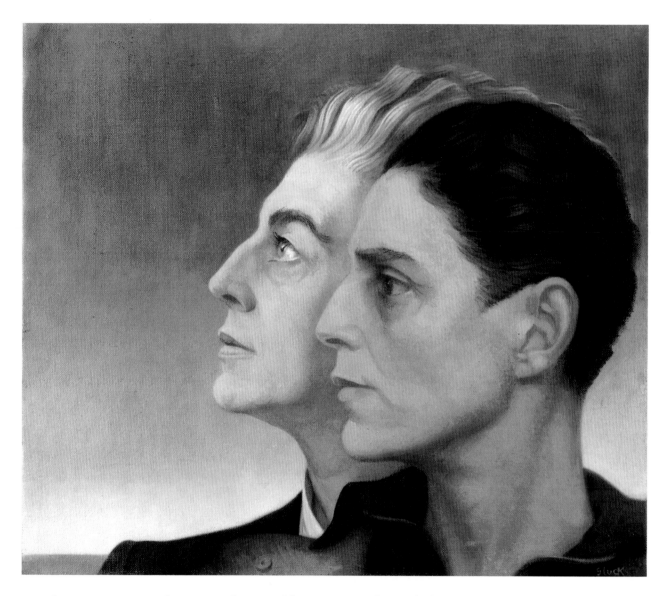

its subject matter. Grace has enjoyed none of the notoriety of Mapplethorpe, Weber or Ritts.

These facts make it clear, I think, why it is difficult to offer any in-depth coverage of contemporary lesbian art. Paradoxically, the identity of such an art was much clearer in the earlier years of the century, and especially during the 1920s and 1930s, when lesbianism had a period of acceptance and even a certain fashionability. The lesbian subculture of Weimar Berlin was depicted by Jeanne Mammen (1910-76) in a series of incisive drawings. In particular, she supplied illustrations for Magnus Hirschfeld's *Sittengesichte der Nachkriegzeit* (*A Moral History of the Post-War Period*). In Paris, Romaine Brooks (1874-1970) made stylish portraits of the members of a lesbian circle surrounding the expatriate American writer Nathalie Barney. Brooks portrayed Barney herself, and made a striking, if somewhat uncharitable, likeness of Una, Lady Troubridge, the lover of Radclyffe Hall,

author of the notorious lesbian novel *The Well of Loneliness* (1928). In London Gluck (Hannah Gluckstein, 1895-1978) sometimes made paintings of a similar sort, among them *Medallion* (1936), a double portrait of herself and her lover.

Brooks and Gluck, though different in temperament (Gluck being much the less "social") did have certain things in common. Both came from wealthy families, and did not have to paint for a living; both were conservative in style; both felt vulnerable in the mainstream art world and preferred to avoid it. Their work was reticent, addressed to a circle of like-minded friends. A good deal more eager for publicity was the bisexual Tamara de Lempicka (1898-1980). Her occasional paintings of pairs or groups of female nudes are translations into a Deco-Cubist idiom of Courbet's *Le Sommeil*. For all the overtness of their sexual content they caused less stir than her dashing portraits of hard, chic women (among them herself) and handsome but rather feminized men. De Lempicka's work has now acquired iconic status – her images of the fashionable society of the interwar period fascinate those who never participated in it. In her own day, however, she was never taken quite seriously. Neither she, nor Romaine Brooks, nor Gluck generated a continuing tradition of specifically lesbian art.

Gluck
Medallion, **1936**
Oil on canvas, 11½ x 13½in/
29.2 x 34.2cm
A self-portrait of the artist with her lover Nesta; Gluck is in the foreground, with dark hair. The profile pose, often adopted by more conservative artists at this period, was suggested by Italian Renaissance paintings.

8 Feminist Art

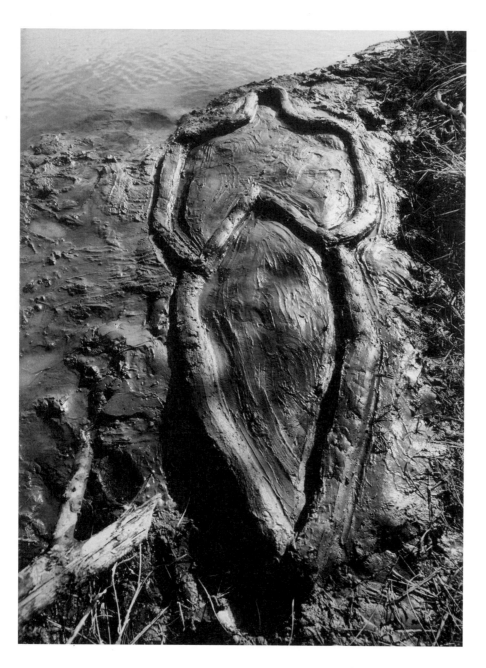

Ana Mendieta
Untitled, 1982–3/1992
**Photograph of earthwork with
carved mud, New Mexico, 61¾ x
48in/156.8 x 121.9cm**
An example of Mendieta's neo-primitive
female figures, sometime based on an
imprint made by her own body.

One of the important things to be learned from the paucity of specifically lesbian art is that women's art is typically less concerned with questions of sexuality linked to eroticism than with much broader questions of gender. It seems as if lesbians have usually preferred to be seen, not as defenders of minority sexuality, but as members of the whole feminist consensus. In general, the female sensibility seems less preoccupied with eroticism than with the problem of difference. Very little, if any, feminist work is interested in arousal. When women venture into erotic territory, their intentions are often ironic. For example, in a series of paintings made in the early 1970s, Sylvia Sleigh offered new versions of familiar erotic masterpieces such as Ingres's *Le Bain Turc*. Her intention, like the gender-reversal imposed by Derek Lawson on Picasso's *Demoiselles d'Avignon* two decades later, was satiric. In her versions of classic compositions, the figures are less solidly drawn, therefore less physically present, than the originals.

In a recent series of drawings, Joyce Kozloff (born 1942) has gone further than this, plundering the erotic art of the world in order to create a series of deliberately hilarious images. In her introduction to Kozloff's collection *Patterns of Desire*, Linda Nochlin points out that, at least to the female viewer, the pleasure offered by the drawings is transgressive rather than directly sexual. Such a viewer identifies, Nochlin says, with the "demystification of the sacrosanct wickedness of the pornographic image" and with the "free play with the sacred texts of all cultures". She sees in this

a disrespectful but often affectionate playing around with the cultural patrimony – patrimony *to be taken in the literal sense of "that which is inherited from the father"*.[1]

However, this takes one only a little way into the complexities of recent feminist art. Far more than any of the other minority expressions so far dealt with in this book (and one must recall its special status in this respect), it represents an attempt to alter the essence of western culture – to change the past, as well as the present and the future. It cannot be seen in isolation, either from feminist theory in general or from the feminist re-interpretation of art history.

One pioneering attempt at reinterpretation is Germaine Greer's *The Obstacle Race: the fortunes of women painters and their work*, published in 1979. Greer, in turn, was inspired by an exhibition held in 1976 at the Los Angeles County Museum of Art, "Women Painters: 1550-1950", organized by Ann Sutherland Harris and Linda Nochlin. Greer dismisses the stock question, posed by Linda Nochlin in a famous essay, " Why are there no great women painters?" and replaces it with others:

The real questions are "What is the contribution of women to the visual arts?" "If there were any women artists, why were there not more?" "If we can find

one good painting by a woman, where is the rest of her work?" " How good were the women who earned a living by painting?" The real questions are based not on the notions of great art entertained by the "layman", which are essentially prejudices, but in the sociology of art, an infant study still in the preliminary stages of inventing a terminology for itself.[2]

The final sentence skilfully dodges the problem of aesthetic value.

It also dodges other issues, which fall within the realm of sociology and social history rather than that of connoisseurship. For example, Greer soon

found that the women's art of the past, even when rediscovered by modern researchers, remained firmly tied to structures of male domination:

Any student of women painters therefore finds that he [sic] is actually study-ing the female relatives of male artists ... Women artists before the nineteenth century seldom expressed their own creativity: they adopted modes of self-expression first forged by integrated, self-regulating (male) genius, most often when they were already weakened by eclecticism and imitation ... Until the nineteenth century liberation from the overwhelming and ubiquitous artist father would also have meant the cessation of all technical training.[3]

Here in a nutshell are most of the problems of the new feminist art history. It was not only that women were heavily dependent, in the most literal fashion, on patriarchal family structures. It was also that the structure of the traditional art world was itself patriarchal: the studio system of training ensured that art-istic knowledge was handed down from one male (the established master) to another (the hopeful apprentice, also a real or surrogate son). Women tended to be drawn into the studio only when no male heir was available.

Not surprisingly, Greer's analysis has not been welcomed by later feminist critics. The objection is made that she is not a trained art historian, but only an amateur, venturing into a field which is not her own. It is also said that her work is "early" – i.e. somewhat primitive – compared to the development of feminist art history as a whole. It is a surprising fact that, while several ambitious general histories of women's art were published in the late 1970s, there have been few books since.* The two which come to mind are Nancy Heller's *Women Artists: An Illustrated History*, published in 1987; and Whitney Chadwick's *Women, Art and Society*, published in 1990. Chadwick, unlike Greer, is a properly accredited art historian, currently Professor of Art at San Francisco State University, and it is interesting to see her reaction to the points which Greer has to make. The truth is that she largely seems to ignore them: Greer's book is listed in her extremely ample bibliography, but Greer is mentioned only once, very much in passing, in the main text, and does not figure in the index. Concerning Tintoretto's daughter, Marietta Robusti, generally considered a prime example of the kind of situation Greer describes, Chadwick is confusing, although also faintly accusatory:

Joyce Kozloff
***Pornament is Crime Series No. 4, Smut Dynasty Vase*, 1987**
Watercolour on paper,
22 x 22in/55.8 x 55.8cm
Collection Terry Stept
An example of feminist appropriation of pornographic material for purposes of satire. The scene in the main register is taken from a Greek Red Figure vase of the fifth century BC; that in the upper register is borrowed from a Chinese erotic scroll.

* There have of course been specialist historical studies covering strictly limited areas. Two of the best-known are Whitney Chadwick's *Women Artists and the Surrealist Movement* (1985 and 1991), and Lisa Tickner's *The Spectacle of Women: Imagery of the Suffrage Campaign* (1988). In addition there have been anthologies of feminist art criticism (see bibliography) and studies of the relationship of feminism to art history – e.g. Norma Broude and Mary D. Garrard, *The Expanding Discourse: Feminism and Art History* (1992). Soon to appear is the first comprehensive history of feminist art since 1970 (Norma Broude and Mary D. Garrard, eds., *The Power of Feminist Art: The American Movement of the 1970s, History and Impact*, Harry N. Abrams, 1994).

Although it is clear that as a female member of Tintoretto's household Robusti was subservient and that her short life resulted in limited production, it is modern scholarship which has buried her artistic life under that of her father and brother.[4]

Contradicting another scholar, Francesco Valconover, whose study of Tintoretto was published in 1985, Chadwick then undermines her case by admitting:

The model Valconover assumes for the Tintoretto workshop is more conservative and hierarchical than that in many other sixteenth-century artists' studios, but we lack the documentary evidence that might revise his view.[5]

Artemisia Gentileschi
Judith and Holofernes, c. 1610–12
**Oil on canvas, 64¼ x 49½in/
163 x 126cm
Museo di Capodimonte, Naples**
The composition is based on a painting by Caravaggio of the same subject of 1598–9, and on another of c. 1610 (lost, but known through engravings) by Sir Peter Paul Rubens. Granted the close similarities between the three pictures it is difficult to read into this the gender-specific meanings offered by some feminist commentators.

Like many feminist art historians, Chadwick sees a somewhat later female painter, Artemisia Gentileschi (1593-1652) as "the first woman artist in the history of Western art whose historical significance is unquestionable."[6] She supports this view with a close analysis of some of Artemisia's best-known works, including the early *Susanna and the Elders* (1610), the *Self Portrait as the allegory of Painting* (1630s) and, most celebrated of all, *Judith Decapitating Holofernes*, which exists in two versions, one apparently circa 1610–12 and the other much later. In view of its theme, it is not surprising that the *Judith* has been the subject of admiring feminist interpretations. What these often ignore, however, is the existence of an earlier painting on the same subject by Caravaggio, the founder of the Tenebrist school to which both Artemisia and her father Orazio belonged. There is no doubt that Artemisia's career marked a significant step forward for women artists, though the progress she made was not to be consolidated for a long time. At the end of her career, after she had settled in Naples in 1630, she was an independent celebrity, competing successfully for commissions with the best-known artists of the time. Yet a survey of her total *oeuvre* makes it clear that her impact was more important from a sociological point of view than a purely artistic one. Excellent painter as she was, the history of western European art, in essential outline, would be no different had she never existed.

Given the difficulty of fitting women's art into existing art-historical structures, one solution has been to broaden the frame and analyse women's visual creativity in ways which go well beyond the conventional boundaries usually imposed on the fine arts. It has been noted, for example, that women have often expressed themselves visually through means other than painting or sculpture; for example, in rural or pioneer societies (which are often the same thing) through crafts such as weaving or stitchery. This in turn has led to the perception that women's creative work, such as the making of a quilt, was frequently plural and cooperative. Similar models have been suggested for the feminist art of the present day, and were indeed followed in Judy Chicago's *The Dinner Party*, and its successor *The Birth Project*.

Observations of this kind lead one well beyond art criticism into the territory of general feminist theory. Intellectually speaking, the growth of the feminist theoretical base has undoubtedly been one of the most remarkable developments of the past thirty years. Theorists have plundered a wide range of sources, particularly structuralist philosophy and related psychoanalytic studies. The work of Baudrillard, Derrida and Lacan has been brilliantly reinterpreted by both French and American feminists, and made to yield ideas and meanings which seem valid in themselves even if they are not what these authors originally intended. The thrust has been both psychological, a searching critique of Freud, negotiated via the writings of Lacan; and sociological, an application of techniques of structuralist analysis to the immediate problems of women in a modern society.

One quite striking thing about this mass of theorization, however, is how little formal art criticism it contains. It makes room for the visual, but the actual analysis of works of art is avoided, perhaps for several reasons. One is that feminist theory has a hostility to hierarchies – the idea that one work of art is "superior" to another, and that an analytical approach seems to follow a patriarchal model. Another is that, in structuralist terms, works of art, like all other objects in a complex universe of phenomena, are only signifiers whose meaning shifts according to context. Thirdly, there is the nature of much of the art itself, which remains on the margin of traditional categorizations. Feminist criticism tends to lay stress on narrative content, because narrative links the various signifiers together. This may explain why feminist analysis of the visual arts has often tended to concentrate on film. It also offers reasons why performance, video and photography have all been favoured means of feminist expression.

A particular crux has been the issue of eroticism, which is both favoured and feared by feminist artists. On the one hand, there has been an effort to

Hannah Wilke
So Help Me Hannah series, 1978
(detail)
Installation at P.S.1, Long Island
City, New York
With Ray Guns, based on a
performance by the artist.

develop an eroticism specific to women. As Miriam Schapiro and Faith Wild-
ing remark in their joint introduction to issue no. 24 of *Heresies* (1989):
"'Cunt art' [became] a defiant challenge to depictions of submissive female
sexuality."[7] They note that, during the 1970s:

*For the first time many women produced work with their own naked bodies
as subject, exploring them from their personal points of view. The body
became the book: it was written upon, painted, photographed, ritually
arranged, bathed in eggs, mud and blood . . . and draped in flowers, seaweed
and other detritus of the natural and* man *made world.*[8]

In *Interior Scroll* (1975), Carolee Schneemann performed nude, producing a
poem-scroll from her vagina. In *So Help Me Hannah* (1985), Hannah Wilke
crouched on the floor of the performance space wearing only a pair of high-
heeled shoes, while being videoed in close-up by two men with camcorders,
with the resultant images appearing on video screens in the background. (It is
worth reflecting what a feminist critic might have said about either of these
events, had the performer been Ilona Staller.)

Carolee Schneemann
*The Delirious Arousal of
Destruction: Or, is there a
Feminist Erotic Iconography?*,
1992
Performance using projections of
photographs of *Interior Scroll*,
1975

 It is, however, not surprising, given the context, that preoccupation with
eroticism in feminist art-making is often accompanied by suspicion. Feminist
writers often emphasize the nature of the gaze – what goes from the spectator
to the contemplated object, rather than what comes *from* the object to the
spectator. Given this framework, erotic representations are easily thought of
as an invitation to voyeurism, and voyeurism in turn is seen as an offence
against women, a form of rape. In its most extreme guise, this leads to disap-
proval of many forms of established art. Even Titian's superb nudes become a
source of embarrassment. In feminist art, one refuge from this is to treat the

Elisabeth Frink
Running Man, **1980**
Bronze, height 7ft/2.1m
When depicting human beings, Frink
confined herself almost entirely to the
male figure.

artwork as something only partly existent in its own right. Partly it serves as a
semi-transparent screen, through which the spectator is invited to discern
something else. The nudes by Sylvia Sleigh, already described, fall into this
category. Art of this sort not only lacks eroticism, but the qualities that go with
eroticism: sensuality, density of physical being.

This is perhaps one of the primary reasons why a number of leading
women artists, rather than identifying with the feminist movement, have, on
the contrary, tended to stress their distance from it. In an interview given
shortly before her death, Elisabeth Frink (1930-93), the most prominent
female sculptor in Britain in the post World War II period, said with some
emphasis: "In the arts you cannot differentiate between the sexes: men and

women are equal." She added: "Women artists who explore their femaleness through their art are being very introverted."[9]

What, then, is contemporary feminist art, and when did it first begin to be made? Its appearance, as a recognizable force in the contemporary art scene, dates from the late 1960s – that is, it emerged at a time when multiple challenges were being offered to existing political and social structures, particularly in a United States torn apart by the Civil Rights Movement and the Vietnam War. In addition to being a challenge to existing social and political structures, it flung down the gauntlet to the art world itself. Could the old way of judging art still stand? Did words like "quality", "objectivity" or "aesthetics" have any meaning in the new terms set by feminist theory? Art criticism of any conventional sort was identified by a new generation of militant women artists as an attempt to uphold age-old phallocratic authority.

The most spectacular public result of the first wave of feminist influence in art was Judy Chicago's massive environment-cum-installation, *The Dinner Party* (1974-79). This was a homage to 39 women whom the artist considered to be major figures in western history, plus 999 others. A triangular table accommodates 39 place settings, each with a different and specially designed plate, goblet and runner. The place settings are arranged thirteen to a side, so that the whole assemblage creates the image of a triple Eucharist. Accompanying the environment is a book, an illuminated manuscript in five sections which offers both a rewriting of Genesis, with a Goddess rather than a God as supreme creatrix, and a new vision of the Apocalypse, in which the world is healed and made whole through feminist values.

In the years since its creation, *The Dinner Party* has met with enormous acclaim. It has also proved extremely controversial, even within the feminist community. One cause of offence was Chicago's own unequivocal support of the primacy of aesthetic values. What follows is an extract from an interview/discussion held in October 1982 at the Great Georges Community Cultural Project, Liverpool, England:

I don't believe in art simply as a tool of social change. I believe in art as art. One can use art as a tool for social change or one can make art which has as one constituent the changing of social and political circumstances, but after all that is over art will continue to exist as beautiful images.[10]

To this Karen Woodley retorted, in an article which appeared in *Artrage* (No. 9/10, 1985):

Judy Chicago's insistence that The Dinner Party *should be seen as a work of art and not as a political statement undermines the reason for its existence. It is this lack of political analysis and political motivation that has created such a superficial and inconsistent exhibition.* The Dinner Party *is a shrine to an unknown woman; a woman whose colour, sexuality, class, struggles and achievements are without political context.*[11]

Judy Chicago
The Dinner Party, **1979**
Mixed media, 48 x 48 x 48ft/14.6
x 14.6 x 14.6m
The most celebrated feminist artwork of
the 1970s, a triple eucharist celebrating
women who played major historical
roles.

Woodley, born in Britain of African descent, is an administrator of the British Minority Arts' Advisory Service and does consultancy and campaign work related to the development of black arts and culture in Britain. Among her other criticisms is one relating to Chicago's use of vaginal imagery:

The representation of each group of women by a plate beautifully crafted as a vagina conjures up the same old misconception of women's sexuality, that of offering not taking. [12]

Her most cogent criticism was of Chicago's use of "thousands of unpaid volunteers" while apparently taking all the credit for herself: "The overall dominance of one woman effectively undermines and negates the purpose of such a work." [13] Despite all this, *The Dinner Party* was a landmark in the development of the new feminist art, most of all perhaps in the assumption by that art of a separate identity, making something different from art simply made by a female, or females, rather than by males. It is worth trying to specify the ways in which it set an agenda for feminist art in general.

First, there was the attempt to create art which would speak about a woman's, rather than a man's, perception of the body. Chicago's use of vaginal imagery is not employed gratuitously, and if it is transgressive in a Modernist sense this is surely a by-product. Second, it not only re-uses old myths, but attempts to create new ones. The transcendental element in much contemporary feminist art is one of its more surprising attributes, given that its context is an increasingly materialist society. The idea of the deity as female recurs frequently in feminist artworks, at a time when other artists have scarcely concerned themselves with religion at all, unless it is with the idea of the artist himself (or herself) as a shaman. One of the neatest expressions of this religious role reversal is the bronze *Christa* (1975) by Edwina Sandys, where the standard male crucifix figure is transformed into a female. Third, *The Dinner Party* deliberately makes use of skills which are thought of as specifically feminine rather than masculine. As Carrie Rickey put it in what she called "an interior dialogue occasioned by *The Dinner Party*", printed in *Artforum* in January 1981:

It's a glossary of the so-called "lesser arts" – tatting, lace, weaving, making ceramic household vessels, embroidering – that women have been confined to for thousands of years. But that all these crafts are brought together, synthesized for a ritual (and it's men who usually make the ritual art in pre-literate cultures) is just one of the canny reversals that The Dinner Party *undertakes. It proposes that the sum of the lesser arts is great art.* [14]

Fourth and last, though *The Dinner Party* goes largely for the sake of convenience under the name of one person, it was a collective enterprise, an experiment in joint self-realization.

Edwina Sandys
Christa, **1975**
Bronze, height 4ft 3in/1.3m
Gender-reversal applied to the traditional image of the crucified Christ.

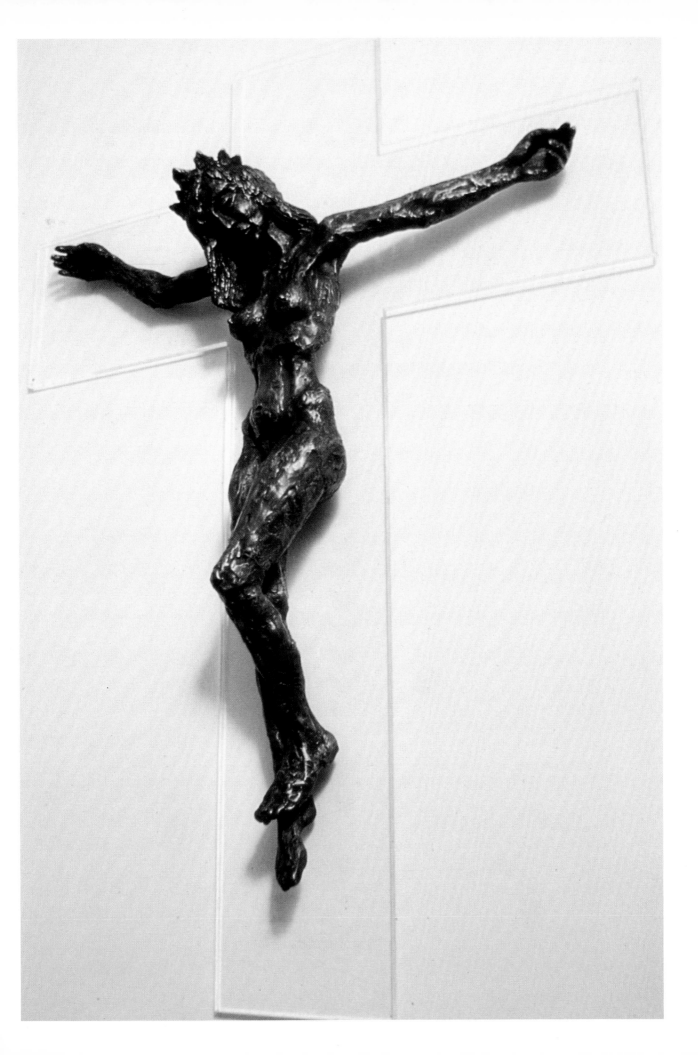

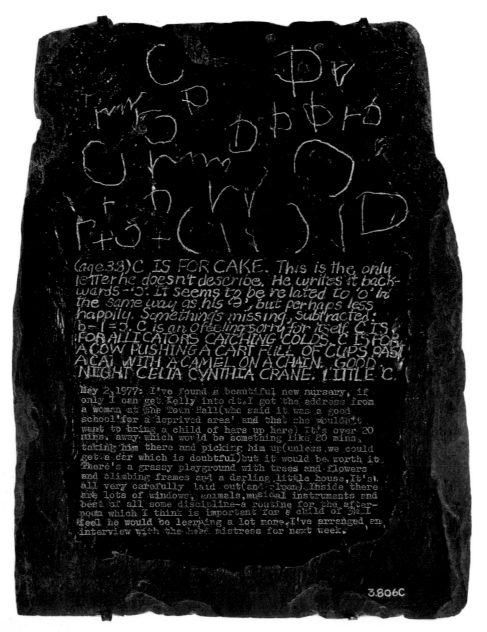

Mary Kelly
Documentation VI, **detail from**
Post Partum Document, **1978–9**
Slate and resin, 18 units, each
14 x 11in/35.6 x 27.9cm
Arts Council of Great Britain

Documentation VI examines the formative phase in which the child begins to read and write. The inscriptions are divided into three registers: at the top are the child's own pre-literate attempts to write, in the middle are the mother's comments, and at the bottom typed excerpts from her diary.

The Dinner Party does, nevertheless, have characteristics which place it firmly within the artistic context of the 1970s. Though the physical realization was ambitious, it was essentially both a conceptual work and a work about process, and these were dominant themes in much of the art of the decade. The only feminist work of the same epoch which rivalled it in celebrity was Mary Kelly's *Post Partum Document* (1978–9). Its fame was partly adventitious. When it was exhibited, still incomplete, at the Institute of Contemporary Art in London in 1977, critics were shocked by a display of disposable nappies showing faecal stains. These objects were used as a record of the feeding and changing of a particular infant, Mary Kelly's own son, over a period of three months.

The complete *Post Partum Document* makes a different impression: it is an elaborate, painstaking, anthropological analysis of the mother's relationship with the child, and the inevitable separation which society imposes. Or, as Lucy R. Lippard puts it in her introduction to the book which reproduces the piece in its entirety: "PPD is the story of a cultural kidnapping and of a woman's resistance to it, made active by visual and verbal analysis."[15] The nappies with their stains are only a small part of the complete work. Much consists of linguistic analysis: the child's first attempts to communicate through speech; later, his earliest attempts at writing. Another segment records the child's spontaneous investigation of his environment, and his questions about sexuality and sexual difference. A work of this type is peculiarly late-Modernist, in the sense that it flouts all the criteria which distinguish a traditional work of art, and at the same time renders aesthetic criteria otiose.

Judy Chicago and Mary Kelly belong to a generation of feminist artists which came to prominence in the 1970s, many when they were already no longer young women. Among them were Miriam Schapiro (born 1923), May Stevens (born 1924), Nancy Spero (born 1926), Betye Saar (born 1926) and Faith Ringgold (born 1930). A staunch supporter from an even earlier generation was the veteran figurative Expressionist Alice Neel (1900-85), who in the course of the 1970s achieved the prominence which had so long been denied to her, in large part because of her sex.

Nancy Spero
Torture in Chile, 1974
**Gouache and collage on paper,
24¾ x 114in/63 x 290cm
Private collection**
The work consists almost entirely of a written statement on the subject of the title. Spero has said: "From this work on I decided to represent 'man' only through images of women."

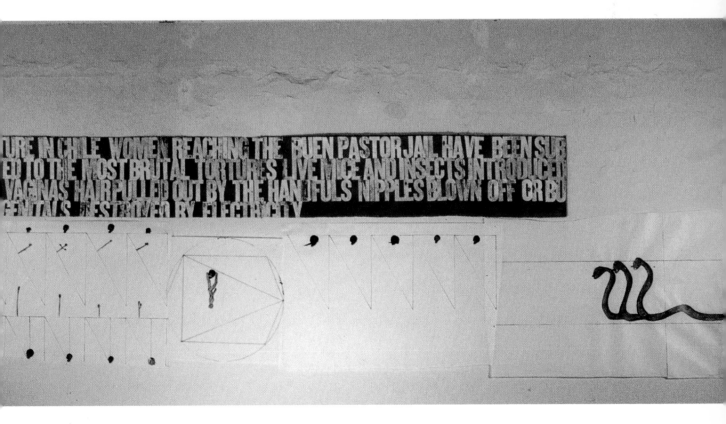

During the decade Schapiro was Judy Chicago's colleague in founding and running the Feminist Art Program at the California Institute of the Arts in Valencia, the first program of its kind. Later she became one of the founders of the school of so-called Pattern Painters, which made a considerable impact on American art towards the end of the 1970s. During this phase she often worked in fabric collage on canvas, having previously been an abstract painter influenced by Abstract Expressionism. Fabric is also a medium which attracted Faith Ringgold, now well-known for sewn, stuffed figures which are also used as props in performances. She and Betye Saar (whose work has already been discussed in Chapter 1) are two of the best-known African American artists now working in the United States, and their careers illustrate how the minority cultures that form the subject-matter of this book interact and connect. The work of May Stevens, and also that of Nancy Spero, is highly political as well as feminist. May Stevens has been influenced by Marxist theory and has made a series of paintings which draws a parallel between the life of her own mother and that of the Communist feminist heroine Rosa Luxemburg.

This first generation has since been succeeded by another, which includes performance artists such as Adrian Piper (born 1948), as well as makers of collages and installations, such as Barbara Kruger (born 1945) and photographers such as Cindy Sherman (born 1954). It may be significant that the most celebrated of these, and probably the most celebrated feminist artist working in the United States, is Sherman, who has replaced Robert Mapplethorpe as the pre-eminent maker of photographic images on the New York art scene. There may be several reasons for this. One is the enormous success of photography itself – the American audience, in particular, now seems to feel more at home with images made by the camera than with those made by more traditional art-making processes, such as painting. Another is her link with film: she made her reputation with a long series of *Untitled Film Stills* in which she herself enacted various roles from imaginary movies which somehow seemed hauntingly familiar; many voiced effective criticisms of the stereotypes which society imposes on women. She followed the film stills with another group of photographs in which she parodied Old Master paintings. One showed her as an extremely unconvincing version of a

Barbara Kruger
Installation, **1991**
Mary Boone Gallery, New York
Kruger takes photomontage techniques invented by the Russian Constructivists (there is a kinship with posters produced by the Shternberg Brothers in the early 1920s), and applies them to a large-scale environmental installation.

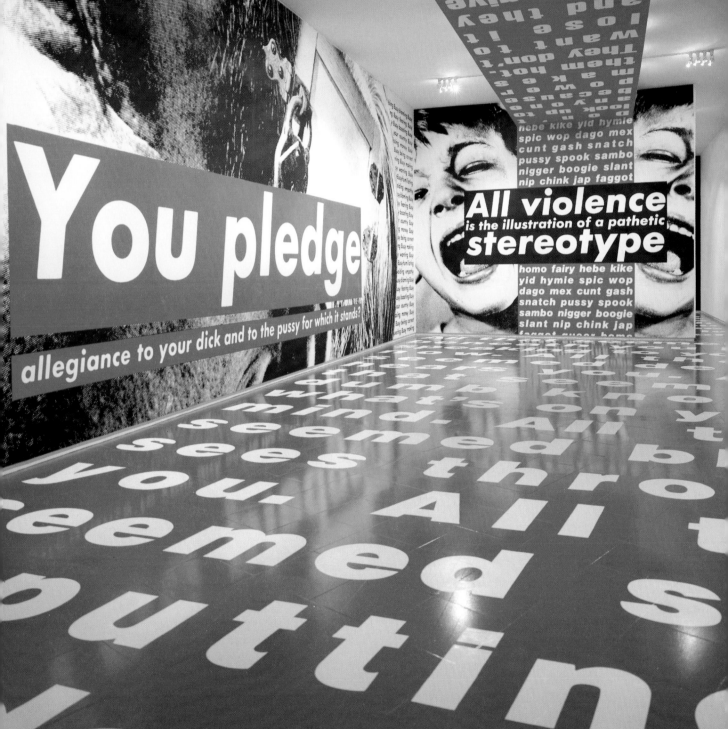

Cindy Sherman
Untitled Film Still, 1979
Photograph, 10 x 8in/25.4 x 20.3cm
An example of the way in which Sherman uses references to Hollywood movies to deconstruct female gender stereotypes. There seems to be an allusion to Marilyn Monroe's "floozie" roles in films such as *Bus Stop* and *Niagara*.

fifteenth-century Netherlandish Virgin, baring her breast to give suck to the child. More recently, Sherman has made a forthright series of images, using body parts borrowed from surgical catalogues, which are a cry of anger against physical violence offered to women. A disturbing aspect of these, perhaps unintended by the artist, is their close resemblance to the bizarre *poupées*, or dolls of his own invention, made in the interwar years by the Polish-French Surrealist Hans Bellmer (1902-75). Bellmer's iconog-

Cindy Sherman
Untitled (No. 264 – Woman with Mask), 1992
Colour photograph, 50 x 75in/
127 x 190.5cm
The Eli Broad Family Foundation,
Santa Monica, California
An assembled composite of body parts which serves as a criticism of male attitudes to female sexuality.

raphy, perhaps the most shockingly erotic produced by the whole Surrealist Movement, conveys a completely opposite message from that of Sherman, but the close kinship between the two sets of images is unmistakeable. With its often pedantic insistence on analysis of society and social situations, feminist art has tended to forget that visual images are by their nature ambiguous, and carry with them a whole penumbra of meanings, some of which may remain unknown to the artist herself.

On occasion, feminist art, like all avant-garde art, is delightfully silly, whether the artist intends it or not. It is hard to keep a straight face, for instance, in the presence of a recent series of sculptures by Helen Chadwick (born 1953). Entitled *Piss Flowers*, these were made by casting the impressions created in snow when the artist and her male partner David Notarius urinated into it. A reviewer in the magazine *Women's Art* solemnly noted the exact circumstances:

Their making involved Chadwick urinating first: physiology determines that a women produces a single, larger hollow or hole in the snow because she squats nearer the ground. The man, on the other hand, urinates from a greater height and has more manipulative control of the stream of urine, forming several more shallow marks. Chadwick art-directed the work so that her partner's urine fell in a circle round hers.

Helen Chadwick
Piss Flowers No. 3, 1992
**Plaster cast, 25 x 25 x 22in/
64 x 64 x 56cm**
A cast made from the negative imprint
created by the artist and her male
partner urinating in the snow.

> *When cast and inverted, the pieces show that the female form looks like a
> penis, with the male's forming a flower's petals round it. This gender-reversal
> produces an androgynous form of great beauty.*[16]

Wish fulfilment or satire? It is a little difficult to tell.

Yet there are also feminist artists who have used the body, and bodily
functions, to give their work a genuinely tragic dimension. The most impres-
sive of these is the Cuban-born Ana Mendieta (1948-85), who owes some
of her posthumous fame to the circumstances surrounding her death. She
fell thirty-two storeys from a New York window; her husband, the Minimal
sculptor Carl André, was accused, but later cleared, of her murder. In a sense,
Mendieta's death seemed a fitting end to an already fated life, spent in exile
both from her homeland and the ruling conventions of the art world. Her
parents sent her to the United States at the age of thirteen in order to allow her
to escape the rigours of the Castro regime; her adolescence was spent in
foster homes. As a young artist, she belonged to a generation which rebelled
against the idea that art was a commodity (very typical of one aspect of artistic
activity in the 1970s): this rebellion was quashed by the great art boom of the
mid-1980s.

However, her feelings on this subject, together with her desire to recover aspects of her Cuban background, led her towards body and performance art. Her use of imagery and her actual materials reflect aspects of the African-derived Santeria religion which also influenced the great Cuban Surrealist painter Wifredo Lam. Unlike the vast majority of other Cuban artists living in exile in the United States, Mendieta was pro-Castro, and this alienated her from the Cuban cultural community, while tending to reinforce her avant-garde credentials in the American art world at large, which perceived her stance as suitably "transgressive".[17] Mendieta's deliberately primitive depictions of the female body, often imprinted directly on the ground and preserved only in photographs, are statements about the fecundity and the essentially female nature of the earth, and in this sense profoundly feminist. In creating images of this type, she achieved effects simultaneously primitive and sophisticated which have prompted not undeserved comparisons with Joseph Beuys. She is certainly the closest that contemporary feminist art has come to producing a genuine shaman.

Feminist art has found it noticeably easier to stay within the accepted boundaries of the avant garde, as opposed to art inspired either by racial considerations or by specialized sexual preferences. This must be due in part to its roots in the conceptual art movement, but it is also something which speaks of a more pressing desire to analyse a situation rather than represent or embody it. In addition, there is actual prejudice against traditional methods of art-making, as Whitney Chadwick notes:

Women involved in painting today often find themselves negotiating a complex territory as they seek to locate themselves within a tradition where they have been historically discriminated against and which has been defined in male terms. Women assuming a position in relation to the art of the past and specifically the tradition of painting, confront numerous assumptions – about the creative process, artistic "style" or methods of applying paint, subject etc.[18]

Nevertheless, the 1980s did witness the emergence of a strong group of women figurative artists, whose work often seemed to carry a freight of feminist meaning. One of the most prominent is the Anglo-Portuguese painter Paula Rego (born 1935). Rego has had a remarkable, indeed exemplary, career. Born in Lisbon to a prosperous middle-class family, she trained at the Slade School of Art in London, where she met her husband Victor Willing. The couple settled in Portugal, then still under the Salazar dictatorship, and Rego's first success was in a Portuguese context. Her first solo show in Lisbon caused a sensation, and in 1969 she was chosen as the Portuguese representative at the XIth São Paulo Bienal.

The direction of her career was changed by two events: her husband's multiple sclerosis, diagnosed in 1967; and the expropriation of the family

Paula Rego
The Cadet and his Sister, 1988
**Acrylic paint on paper laid on
canvas, 84 x 84in/213.4 x
213.4cm**
Private collection
An ambiguous image in which the
apparently subservient figure, the
female, dominates her male
companion.

electronics business in 1975 as a result of the Portuguese Revolution. In 1976 Rego moved to London, though she continued to be thought of as primarily a Portuguese artist. She represented Portugal once again in the São Paulo Bienal of 1976, and in 1978 was prominently represented in the survey show "Portuguese Art since 1910", held at the Royal Academy of Arts in London.

Willing's illness and the move to London led to changes in Rego's work as well as her life. Her paintings had been heavily influenced by Surrealism, cryptic and coded. It now became much more forthright. In particular, she developed an interest in narrative. By the second half of the 1980s she was making ambitious figurative compositions which can be compared both to Hockney's realist phase of the 1970s, and to the art of Balthus. Especially Balthusian is the emphasis on adolescent eroticism, but seen from a feminine point of view. Female protagonists are given a dominant but at the same time ambiguous role. A good example is *The Cadet and his Sister* (1988): an older, powerful-looking girl kneels at the feet of a young boy in uniform, tying up his shoe. Rego has commented about the painting in some detail:

I wanted the young man to be slightly younger than his sister, possibly thirteen and she'd be like fifteen, and she's more knowing than he is and he's depending on her quite a lot. I really can't explain it any more because the whole thing came to me in one go. I very much wanted the avenue going up and disappearing into the distance, a bit like a theatrical backdrop. And the sky is meant to be like a sky from my catechism book. And then the props were very important. Her bag had to be brown like that, and lined in red. I mean it had to be dangerous, as if it could snap shut. Both it and the gloves are like – I suppose it's pretty obvious – but like sex symbols. But opposites. And the cockerel is small and puffed up, and a pretend one, a porcelain one; so it shows he's impotent, the poor cadet.[19]

This was said when the painting was first exhibited. In a further interview, two years later, Rego expanded:

It's about incest. They have just made love. She dresses him. He's going away to do his military service. The cock is his masculinity. The handbag is her femininity. It's a container but it snaps shut. It could castrate him. The gloves have various connotations – a surgeon, a gardener, a butcher. The walls are abrupt and the avenue seems false, like a backdrop. Or if it is real it is a dead end – incest leads nowhere. His future is destroyed. She will control him forever.[20]

Later still, Rego denied ever describing the picture in this way, although the description itself seems plausible.

Rego's art, though it has become more forthright and open in terms of her own development, retains an essential element of ambiguity. This, quite apart from the fact that her work is figurative and makes use of conven-

tional formats, marks it off from the theory-dominated and theory-dictated art which has so much monopolized the attention of feminist art critics.

In this context, another artist of great interest is the American painter Martha Mayer Erlebacher (born 1937). Erlebacher belongs to a group of contemporary American artists who have recently been re-exploring the Old Master heritage in a fashion reminiscent of the way in which leading Post-Modernist architects have re-examined the heritages of Palladio and Neo-Classicism. She paints compositions which echo established models without copying them. *A Man and a Women* (1993) has a number of Old Master references – the male figure, for example, is distantly derived from a drawing by Michelangelo. The composition is not erotic in a conventional sense: its most noticeable feature is the way in which the two nude figures turn away from one another. The male gazes upward – as the artist says, he looks "to the light, to reason, to Apollo, to the sun".[21] The female looks frankly, and perhaps with a trace of wryness, at the spectator. What she holds is a branch of the apple tree, the tree of (sexual) knowledge. Had it been painted by a man, the composition would no doubt have been perceived by many feminists as politically "incorrect". The forthright, full-frontal treatment of the female nude would distress them particularly, and might even be construed as an invitation to rape. The arguments for taking this attitude become rather convoluted when it is known that the painting is the work of a woman.

A Man and a Woman can be interpreted in a different sense altogether. If we look back at Germaine Greer's *The Obstacle Race*, and more recently at Whitney Chadwick's *Women, Art and Society*, we see that it was precisely weakness in drawing and painting the nude which seemed to debar women artists from any possibility of a position in the first rank. Erlebacher's accomplished rendering of nude figures, the almost icy skill with which she presents them, are therefore acts of feminist recuperation. By insisting on her right to tackle this kind of subject matter, she opens a serious fissure in feminist theory. Her assault is more serious than that mounted by Sylvia Sleigh's reversal of well-known compositions, substituting nude males for nude females, noticed at the beginning of this chapter. First, Erlebacher is as ready to paint the female as the male. Second, her figures do not lack physical density and substance. Erlebacher herself has said:

… subject is at the core of the latest art, in particular … race, sex and gender. I believe most of this art is generated by reactions to the social phenomena making headlines in the media, i.e. sexual abuse, the women's liberation movement, the AIDS phenomena, sexual harassment and aggression, child abuse, elderly abuse, racial discrimination, etc., and is born out of the widely held belief that all art is in some way a political statement.

I feel issues of sex and gender have always been at the core of art, along with all of the other profound concerns of human beings (to name a few –

Martha Mayer Erlebacher
***A Man and a Woman*, 1993**
Oil on linen, 72 x 54in/182.8 x 137.1cm
Private collection
In this post-Modern work a female artist rehandles a theme long established in Western art – Adam and Eve, either just before or just after the Fall. In this version the female is noticeably stronger and more self-confident than her companion.

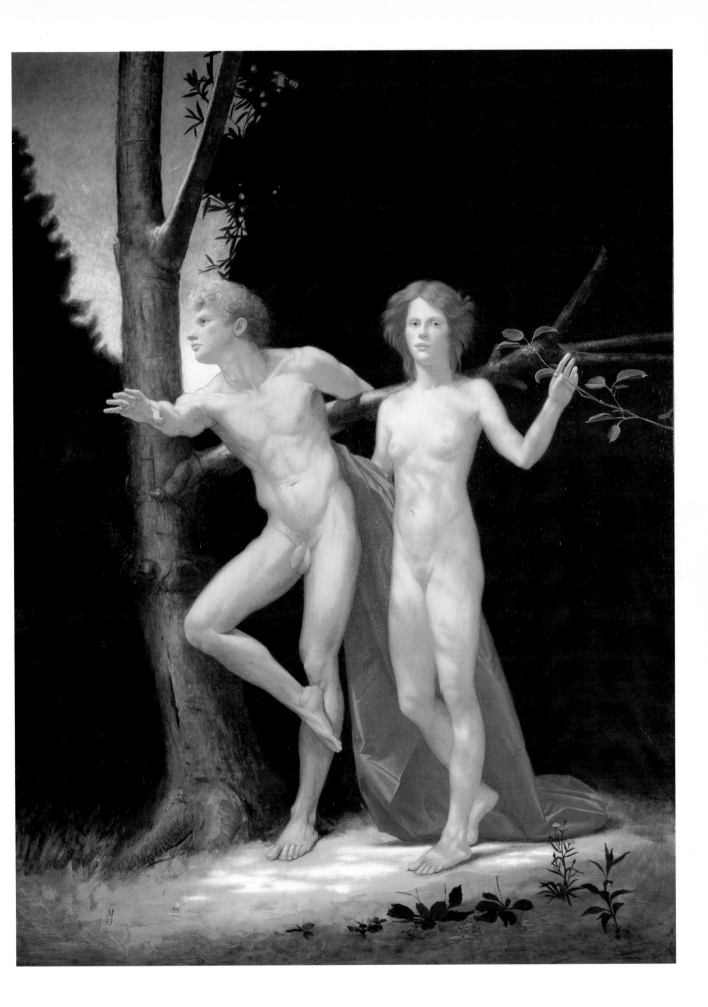

procreation, growth, aggression, hunger, ageing, fear, death, etc.). I argue that the eternal question What is Art? can be answered in this way – Art is the greatest possible rationalization of our deepest fears, joys, and instincts as human beings. Beautiful nudes make it possible for us to contemplate our sexuality in safety.[22]

The committed feminist might be tempted to dismiss Erlebacher's work, and even that of Rego, as aberrant and wrong-headed, a fresh surrender to the entrenched patriarchal expectations of the contemporary art world, and indeed of society at large; and also a surrender to commercial expectations, the pressure to make work which will and can be sold. Yet one of the problems of contemporary feminist art has been its divorce from standard commercial structures. It is characteristically seen in public spaces, and appears much more rarely in commercial ones. The collapse of the 1980s art boom and the return to prominence of publicly funded art (a pattern visible during previous economic downturns, as well as in the severe recession of the late 1980s and early 1990s) have not brought concomitant economic success to kinds of art the boom itself did not affect. Feminists see this as closely related to the generally disadvantageous situation of women in a modern industrial society. Questioned about this, Judy Chicago said, with typical forthrightness: "Not being able to enter the cultural commodity pool as a market is one of the things that makes us disenfranchised."[23]

Yet there are other aspects. Feminism demands a place in the sun for feminist art, but has been determined to create this on its own terms – some would say, without sacrifice of principle. Its characteristic hostility to the idea of phallocratic hierarchies – which in this case include traditional modes of aesthetic judgement whereby a work of art tends to be rated as either "better" or "worse" than others which serve as points of comparison – has created a curious situation. Discussions of feminist art, mostly conducted by those who are committed feminists, go in two apparently opposite directions. First, there are non-judgemental surveys, where the reader or auditor is supplied with long lists of participating artists, without much distinction being made between them in terms of interest or importance. Second, there are theoretical discussions of what feminist art is or should be, which tend to stick to the enunciation of broad principles, without giving specific examples.

The result is that feminism is widely influential in curatorial circles (many curators are now women) but has been much less successful in reaching the general art public. This assertion is supported by the computer index to 200 art periodicals, from December 1984 onwards, available in the Victoria & Albert Museum Library, which offers fewer than 200 references to feminism and feminist art. The exact number is difficult to ascertain as the topics overlap. During the same period the index cites no fewer than 182 references to a single male artist, David Hockney.

Is this imbalance due solely to ingrained prejudice? Another way of checking is to look through the index for names of artists cited in a feminist context in recent histories and dictionaries of women's art. Here the yield is quite large, but frequency of mention is low.[24] On average a "known" feminist could expect to be mentioned around 20 times in the course of eight years; and to have her work illustrated perhaps twice. Most of these references are brief citations, rather than a full discussion or exhibition review. The situation for successful male artists is very different. Hockney, as has already been said, appears 182 times, with 100 illustrations; Francesco Clemente 113 times, with 40 illustrations; Jeff Koons 91 times, with 15 illustrations; Julian Schnabel 89 times, with 27 illustrations; David Salle 83 times, with 20 illustrations. The only feminist-identified artist to enjoy anything like this level of public recognition is Cindy Sherman, cited on 86 occasions.

It should be added that the list of periodicals used as the basis for the index probably favours feminist expression rather than putting it at a disadvantage. In addition to magazines which routinely cover the whole of the avant-garde art scene, such as *Artforum*, *Flash Art International* and *New Art Examiner*, it includes specifically feminist publications such as *Women's Art News*, radical ones such as *Afterimage*, and those which cover areas now regarded as feminist specialities, such as *High Performance*, which reports on performance art.

The impression given by research into the index is that coverage of feminist art is sometimes unfocused because of rules laid down by feminists themselves. This art has been disadvantaged in other ways as well, which have nothing to do with prejudice against women. Video and performance – chosen, as Whitney Chadwick suggests, because they do not carry the burden of the past – are not media which communicate efficiently in the official museum spaces which are now beginning to welcome feminist expression. Performance pays for its spontaneity with ephemerality – all that remains, after the performance is finished, are photographs, perhaps a rough video record, and a few, necessarily subjective, written accounts, where what has happened is filtered through the consciousness of another individual. Outsiders cannot be blamed if they take away the impression that such performances, however therapeutic to participants, or to spectators with a background in feminism, are for others like the rituals of an esoteric religion. If much feminist art remains in a minority category this may be quite largely a matter of choice.

9 Aboriginal and Maori Art

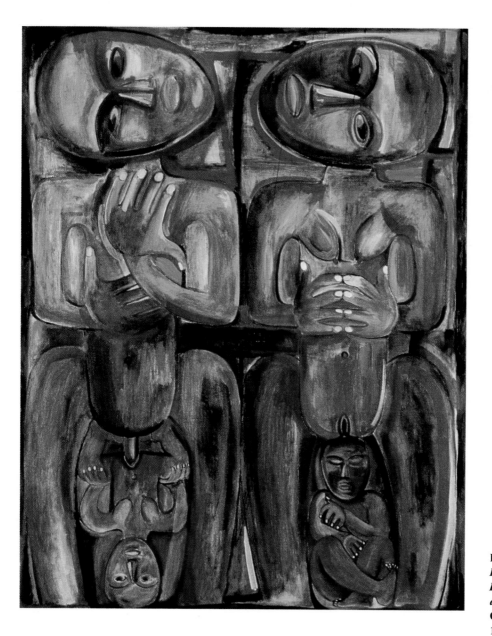

Robyn Kahukiwa
He purapura i ruia mai i
Rangiatea (The seeds scattered
abroad from Rangiatea), 1985
Oil on canvas, 52¾ x 40½in/
133.9 x 102.7cm
National Art Gallery, Wellington,
New Zealand

The success of the art of Africa in Europe, which coincided with and was abetted by the rise of Modernism, has already received attention here. At first sight, the more recent success of Australian Aboriginal art outside Australia would seem to offer an almost exactly similar case; in fact, this is not so, and the differences are illuminating.

Aboriginal art is usually approached via its subject matter, largely the Dreamings which are said to be owned by Aboriginal tribesmen. These Dreamings were first widely publicized, not through scientific and anthropological publications, but through the use made of them in a successful novel, Bruce Chatwin's *The Songlines* (1987). Chatwin, an antiquarian and a remarkable traveller–writer as well as a novelist, had throughout his adult life ben fascinated by the subject of nomads and nomadism. *The Songlines*, written when he already knew that he was fatally ill, is a romantic summary of his feelings on the subject. Into it he poured ideas inspired not only by the intermittent research he had done and the scholarly material at his disposal, but by his own life-long wanderlust. The result was an amalgam of subjective and objective elements which for the first time made inherently difficult material available to a wide public. Deservedly, the book became a best-seller.

Dreamings are simultaneously property and myth. They are myth in the sense that they encapsulate stories about ancestral beings. Some of these stories relate to particular places; others are connective, and link several places or regions, often separated by considerable distances. In this sense, in addition to being narratives, they also have the characteristics of a chart or map. Yet they are more even than that: they offer social and moral injunctions, and are present both in the land itself and within particular individuals. They are brought from the passive to the active state through the use of ritual, in which artistic activity plays an important part.

The use and ownership of Dreamings are regulated by the position of an individual within a kinship group, and also by his situation as a member of one or another moiety – the complementary halves into which the universe itself, and those who dwell in it, are divided. His kinship status dictates what subject, what Dreaming, the Aboriginal artist has a right to depict. He can only work in cooperation with members of the opposite moiety, who have their own, but secondary, rights in the same Dreaming. Primary rights are almost invariably derived from patrilineal inheritance, secondary rights are matrilineal. While it is the patrilineally descended owners who must give permission for a particular Dreaming to be used, it is generally matrilineal descendants who do the work.

Aboriginal art in its traditional guise takes a number of forms – these include rock-carving, ephemeral sand paintings made in connection with particular ceremonies, and paintings on bark. Examples of Aboriginal work had already found their way into the museums and private collections of

Europe and the United States long before enthusiasm for Aboriginal painting, as we now know it, took root.

The new movement in Aboriginal art did not begin until the 1970s. Both the date and the place can be precisely located: the first impulse came at Papunya, in 1971. Papunya was an Australian outback settlement established ten years earlier as part of the assimilation policy then being pursued by the Australian government, which wished to persuade, or force, Aboriginals to abandon the remnants of their old semi-nomadic life for one in fixed settlements. The first "modern" Aboriginal painting was a mural using traditional designs related to the Honey Ant Dreaming, painted on the walls of the local school at the suggestion of a non-Aboriginal art teacher, Geoffrey Bardon.

The making of murals encouraged members of the Papunya community to think of painting independently; Bardon provided the original supply of materials – synthetic paints and artists' boards. Within three years, when it was found that there was a market for Papunya work, the artists moved to working on canvas rather than on boards, making it possible to increase the scale of the designs. A major reason for the change to canvas mirrors the move to oil paint on canvas which took place in European art at the beginning of the sixteenth century: when art became a commodity which could be traded over long distances, it was more convenient to have it in a form where it could be rolled and easily packaged for transport. Aboriginal artists, trading first with the great coastal cities on the Australian seaboard, and then with galleries outside Australia, were following the example of Titian, when he became a supplier to the Emperor Charles V, then to Philip II of Spain marooned in the distant Escorial.

The actual designs in Papunya painting were, however, a result of local considerations. Their typical all-overness, which seemed to chime with the all-overness of much North American and European art, was dictated by the fact that the artists tended to paint surfaces placed flat upon the ground in imitation of the traditional ritual paintings made with sand and earth. Their method was thus, though only by coincidence, very much like that used by the leading Abstract Expressionist Jackson Pollock, who used the canvas as a "place" or arena, rather than positioning it on an easel in the conventional way. It has been surmised that Pollock may have been inspired by the Navajo sand-paintings which he saw as a young man.

While the earliest Papunya work sometimes included representations of human figures, as well as of objects such as shields, spears and axes, these naturalistic details were soon abandoned, for two reasons. First, in traditional Aboriginal terms the designs painted upon an object made it as easily recognizable as a representation of the object itself. Second, Dreamings were of a sacred and secret nature. When the artists realized the extent to which their work would now be available to outsiders, they moved to protect these secrets by reducing the narrative to an abstract code. One feature of this new

Tim Leura Tjapaltjarri
Wild Potato Bush (Yam)
Dreaming, 1972
Poster paint and PVA on board,
$27\frac{1}{8}$ x $23\frac{1}{2}$in/69 x 60cm
An example of Papunya painting in its
earliest phase.

abstract style was an elaborate use of dots. These have been interpreted in a bewildering number of ways – as feathers or bird's down, as an imitation of woven fibres, and as an echo of the technique used to make paintings in earth or sand.

The movement which began at Papunya gradually extended to other Aboriginal settlements in the outback, each of which has its own style. At the settlement of Yuendumu, associated with the Walpiri tribe, it was again a project connected with the local school which first developed the impulse to paint. The headmaster there encouraged a group of men to paint the doors of the school with the major Dreamings associated with the area. Artists at Yuendumu, having started later than those at Papunya, were better informed about the way in which the art market operated. Their paintings were from the first presented in a coded form, which makes one level of information available to outsiders while reserving another, more complex, one for those with a deeper knowledge of Aboriginal culture.

One consequence of the growth of the new Aboriginal art movement during the 1980s was that women began to take part. Their participation was undoubtedly linked to the feminist upsurge which had begun to affect white Australian society in the same way that it affected society in the United States. In part, women's art was dependent on the emergence of a new feminist anthropology. To quote Henrietta Fourmile, a teacher and scholar of Aboriginal origin:

Aboriginal women's traditional status as equals, maintaining autonomous and complementary roles with their menfolk . . . was not properly acknowledged until the sixties and seventies when female anthropologists began to correct the distorted views of their male counterparts.[1]

The acknowledgement did not begin to take practical effect until the mid-1980s, when white female co-workers started to encourage and facilitate the production of art by Aboriginal women, following the pattern already established earlier by men working with men. Of particular help was the fact that, in certain Aboriginal communities, the production of paintings was already equated with the production of craft: that is, the two activities were structured in such a way that producers saw little distinction between them, even if one existed in the minds of consumers.

Art and craft, in a female context, were also assimilated in a more direct fashion. In the small outstations that now occupied lands which had once formed part of the Utopia cattle station north east of Alice Springs, Aboriginal women were introduced, once again by outsiders, first to woodblock printing on fabric, then to batik. A Utopia women's batik group was formed in 1978. The designs produced were often based on the body painting designs, *awelye*, reserved by custom for the use of women but, despite the difference in technique, the end product was very little removed from the paintings

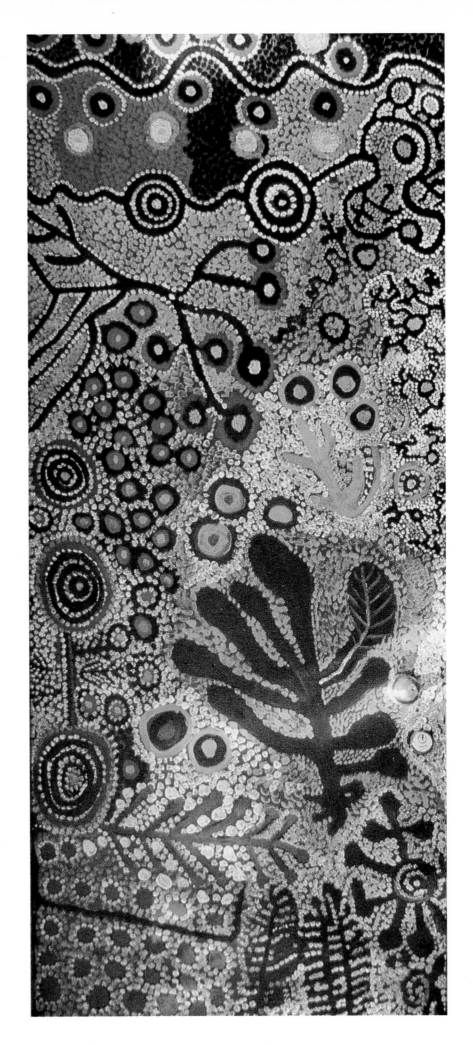

Paddy Japaljirri Stewart
Yam and Bush Tomato
Dreaming, 1983
Synthetic polymer on wood
Schoolhouse door from the settlement
at Yuendumu, associated with the
Walpiri tribe.

Eunice Napangardi
Bush Banana Dreaming, 1992
**Acrylic on canvas, 33 x 52¼in/
84 x 133cm**
An example of fully developed
Aboriginal painting from Papunya;
significantly, the work of a woman.

made by men. It is sometimes said, however, that the paintings of Aboriginal women tend to be more innovative than those made by men, perhaps because the women are less tightly bound by ancestral custom.

Although the rise of Australian Aboriginal art, in its new form, has occupied only two decades, the phenomenon has already been celebrated in a number of books and has been the subject of scores of exhibitions. Despite this widespread success, few searching questions have been asked about how it functions, such as whether the art is situated within Aboriginal communities, or in the world outside.

For the artists, the paintings have provided an important economic resource, a lifeline to groups of people who had previously been forced to lead extremely deprived existences. In particular, they have provided the means to purchase capital goods formerly outside the reach of members of outback settlements, notably automobiles. Though the impulse to make art seems to have sprung, in almost every case, from the prompting of non-Aboriginal outsiders, the paintings have been an important means of self-recognition and a source of racial and community pride – although also, sometimes, a source of anxiety about revealing tribal secrets to a non-tribal audience. In a political sense, the rise of the Aboriginal art movement can be linked, though not always directly, to the successful Aboriginal land claims of the same period. A turning point was the great demonstration held in 1972 outside the federal parliament building in Canberra.

Once they are made, however, the paintings are not used or seen in an Aboriginal context. The commodification of Aboriginal art, and its departure from the community, echoes the fate of traditional Aboriginal artefacts, already coveted by museums and collectors worldwide. The situation has recently aroused fierce criticism amongst Australian intellectuals. Henrietta Fourmile has this to say in her essay, originally written for the Art Gallery of New South Wales, Sydney, and later reprinted in the catalogue of the international touring exhibition *Aratjara: Art of the First Australians*:

Many of these [Aboriginal] communities have no representative collections of their own artistic heritage, a fundamental source of inspiration and identity. What remains is now mostly located in the state museums, thousands of kilometres away from the communities in which such items and symbols originated. The situation in itself constitutes a massive breach of our cultural rights as expressed in many international human rights instruments, and has led to many artists growing up without knowledge of their own tribal heritage, their birthright.[2]

She expands further upon this theme:

Museums, which once acted as agents of protection for Aboriginal cultural heritage, must now be seen as agents of destruction by withholding cultural property and resources from our communities.[3]

Various artists
Dreamings, 1904-5
Group of *toas*
South Australian Museum,
Adelaide

Even if what is said here applies primarily to objects made before modern Aboriginal painting existed, it may soon be extended to more recent work, as this becomes increasingly a source of racial and national pride as well as a source of income. Effectively, therefore, a nascent conflict exists between the notion of Aboriginal painting as a communication addressed to outsiders, which is certainly how the movement began, and the notion of this art functioning as a means of self-recognition for the community itself. Given both the geography and demography of Australia, with small Aboriginal settlements scattered in the outback but the bulk of the population concentrated in large coastal cities, it is difficult to see any successful solution to this. The outback settlements continue to need, perhaps more than ever, the economic support that Aboriginal art provides.

Meanwhile the welcome given to this art in the great Australian cities, and also in Europe and North America, is something which springs from complex roots. Being apparently abstract (with specific meanings deliberately concealed), these paintings fit well into an existing context which has nothing to do with their own origins: they can be assimilated to Modernism even though there is no real link with the development of the

Modern Movement. Their esoteric side – not entirely intractable, since it is known that they refer to mythologies and ideas about the land and man's relationship to it – means that they are easily sacralized; more easily than most Chicano art, for instance. They fit particularly comfortably into the idea of the museum as a sacred space. In addition to all this, they offer an assuagement for liberal guilt about the way in which Aboriginal people have been treated in the past.

Yet there does remain a question mark about the real depth of the relationship of this art with Aboriginal culture. Whether or not it is an artificial product, a projection of white needs and fantasies which has met an opportunistic response, is an issue that will not entirely go away. There is a precedent. In the early years of the twentieth century some Australian Aborigines produced another kind of desert art intended for sale. These were *toas*, small assembled sculptures made of wood and other natural materials. *Toas* were created for only a brief period, and at one spot – the Lutheran Mission at Killapaninna, near Lake Eyre in South Australia, between 1903 and 1905. The missionary in charge, Pastor Johann Reuther, wanted to build up a collection of Aboriginal artefacts in order to raise funds. Tellingly enough, production

Ada Bird Petyarre
***Women's Dreaming*, 1992**
Acrylic on canvas, 23³⁄₄ x 82³⁄₄in/60.5 x 210cm
This example demonstrates the apparent correspondence between Aboriginal painting and Western abstraction, although the significance of the designs is quite different.

ceased when he left his post in 1906, by which time about four hundred had been made. In 1907 the whole collection was sold to the South Australian Museum, Adelaide.

Toas, which use many of the same symbolisms as now appear in Australian Aboriginal painting, now seem to be a subject of confusion, and indeed embarrassment, to specialists. In his recent book on the subject, Wally Caruana, Curator of Aboriginal Art at the National Gallery of Australia, Canberra, offers the following verdict:

The popular belief that Aboriginal culture was static encouraged the view that the toas *were a traditional form of sculpture. The Diyari themselves described them as direction-markers or signposts that were left at abandoned camps to inform the next visitors of the ancestral nature of the landscape, or to indicate where the previous party had gone. However, it appears that the* toas *were purely innovative works with no recorded antecedent in traditional life, although they embody a prevailing system of iconography and meaning.*[4]

One significant aspect of the reception given to Australian Aboriginal art is that until recently very little attention has been focused on art produced, not by Aborigines working in the outback, but by those living in great Australian cities. Though urbanized Aborigines are often despised, certainly within Australia itself, as a race of detribalized half-breeds, the cities do in fact house a very significant proportion of all people with Aboriginal blood. This is not surprising, as they also house so large a proportion of the Australian population as a whole.

Urban Aboriginal artists are, of course, much more fully exposed to all aspects of the European heritage. Some have been through a conventional art school curriculum. However, they are also keenly aware, thanks to the stresses placed on them by their immediate environment, of their loss of heritage. The result is art which is much more directly politicized and which, while it is now beginning to attract attention within Australia, has so far had little international appeal. In many respects it resembles Chicano art – it is militant, direct, angry and little concerned with niceties of style.

Curiously, Aboriginal art from Australia is seldom discussed in conjunction with contemporary Maori art from New Zealand. The parallels between the two cultural situations, and their divergences, are of some interest. Maori tribal structure has remained more coherent than that of the Australian Aborigines, both because the Maori had a more developed culture when they first came into contact with Europeans, and because they were less nomadic. In addition, though they are still a minority of the total population of New Zealand, the Maori are a much larger minority. Land claims have been easier to pursue thanks to the provisions contained in the Treaty of Waitangi (1840), which is still the fundamental document governing *pakeha* (white) and Maori relationships.

Nga Hau E Wha National Merae (meeting house), Christchurch, New Zealand

Ralph Hotere
**From *The Black over the Gold*
series, 1993**
**Paint and gold leaf on glass, in
wooden window frame**
A fully Modernist work by a leading New
Zealand artist of Maori origin.

The traditional Maori art form is carving rather than painting. Elaborate carved ornaments were made both for the small structures used for storage and for the immense *wakas* or ceremonial canoes which were the foci of tribal identity. In the modern, post-contact period, however, the focus has gradually shifted from the *waka* to the *merae* or meeting house. *Meraes*, which combine a sacred with a social function, are now the chief vehicle for Maori carving. The main consumers of art, certainly in its traditional guise, therefore remain the Maori themselves, though art and craft centres, such as the carving school at Rotorua, also make copies of old work for sale to collectors and tourists.

Shane Cotton
***Metrocharts III*, 1992**
Oil and encaustic on plywood
Brooke-Giffend Gallery,
Christchurch, New Zealand
Contemporary Maori art influenced
both by the Modern Movement and by
traditional symbolisms.

Kura Rewiri-Thorsen
Cast No Shadows
Acrylic on unstretched canvas
Museum of New Zealand/Te Papa
Tongarewa, Wellington

Lyonel Grant
Figure, 1993
Bronze, height 3in/7.8cm
Grant is of Maori origin and trained as
a traditional Maori carver, but also
makes Modernist works, including this
miniature figure.

Whereas there is now a voracious market for modern Australian Aboriginal art, the same conditions do not exist for traditional Maori work. One reason is that there exists in Maori society a strong inhibition, amounting almost to a formal taboo, against accepting payment for artwork. A work of art, and also a fine work of craft (no real distinction is made between the two) should change hands only as a gift. In traditional terms, an artwork which has been exchanged directly for money loses its inner virtue, and the transaction shames the maker.

Traditional Maori arts in New Zealand are now being challenged by the emergence of "modern" Maori work, particularly painting, which does not represent a traditional Maori skill and is therefore much freer from the taboos and inhibitions which surround the making of sculpture. Since Maori enjoy a much greater degree of social equality in New Zealand than people of Aboriginal origin usually possess in Australia, pupils of Maori origin frequently go through the normal processes of art education in New Zealand's well-equipped polytechnics, and emerge ready to make artistic careers for themselves on the same basis as *pakeha* (white) compatriots. It is students of this type who are providing a new generation of Maori painters.

Their work is based on two principles: the wish to produce art which is visibly contemporary, and the sometimes conflicting desire to maintain a foothold in traditional New Zealand culture. Rapidly assimilated into the mainstream of New Zealand art, and finding role models in a handful of senior artists of Maori descent, chief among them Ralph Hotere (born 1931), this generation does not see itself as occupying a typical minority situation. The sculptor Lyonel Grant, for example, trained in the carving school at Rotorua, which is a focus for traditional craft skills, but produces work in both traditional and Modernist modes. His most ambitious "traditional" product is a full-scale *waka,* or ceremonial canoe, made for the use of his own tribal group, with which he maintains close ties. Shane Cotton (born 1964) likes to endow forms derived from science and biology textbooks with the kind of coded representation of natural forms found in Maori art. "I like to give the viewer enough to look at," he says, "but not enough to pin it down, so they can revisit it again and again."[5]

Sometimes the Maori references are more obvious than they are in Cotton's work. In *Cast No Shadows,* by Kura Rewiri-Thorsen, one of the best known of the younger generation of Maori artists, the three figures depicted are directly reminiscent of traditional representations, but still not imitative. It is also important that these images are transferred to the non-traditional medium of acrylic on canvas, and thus enter the European sphere. The transference, however, is a more sophisticated and transformative kind than one finds in Australian Aboriginal art.

10 Modern Africa and Asia

S.J. Akpan
Portrait of a Seated Chief, 1989
**Cement and acrylic paint, height
5ft 8¼in/1.73m
Collection Musée d'Art
Contemporain, Lyons**
An elaborate example of modern,
naturalistic African sculpture in cement
by a Nigerian artist.

The United States and Western Europe are increasingly interested in modern African art, as evidenced by survey exhibitions such as *Africa Explores: 20th Century African Art*, seen in New York in 1988: and *Africa Now*, a touring exhibition drawn from the Jean Pignozzi Collection, seen in Las Palmas, Groningen, Holland, and Mexico City in 1991-2. These events, though showing a greater respect for the "Post-Classical" period of art in Africa, nevertheless continue to be a view of the material seen through European eyes. There is a feeling that, in the United States at least, they are yet another sop to the cult of "politically correct". Yet, despite the new availability of the material, few comparisons are made between art from modern Africa and African American work – perhaps because they are in many respects remarkably unalike.

A substantial amount of contemporary African art is political, but only a small segment qualifies as art with genuine minority status, even if one uses the word "minority" in a rather loose way. The most obvious example is the art made by South African blacks, and especially art directly engaged in the struggle against apartheid. Even here, one must enter a caveat. In a collection of images such as that presented in Sue Williamson's *Resistance Art in South Africa* (1989), it is immediately striking that the majority of the overtly political works included are by white artists who are sympathisers with the black cause. This alone tells us something about the true bitterness of the South African situation.

A few African artists have succeeded in using their art to make political points and at the same time to transcend the political. One, who spent much of his career within the South African orbit, although not himself South African, is the print-maker John Muafangejo (1943-87), born in Angola but now regarded as the national artist of the new nation of Namibia. Muafangejo's connection with the situation in South Africa sprang from his upbringing in the former South African protectorate of South West Africa, which was treated as an integral part of the ruling country, and also from his time at the mission-run Art and Craft School at Rorke's Drift in Natal. From its foundation in 1962 until the closure of the fine art section in 1982 this was one of the very few places in South Africa where a black person could receive any kind of artistic education.

Muafangejo was not a militant, and sometimes protested to interviewers that he was "not a political artist".[1] Some of his prints – he worked chiefly in linocut, a typical mission-taught medium favoured both for its cheapness and its simplicity – are, however, directly concerned with the events of the day: war in Ovamboland, deportations from South West Africa of leading figures in the Anglican Church, to which Muafangejo belonged. He also had a shrewd eye for white condescension: a hilarious early print entitled *An interview of Cape Town University in 1971* shows the diffident artist confronted with the full panoply of academic self-satisfaction. Muafangejo's most constant themes,

however, are religion – he took great comfort from the faith instilled by the missionaries who were responsible for educating him and allowing his talent to flower – and his own deep personal loneliness. The latter is heartrendingly evident in the print *Lonely Man, Man of Man* (1974), which vividly sums up his sense of cultural isolation.

The main theme in modern African art is not politics, nor the consciousness of being in a minority or pseudo-minority situation. It is the dialogue with the world outside Africa and the vast changes which the twentieth century has brought to traditional African life. Artworks deal with all those matters which are most likely to bewilder supporters of a tradition of classical African art, and to confuse minority groups in fully developed societies who are looking hopefully for African roots.

Though traditional African art has continued to exercise an influence in some regions of Africa, chiefly for nationalistic reasons, there are other in-

fluences whose impact has been even more powerful. The Christian missions exercised a decisive effect on Muafangejo's career, for one. These missions belong to a wide spectrum of different denominations: Catholics, Anglicans, Lutherans and other Protestants have all encouraged the making of art in Africa and, as a result, much of the strongest and most effective recent work has Christian themes. There are, in addition, influential secular institutions of higher education, which follow the European model. One is the art department of the University of Science and Technology in Kumasi, Ghana, founded (on a different site) as long ago as 1936.

All educational facilities, both mission-run and secular, have suffered heavily in the wars and civil disturbances which have filled the history of post-colonial Africa. Jan Hoet, director of Documenta IX, wrote eloquently about the situation he found in Zaire, Tanzania, Zambia and other countries which he visited in search of new artists for the great survey exhibition in Kassel:

John Muafangejo
Shiyane Home, 1969
Linocut, 21³⁄₄ x 33¹⁄₂in/55.3 x 85.3cm
Also known as *The Old People's Home*, this is one of the earliest examples of Muafangejo's mature style.

John Muafangejo
Lonely Man, Man of Man, 1974
Linocut, 18³⁄₄ x 17¹⁄₂in/47.9 x 44.4cm
A poignant autobiographical image recording the artist's feelings of isolation.

In the empty academies, even the windows have vanished. Smashed during coups or by time. I could see from the broken remains of the tables that had once been used for drawing and sculpture that they had once been academies. But there were no students, no professors, not even a secretariat. When I saw those shattered doors, the collapsed ceilings and the countless tokens left by torrential rainstorms I realized there was nothing here to suggest that anything might change in the near future. There I was, looking for art beyond any infrastructure.[2]

Hoet was also dismayed by the absence of anything resembling the European and North American art worlds to which he was accustomed:

I did not find any houses of the well-to-do containing contemporary art. Nor any press providing artistic and cultural information.[3]

It is other powerful influences which have seen that modern African art has survived the effects of war and revolution. One, usually deplored by European critics, is the tourist trade. There continues to be an immense production of souvenir art in contemporary Africa, sold to visitors, usually Europeans, and also exported in large quantities. One peculiarity of the trade is that the dealers who control it often do not come from the same tribal groups as the producers but from the tribes which traditionally control commerce of all kinds. Both the Hausa of West Africa and the Wakemba of Kenya can be found trading in the Central African republic of Zaire.

While much of this souvenir art consists of spiritless copies of traditional artefacts, and much more of ugly trash, the trade has also been responsible for the production of original works. Perhaps the most interesting carvings in the souvenir category are those made by the Makonde carvers who have moved to the outskirts of Dar-es-Salaam from their traditional locations in north-western Mozambique and south-eastern Tanzania. These sculptures, made of ebony, are fantastic representations of sorcerers and spirit beings, often with deliberately misplaced limbs and other quasi-Surrealist distortions. Despite the fact that the style is now successful and widespread, no authority on modern African art provides a convincing explanation for the unique nature of Makonde work. Interpretations range from the speculative (it has been suggested, without solid supporting evidence, that the carvers make use of consciousness-altering drugs) to the mundane – one suggestion being simply that the more fantastic carvings sell better.

The Makonde phenomenon is fascinating because it points to an unsettling characteristic of the new African art regarded as a whole. Rather than being involved in the mystical and ritual aspects of Africa, which is what European critics and African American idealists might prefer, many of its deepest roots are in commerce. Some of the most vital work currently emerging from African countries, especially from those of francophone Africa, con-

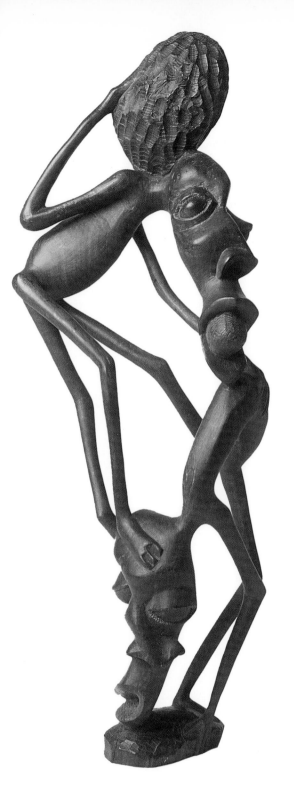

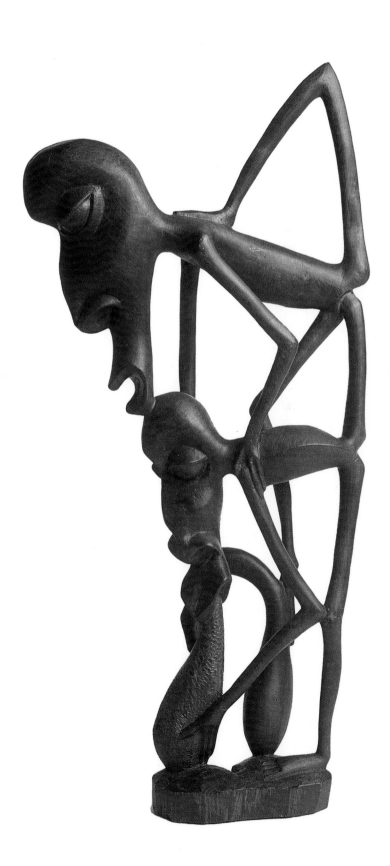

Makonde carvings
African blackwood
These are so-called *shetani* ("spirit")
carvings of typically fantastic and
asymmetrical form. Though the
carvings are produced for purely
commercial reasons as goods for sale to
European and American collectors, they
are among the most imaginative
products of modern African art. The
shetani style first appeared in the
1950s.

sist of narrative paintings, often equipped with speech balloons and other inscriptions, and full of irreverent humour. In the western world one of the best-known makers of these is the Zairean artist Chéri Samba (born 1956), who has had a number of prestigious solo shows in Europe and the United States, as well as making regular appearances in anthropological exhibitions, such as *Africa Explores* and *Les Magiciens de la Terre*.

Samba's background did not include a stint at a mission-run art school. After he left his native village in Lower Zaire for the capital Kinshasa, he worked for several months in a studio specializing in signboards, then set up in business on his own account painting signs and advertisements, and also working as a cartoonist. In her essay "About the Here and Now" in the book which accompanied *Africa Explores*, the curator Susan Vogel notes what is in any case obvious:

The affinities between Chéri Samba's art and certain traits of current western avant-garde painting have nothing to do with the influence of western art. Rather, both he and certain western artists, quite independently of each other, have drawn upon popular "low art" images, and these similar sources have resulted in parallel forms.[4]

However, there is something important which Vogel does not add – in the culture Chéri Samba comes from, the distinction between "low art" and "high art" is not a meaningful one. It is only made in the west, or in places where western influence is strong. Pop artists use commercial forms self-consciously; Samba and other artists like him regard the transition from an advertising sign or a strip cartoon to an "independent" work of art as a completely natural process. There is no identifiable moment at which the product, the painting or drawing, ceases to be the one and becomes the other.

Even when one turns to apparently religious or mystical work from a modern African context – especially when this work is not Christian – one finds that this too tends to have commercial roots, or at any rate roots in the mechanisms of contemporary African trade. One explanation for the cult of the Mamy Wata (Mother Water), now widespread throughout Africa though unknown to traditional African religion, is that this mermaid-like being, a goddess of love and wealth, was originally inspired by Hindu bazaar oleographs seen pinned up in the shops of the Indian traders who still abound throughout the continent.

Other explanations have also been offered, amid arguments about the precise date when the Mamy Wata appeared in the African pantheon. In West Africa the cult is said to have been known before 1920. In Zaire it did not manifest itself until the 1960s, through the intermediary of West African rather than Indian traders. It has also been suggested that the real origin of the goddess and the cult surrounding her is not Hindu but purely western:

Chéri Samba
The Art of Do-Nothings, 1990
Acrylic on canvas, 21 x 24½in/
53.3 x 62.2cm
A typical work, simultaneously
moralistic and satiric. The main figure
is entwined in vegetation, which
indicates his disinclination to move.
The French inscription at the bottom
reads: "The art of do-nothings is to
hold out their hands all the time while
formulating ridiculous criticisms of
those to whom experience remains the
only visible proof."

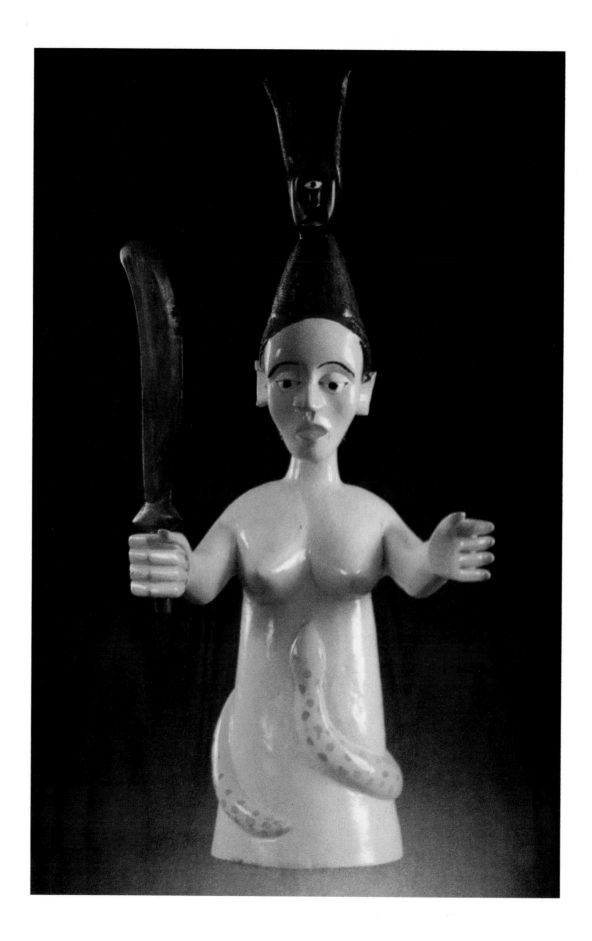

Agbah Kossi
Mamy Wata Figure, 1990
Painted wood, 37 x 16½ x 13in/
94 x 42 x 33cm

The Mamy Wata, focus of a new African cult, is a water goddess who brings sexual and financial success to devotees. This representation bears a strong resemblance to Minoan snake goddesses of the second millenium BC. She is shown with a white (pink) skin and Caucasian rather than African features.

that it is a transformation of the age-old legend of the mermaid or siren, and that a previous manifestation of the Mamy Wata can be found in the medieval legend of the fairy Melusine, half-woman and half-serpent, and ancestress of the noble house of Lusignan. A constant factor in all this is the association, very close in African minds, between sexual good fortune and wealth. In Zaire the Mamy Wata is sometimes said to have a snake for a lover, who vomits up money every time they have intercourse.

Modern African culture has many characteristics which may remind a westerner of much earlier epochs in western history. The curious mixture of materialism and religious belief embodied in the Mamy Wata, and the underlying insistence on the powers of Fate and Chance which the image represents, are strongly reminiscent of the intellectual condition of Europe under the Roman Empire, when just such powers were held to be paramount. Modern African art is often, therefore, more rather than less intimately linked to the social situation and to specific practical demand than the art which now fills contemporary museums in the west. Even Mamy Wata images exist on this basis. They are made because they are seen as purveyors of material benefits in terms of money and sex.

It is because the art made by Africans for Africans has such a thoroughly practical function, at least in the minds of consumers, that such a vigorous art-making impulse survives in most areas. Souvenir art is important, because it serves as a conduit of funds to deprived communities – a comparison can be made here with Aboriginal Art in Australia (see Chapter 9), although the latter enjoys much greater prestige. Much African art, however, remains a response to purely local needs and preoccupations, and does not look over its shoulder at outsiders. For example, a great deal of contemporary African sculpture, instead of being carved from wood, as purists might like, is modelled in termite-resistant concrete and then painted. Such sculpture can have a religious or commemorative role; it can also fulfil a purely mundane one. While some concrete sculptures are made as cult figures or grave-markers, others are erected on commercial sites, as attention-getters at hotels and filling stations. An irreverent mind might compare some of them to that politically incorrect relic of an earlier America, the cigar-store Indian.

The spectrum of modern African art is extraordinarily wide, though it is in addition sometimes artificially widened by western fascination with objects which would not normally count as art if found in a purely western context. What is one to make, for example, of recent European and North American enthusiasm for the work of Kane Kwei (born 1927), a Ghanaian maker of fantasy coffins? Kwei, like Chéri Samba, was represented both in *Les Magiciens de la Terre* and in *Africa Explores*. He has also had several solo shows on the West Coast of America.

By enthusiasts, Kwei's work is classified as an example of a so-called New Functionalist tendency in African art. Susan Vogel writes: "The creativity

of most New Functional art lies less in the making of the individual object than in the conception of the style."[5] With Kwei's assistance, one can be buried in an airliner, or the kind of Mercedes one could never afford in life, or a cocoa-pod, or a crayfish, or even a giant hen – all according to taste. Given the context, one might perhaps attribute the same kind of artistic creativity to a Regency chaise-longue, *style retour d'Egypte*, in the form of a gilded crocodile. It seems unlikely that Kwei himself has ever claimed to be an artist. His first unorthodox coffin was made at the request of a dying uncle, who had been a fisherman by trade and wanted to be buried in a boat. The result attracted a lot of attention in the local community, and demand for his wares grew. Like the makers of Minimal sculpture, but more innocently, he provides a node around which the vapours of Modernist theorizing can wrap themselves.

More significant is the emergence of a handful of artists of African origin who take their place more comfortably within a western framework, usually because they have ceased to live and work in Africa itself. One is the gifted Nigerian sculptor and print-maker Uzo Engonu (born 1931). Another is the

Kane Kwei
Mercedes Benz-Shaped Coffin, **1989**
Wood and enamel paint, length 8ft 8¼in/2.65m
Collection Museum voor Volkenkunde, Rotterdam
A number of so-called fantasy coffins by this Ghanaian artist-craftsman have entered Western museums. They have also been exhibited in American commercial art galleries, as independent art objects.

Uzo Engonu
Lone Eater, 1979
Screenprint, 20 x 28in/51 x 71cm
Private collection
This print by a leading Nigerian artist employs a typically Western technique, and is a stylistic fusion of African and Western elements.

sculptor Sokari Douglas Camp, with her creations in welded iron (see page 93). Perhaps the best-known is the Sudanese Ibrahim El-Salahi (born 1930), who trained during the 1950s at the Slade School, one of London's premier art-teaching institutions (he now says that he disliked the experiences he had there). As a Muslim, he describes himself as being as much Arab as African.

Thanks to the political upheavals of the Sudan, El-Salahi, like many African intellectuals, has been a political prisoner, and is now an unwilling exile from his homeland, living most of the time in the Gulf States and exhibiting frequently in western Europe. His work is a skilful fusion of western and African influences; more importantly, it is a perfectly self-aware and conscious fusion, which aims to make the fullest possible use of the cultural sources available.

Interestingly, the hybridization to be found in El-Salahi's art has long been typical of the art of Latin America. The various indigenist movements in Latin American art are all rooted in it, particularly the Anthropophagism of Tarsila do Amaral (see page 75), which represents the real start of a typically Brazilian form of Modernism, in which tropical appetite consumes and transforms what originated in Europe.

Variants of the same impulse can now be found in the contemporary art of nearly all the nations of Asia, and especially in the major ones. Since the foundation of the Gutai Group in Japan in Osaka in December 1954 Japan has been in possession of an avant garde which is fully the equivalent of western counterparts, and if Japanese art has felt the impact of European and North American innovations, it has also been innovative in its own right. Two of the most interesting developments in this context have been a deliberate parody-

Ibrahim El-Salahi
Mother and Child
**Pen and ink on paper, 9½ x
9½in/24 x 24cm**
The artist, born in the Sudan, has a
double identity, Arab and African. The
imagery owes something to traditional
art from the neighbouring state of
Zaire.

ing of western forms, as a retort to the way in which westerners, from the time
of Impressionism onwards, have made use of ideas borrowed from tradi-
tional Japanese art; and, secondly, a deliberate blending of western forms and
traditionally Japanese techniques. The first tendency is exemplified in the
Playing with Gods series by Yasumasa Morimura (born 1951), in which the
artist makes satirical use of paintings by the German Renaissance master
Lucas Cranach. The second can be seen in the striking portraits of westerners
made in carved, joined and painted cypress wood by Katsura Funakoshi.
The methods Funakoshi uses are those of Japanese portrait sculptors of the
Kamakura period (1185-1333), the time at which the military dictatorship of
the Japanese shoguns was established.

In China there is a striking division between paintings made in purely
western, often photorealist style, and the revival of Chinese ink painting. The
new masters of the brush, such as Huang Yonyu (born 1924) and Fan Zeng
(born 1937), are now widely recognized outside China as well as being
famous within it. Huang Yonyu, persecuted during the Cultural Revolution
but restored to favour after it, was commissioned to make an immense
tapestry for Chairman Mao's mausoleum. He has exhibited in the United

Yasumasa Morimura
Playing with Gods: No. 3, Night,
1991
**Photograph, 141 x 98½in/358.1 x
250.1cm**
A parody of Lucas Cranach's
Crucifixion of 1503 (Alte Pinakothek,
Munich). In this photopiece all the
figures were posed by Morimura
himself.

Katsura Funakoshi
Exhibition view, Annely Juda Fine
Art, London, September–October
1991
Funakoshi's sculptures in camphor
wood, pieced together and painted, are
traditionally Japanese in technique, but
the subjects are mostly European.

Katsura Funakoshi
Staying in the Water, 1991
Painted camphor wood and
marble, height 32¼in/82cm

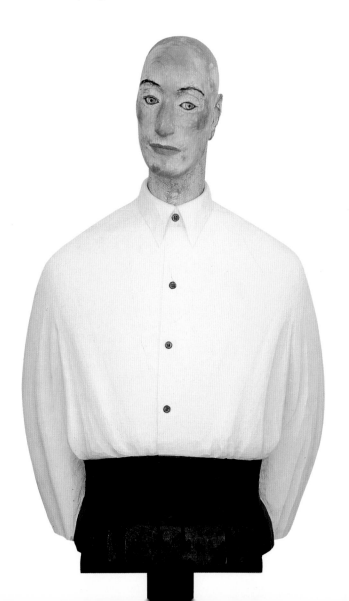

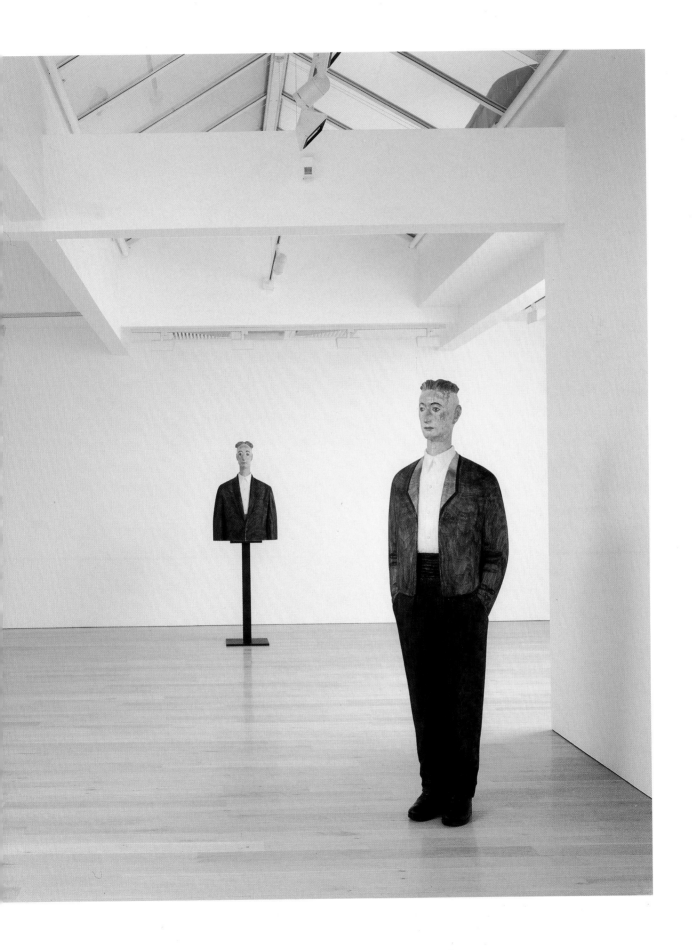

States, Australia and Japan. Fan Zeng painted one of the murals for the new Beijing airport, and in 1984 one of his enthusiastic patrons created a special museum dedicated to him in Japan. In their unabashed boldness and frequent delight in powerful colour, the Chinese ink painters of the present day show unmistakable signs of influence from the west. Yet the very nature of the techniques they employ stress the debt they also owe to a purely Chinese tradition, which links the making of painted images to calligraphy.

Modern Indian artists have had a more difficult struggle for recognition than their Chinese and Japanese counterparts, both within India itself, and in the world at large. Probably the best-known contemporary Indian artist working in India is Bhupen Khakhar (born 1934). Despite his current celebrity, Khakhar was not free to paint full-time until he reached his fifties. He trained as an artist in a western-style art school, but spent many years working part-time as a bookkeeper in a small factory. Khakhar's work is a unique cultural blend: a mixture of western and eastern elements. On the one hand influences include Douanier Rousseau, Sienese fourteenth- and fifteenth-century painting and David Hockney; on the other, bazaar oleographs, Nathwadara painting and the art of the so-called Company School – Indian painters working for the British in the late eighteenth and early nineteenth centuries. He uses this quintessentially "mixed" style to render the details of half-westernized Indian urban life. More recently, he has also used his work as a medium for personal confessions of a quite un-Indian kind. His *Yayati*, painted in 1987, is a thinly disguised declaration of his homosexuality, wrapped up in a theme taken from the Indian epic the *Mahabharata*, in which Yayati, an old king, becomes impotent and asks his son to give him his youth. Khakhar had no institutionalized minority to rely upon, as is the case with the majority of gay artists in the west.

Khakhar can now be regarded as the leading figure in a well-established contemporary Indian school, which produces not only paintings, but also sculptures and environmental works, and which aspires to the same kind of status, cultural position and patronage as already accrues to contemporary art in developed western countries. The whole late-Modernist infrastructure, which already exists in Japan and in non-Communist fragments of China such as Hong Kong, is in the process of being created in India. Art from all these areas, and even to some extent from Communist China, posits mechanisms for the reception, consumption and diffusion of works of art which bear some resemblance to the familiar western model. Only the art of modern African maintains a kind of minority status in its complete rejection of this – good reason indeed for the curator of the most recent Kassel Documenta to feel disconcerted by it.

The western art world is confronted by a series of uncomfortable dilemmas and paradoxes. It has successfully institutionalized Modernism, but part of the viability of that Modernism is its transgressive character. If it does not at

Bhupen Khakhar
Yayati, 1987
Oil on canvas, 67½ x 67½in/
171.2 x 171.2cm
Private collection

The ostensible theme of this painting is
taken from the Indian epic, the
Mahabharata. Yayati is an old king
who, becoming impotent, asks his son
to give him his youth. The underlying
subtext is homosexual, and the painting
can be compared with homoerotic
works by Western artists.

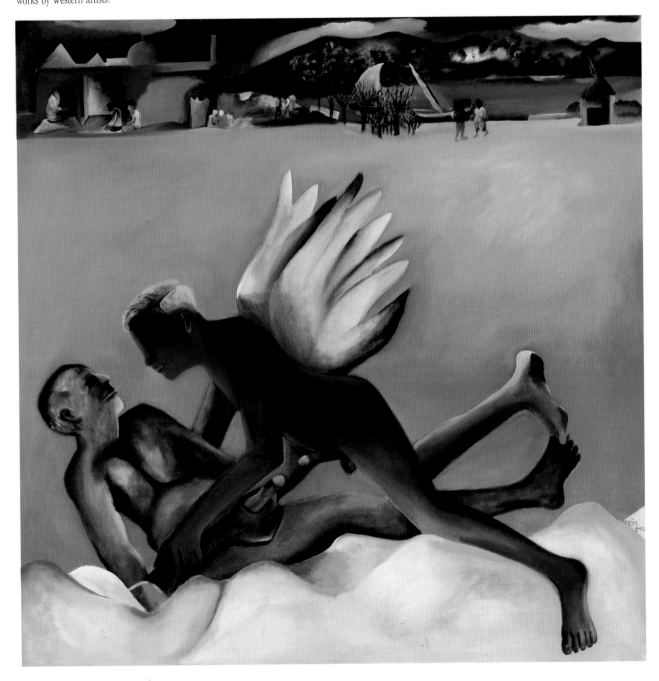

204 / **Modern Africa and Asia**

least appear to transgress social norms and expectations it loses potency. The idea of potency now also involves the idea of *mana*, or sacredness, thanks to the religious function which the museum itself has assumed. The idea of the sacred applies to persons as well as artworks – the barrier which used to separate the maker from the object has become somewhat tenuous.

Minority art, even when it is not very visibly in the main Modernist tradition (Chicano art, for example) fulfils many of these desiderata, not least because the transgressive element is more or less built in to it. So, too, is the moralistic overtone which traditionally helps to facilitate the operations of art criticism: that is, good morality – in the eyes of most contemporary critics – is a more than adequate substitute for aesthetic merit, so much so that many theorists call into question the whole idea of a scale of aesthetic values. For the entrenched feminist critics, for example, a demand for aesthetic pleasure can easily translate into yet another example of the subtle dictatorship of patriarchal or phallocentric attitudes.

"Exotic" art – that is, art from non-western cultures – is now sometimes brought within the "minority" framework which I have attempted to describe, but increasingly resists this kind of classification as it becomes more accessible and familiar. It does, however, increase the centrifugal forces which are now tearing a once unitary art world apart.

Conclusion

What conclusions can one usefully draw from minority art and the way it operates within contemporary culture? There seem to be several, and none is likely to be popular in the current social and artistic climate. The custom has been to study minority expressions separately, each on its own terms. This eases the demand made on behalf of many forms of minority expression that traditional aesthetic standards be abrogated. This aspect of the contemporary scene has been sharply attacked by Robert Hughes in his polemic, *Culture of Complaint* (1993):

As a maudlin reaction against excellence spreads to the arts, the idea of aes-thetic discrimination is tarred with the brush of racial or gender discrimina-tion. Few take a stand on this, or point out that in matters of art "elitism" does not mean social injustice or even inaccessibility. The self is now the sacred cow of American culture, self-esteem is sacrosanct, and so we labor to turn arts education into a system in which no-one can fail. In the same spirit, ten-nis could be shorn of its elitist overtones: you just get rid of the net.[1]

One of the questions Hughes does not directly address – perhaps he felt it would lead him too far from his brief – is that of competing minorities. The system of judgement – or, if judgement is outlawed, then of approach and absorption – which is effective when dealing with the artistic production of one minority may not be so when dealing with that of another. The machismo of some racially-based art conflicts with the tenets of feminism; the racism of some gay art is unacceptable in African American terms; the hostility of feminists to eroticism, and particularly to sadomasochism, conflicts with the demand of liberated homosexuals that they be allowed to give free expres-sion to truths about their own sexuality. A member of an oppressed minority, placed in a different context, is easily transformed into a member of an op-pressor class. Meanwhile, it is typical of all forms of minority expression that they require the spectator to identify wholly: he or she cannot stand aside, and certainly not above.

There is, however, one characteristic which all forms of minority ex-pression necessarily share – they are not wholly independent entities, but are defined by the existence of a majority. The dynamic of minority art is that it answers what the majority has to say. It is, in fact, largely shaped by this: all of its statements are ripostes. This effectively means that minority art is shaped by majority pressures, and that the same individuals would probably produce very different work if these did not exist.

Although, as I have tried to show, African American art escapes more successfully from self-imposed stereotypes than most of the other forms of artistic expression described here, it must be said that it is conditioned more by America than it is by Africa. As I have also tried to demonstrate, the "classical" African art which many African American artists regard as exemplary is itself an artificial construct, which owes as much to the rise of European Modernism as it does to Africa. The art of modern Africa, flourishing despite all difficulties, has very different preoccupations from those which typify African American expression, or the work of Afro-Caribbean artists in Britain. African American and Afro-Caribbean artists may feel alienated by the western industrial society that surrounds them, but they can only separate themselves from it in fantasy, never in fact. Similarly, both homosexual and feminist art often operate by deconstructing male heterosexual stereotypes. The deconstruction would not be effective if these stereotypes had no objective recognizable existence of their own, separate from that of their critics.

What adds a further dimension to this dialogue is the entry of minority forms of expression into the museum – that is to say, they have now been co-opted into the world of official culture, which the museum, despite curatorial obsession with the idea of the avant garde, continues to represent. Once the minority artist finds a place within museum structures – organizational as well as physical – he or she assents as well as dissents. Embracing the minority, the museum puts forward the idea that we live in a certain kind of society: a society whose aim is consensus over a broad spectrum. This idea can of course be challenged by other elements within the "official" world, and sometimes is, but the role of the minority in these conflicts is to be a hostage rather than an opponent.

Where the contemporary museum sometimes finds difficulty with minority expression is in the conflict with Modernist orthodoxy. As can be seen from the range of minority art shown here, one of the ways in which minority groups most differ from one another in the artistic sense is to be found in their widely varying relationships with the main Modernist line of descent. These variations spring from differences in cultural and educational background, but also from what the artists want to express. Chicano painting, often made by people who are culturally and educationally disadvantaged, certainly in terms of the society that surrounds them, takes little from main-line Modernism. Its most specifically Modernist elements come not direct from Europe, nor from the United States, but from Mexican art of the 1920s to the 1940s. Feminism, which has mostly been a middle-class movement, whose participants enjoy a high level of education and easy intellectual access to all manifestations of contemporary culture, has enthusiastically adopted many characteristic late-Modernist criticism. Much art by gay men, on the other hand, has been alienated from late Modernism by the coded

nature of its preferred modes of expression. These make the art of the post-Pop epoch an inefficient vehicle for sexual feeling.

The response of museums, or more precisely that of curators and critics within the museum orbit, to possible fissures between minority expression and avant gardism as defined by the now long history of Modernism is to speak in terms of an ongoing deconstruction of the Modern Movement. What is at first sight non-Modernist is co-opted and made part of the necessary continuity by being described as "post" rather than "non". That is, it acquires its essential identity not from difference alone, but from a relationship expressed in terms of what has gone before it. Even completely non-Modernist expressions, such as Australian Aboriginal Art, have proved assimilable because they are dependent on existing arrangements for display, and also on existing marketing structures. To put it bluntly, they look enough like Modern art to be displayed and sold as if they *were* Modern art.

The main conclusion must be that the minority visual arts, though on the surface often an expression of revolt against contemporary western society and its social and economic structures, are in fact completely dependent on that society. They are in many ways most accurately defined as one of the most visible aspects of the debate which that society continues to have with itself.

Notes

Chapter 1: African American Art

1. M.F. Ashley Montagu, "The African Origins of the American Negro and his Ethnic Connections", *The Scientist*, Volume LVIII, January–June 1944, pp.63–4.

2. Thelma Golden, "What's White . . .?", Whitney Museum of American Art, *1993 Biennial Exhibition*, New York, 1993, p.27.

3. Rae-Alexander Minter, "The Tanner Family: a Grandniece's Chronicle", Dewey F. Mosby et al., *Henry Ossawa Tanner*, New York, 1991, p.29.

4. Henry Ossawa Tanner, quoted in Dewey F. Mosby et al., *Henry Ossawa Tanner*, p.13.

5. Camille Pissarro, *Letters to his son Lucien*, ed. John Rewald, Marmoreck, New York, 1972, p.221.

6. William Rubin, "Picasso", *"Primitivism" in 20th Century Art*, ed. William Rubin, Museum of Modern Art, New York, 1988, Vol. I, pp.234–5.

7. Edmund Barry Gaither, *Afro-American Artists*, New York and Boston (Boston: The National Center of Afro-American Artists), 1970, pp.3–4.

8. Robert Storr, quoted in Neal Benezra, *Martin Puryear*, Chicago and London, 1991.

9. Martin Puryear, quoted in Benezra, op. cit., p.17.

10. Craig Castleman, *Subway Graffiti in New York*, Cambridge, Mass., 1982, p.67.

11. Ibid., p.176.

12. Jeffrey Deitch, *Flash Art*, No. 16, May 1982, p.50.

13. Eleanor Heartney, *Flash Art*, No. 125, December 1985– January 1986, p.43.

Chapter 2: The Artistic and Political Background

1. "The Founding and Manifesto of Futurism", *Marinetti: Selected Writings*, ed. R.W. Flint, London, 1972, p.42.

2. Quoted in *The Avant-Garde in Russia, 1910–1930*, Los Angeles and Cambridge, Mass., 1980, p.17.

3. Pablo Picasso, *L'Humanité*, 5 October 1944, p.1.

4. Louis Aragon, *Les Lettres Françaises*, 19 March 1953, p.9.

5. Max Kozloff, "American Painting During the Cold War", *Artforum* 11, no. 9, May 1973, p.44.

Chapter 3: Art as a Substitute Religion

1. *The Spiritual in Art*, exhibition catalogue, Los Angeles County Museum/ Abbeville, New York, 1986, p.389.

2. Mark Rothko, quoted in Edward Lucie-Smith, *Lives of the Great 20th Century Artists*, London, 1986, p.276.

3. Denis Diderot, *Salons*, ed. J. Seznec and J. Adhémar, Oxford, 1967, Vol. III, pp.148–9.

Chapter 4: Transgressive Art and the Modern Shaman

1. Heiner Stackelhaus, *Joseph Beuys*, New York, 1991, p.73.

2. Ibid, p.95.

3. Joseph Beuys, quoted in ibid., p.109.

Chapter 5: Chicano and Cuban Art

1. *Chicano Art: Resistance and Affirmation, 1965–1985*, Los Angeles, 1991, pp.361–2.

2. Tomas Ybarra Frausto, "Rasquashismo: a Chicano Sensibility", in ibid., p.155.

3. Ileana Fuentes-Perez, "The Inevitable Exile of Artists", *Outside Cuba: Fuera de Cuba*, New Jersey, 1988, p.19.

4. Ricardo Pau Llosa, "Identity and Variations", ibid., p.53.

5. Mario Bencomo, artist's statement, ibid., p.254.

Chapter 6: Racially Based Art in Britain

1. John Ruskin, quoted by Rasheed Araeen, *The Other Story: Afro-Asian Artists in Post-war Britain*, exhibition catalogue, Hayward Gallery, London, 1989, p.10.

2. Marco Livingstone, *Anish Kapoor*, exhibition catalogue, Walker Art Gallery, Liverpool and Le Nouveau Musée, Lyons, 1983, p.4.

3. Anish Kapoor, quoted by Sarah Kent, "Mind over Matter", *20:20*, May 1990, p.40.

4. Ronald Moody, quoted by Rasheed Araeen, op. cit., p.19.

5. Frank Bowling, quoted by Rasheed Araeen, op. cit., p.39.

6. Frank Bowling, quoted by Rasheed Araeen, op. cit., p.40.

7. Quoted by Rasheed Araeen, op. cit., p.74.

8. Keith Piper, quoted by Rasheed Araeen, op. cit., p.77.

9. Rasheed Araeen, op. cit., p.100.

Chapter 7: Minority Sexuality

1. John Caldwell, in *Jeff Koons*, exhibition catalogue, San Francisco Museum of Modern Art, 1992, p.14.

2. Ibid.

3. Ibid., unpaginated insert.

4. Steven Naifeh and Gregory White Smith, *Jackson Pollock*, New York, 1989, p.482.

5. Glenn Ligon, quoted in Whitney Museum of American Art, *1993 Biennial Exhibition*, New York, 1993, p.191.

6. David Wojnarowicz, *Close to the Knives: a Memoir of Disintegration*, New York, 1991, p.149.

7. Ross Bleckner, in *Ross Bleckner*, exhibition catalogue, Kunsthalle, Zürich, 1990.

8. Derek Lawson, statement issued in connection with the exhibition "Queer Nudes. Derek Lawson: Paintings and Sculptures", Baik Gallery, London, 24 March–11 April 1993.

9. Joyce Fernandes, "Sex into Sexuality", *Art Journal*, Vol. 50, No. 2, Summer 1991, p.36.

10. Betsy Damon, in *Heresies: a Feminist Publication of Art and Politics* (Lesbian Art and Artists issue), 1977, p.2.

11. Lourdes Kanou, in *Women Artists' News*, Vol. 15, Nos. 1 and 2, Spring/Summer 1990, p.14.

Chapter 8: Feminist Art

1. Linda Nochlin, "Pornography as a Decorative Art", introductory essay to Joyce Kozloff, *Patterns of Desire*, New York, 1990, p.11.

2. Germaine Greer, *The Obstacle Race: the Fortunes of Women Artists and Their Work*, London, 1979, p.6.

3. Ibid., p.13.

4. Whitney Chadwick, *Women, Art and Society*, London, 1990, p.19.

5. Ibid., pp.18–19; the emphasis is, of course, my own.

6. Ibid., p.87.

7. Miriam Schapiro and Faith Wilding, *Heresies*, No. 24, 1989, p.7.

8. Ibid.

9. Elisabeth Frink, quoted in Ianthe Ruthven, "A Sculptor's Conscience", *The Independent Magazine*, London, Issue 242, 1 May 1993, p.34.

10. Judy Chicago, interviewed by Dinah Dossor, in *Visibly Female: Feminism and Art, an Anthology*, New York, 1988, p.43.

11. Karen Woodley, *Artrage*, No. 9/10, 1985; reprinted in *Visibly Female*, op. cit., p.99.

12. *Visibly Female*, op. cit., p.97.

13. Ibid.

14. Carrie Rickey, "Judy Chicago: The Dinner Party", *Artforum*, January 1981; reprinted in *Visibly Female*, op. cit., p.95.

15. Lucy R. Lippard, Foreword to Mary Kelly, *Post-Partum Document*, London, 1983, p.X.

16. Ann Cullis, "Nice Women Don't Play Dirty", *Women's Art*, No. 52, May/June 1993, p.24.

17. Ileana Fuentes-Perez, "By Choice or Circumstance: the Inevitable Exile of Artists", *Outside Cuba: Fuera de Cuba,* New Jersey, 1987, p.28, note 50.

18. Whitney Chadwick, op. cit., p.350.

19. Paula Rego, quoted in John McEwen, *Paula Rego*, London, 1992, pp.166–7.

20. Ibid., p.167.

21. Martha Mayer Erlebacher, letter to the author, February 1993.

22. Ibid.

23. Judy Chicago, interviewed by Dinah Dossor, in *Visibly Female*, op. cit., p.43.

24. Victoria & Albert Museum Library, London, computer index of art periodicals from December 1984, citations of feminist-identified artists:

Eleanor Antin	10	Adrian Piper	23
Ida Applebroog	37	Yvonne Rainer	11
Lynda Benglis	22	Faith Ringgold	32
Elizabeth Catlett	2	Rachel Rosenthal	18
Betsy Damon	2	Betye Saar	16
Mary Beth Edelson	12	Cindy Sherman	86
Audrey Flack	12	Sylvia Sleigh	2
Joan Jonas	10	Nancy Spero	33
Mary Kelly	27	Sylvia Snowden	4
Barbara Kruger	68	Joan Snyder	25
Suzanne Lacy	5	May Stevens	8
Annette Lemieux	27	Mierle Lademan Ukeles	13

Chapter 9: Aboriginal and Maori Art

1. Henrietta Fourmile, "Aboriginal Women – Artists at Last!", in *Aratjara, Art of the First Australians*, exhibition catalogue, Düsseldorf and Cologne, 1993, p.73.

2. Ibid., p.74.

3. Ibid., p.75, note 18.

4. Wally Caruana, *Aboriginal Art*, London, 1993, pp.101–2.

5. Shane Cotton, in an interview with Clare Barry in *The Press*, Christchurch, New Zealand, 4 May 1990.

Chapter 10: Modern Africa and Asia

1. Pat Gilmour, "On Not Being a Political Artist", in Orde Levinson, *I Was Loneliness: the complete graphic works of John Muafangejo*, Cape Town, 1992, p.313.

2. Jan Hoet, *Africa Now: Jean Pignozzi Collection*, Gröningen, 1991, p.29.

3. Ibid.

4. Susan Vogel, "About the Here and Now", *Africa Explores: 20th Century African Art*, New York and Munich, 1991, p.124.

5. Susan Vogel, "Functional Traditions", *Africa Explores*, op. cit., p.103.

Conclusion

1. Robert Hughes, *Culture of Complaint: The Fraying of America*, New York, 1993, p.7.

Bibliography

Introduction

Russell Ferguson, Martha Gover, Trinh T. Minh-ha and Carnel West (eds.), *Out There: Marginalization and Contemporary Cultures*, New Museum of Contemporary Art, New York/MIT Press, Cambridge, Mass., 1990.

Whitney Museum of American Art, *1993 Biennial Exhibition*, catalogue published in association with Harry N. Abrams, Inc., New York, 1993.

Chapter 1: African American Art

Neal Benezra, *Martin Puryear,* Art Institute of Chicago/Thames and Hudson, New York, 1991.

Black Art: Ancestral Legacy – the African Impulse in African-American Art, exhibition catalogue, Dallas Museum of Art, 1989.

Mary Schmidt Campbell, David Driskell, David Levering Lewis and Deborah Willis Ryan, *Harlem Renaissance: Art of Black America*, Harry N. Abrams, Inc., New York, 1987.

Craig Castleman, *Getting Up: Subway Graffiti in New York*, MIT Press, Cambridge, Mass., 1982.

Elsa Honig Fine, *The Afro-American Artist: a Search for Identity,* Hacker Art Books, New York, 1982.

Samella Lewis, *Art: African American*, Hancraft Studios, Los Angeles, 2nd revised edition, 1990.

Lucy R. Lippard, *Mixed Blessings: New Art in a Multicultural America*, Pantheon Books, New York, 1990.

Richard Marshall, *Jean-Michel Basquiat*, Whitney Museum of American Art/Harry N. Abrams, Inc., New York, 1992.

Dewey F. Mosby, Darrell Sewell and Rae Alexander-Minter, *Henry Ossawa Tanner*, Philadelphia Museum of Art/Rizzoli, New York, 1991.

Regenia A. Perry, *Free Within Ourselves: African-American Artists in the Collection of the National Museum of American Art*, National Museum of American Art, Smithsonian Institution, Washington D.C., in association with Pomegranate Art Books, San Francisco, 1992.

Gary A. Reynolds and Beryl J. Wright, *Against the Odds: African-American Artists and the Harman Foundation*, The Newark Museum, New Jersey, 1989.

Robert Farris Thompson, *Flash of the Spirit: African and Afro-American Art and Philosophy*, Vintage Books, New York, 1984.

Ellen Harkins Wheat, *Jacob Lawrence: American Painter*, University of Washington Press, Seattle, in association with the Seattle Art Museum, 1986.

Chapter 2: The Artistic and Political Background

Chapter 3: Art as a Substitute Religion

Chapter 4: Transgressive Art and the Modern Shaman

Douglas Davis, *The Museum Transformed: Design and Culture in the Pompidou Age*, Abbeville Press, New York, 1990.

John C. Gilmour, *Fire of the Earth: Anselm Kiefer and the Post-Modern World*, Temple University Press, Philadelphia, 1990.

The Spiritual in Art: Abstract Painting 1890-1985, exhibition catalogue, Los Angeles County Museum of Art/Abbeville Publications, New York, 1986.

Heiner Stackelhaus, *Joseph Beuys*, Abbeville Press, New York, 1991.

Caroline Tisadall, *Joseph Beuys*, exhibition catalogue, Solomon R. Guggenheim Museum, New York, 1979.

Michael Tucker, *Dreaming with Open Eyes: the Shamanic Spirit in Twentieth Century Art and Culture*, Aquarian/Harper, San Francisco, 1990.

Chapter 5: Chicano and Cuban Art

CARA: Chicano Art, Resistance and Affirmation, exhibition catalogue, Wight Art Gallery, University of California, Los Angeles, 1991.

Chicanismo en el arte, exhibition catalogue, Los Angeles County Museum of Art, 1975.

Eve Spurling Cockcroft and Holly Barnet-Sanchez, *California Chicano Murals*, Social and Public Art Resource Center, Venice, California, 1990.

Le Demon des Anges: 16 artistes chicanos autour de Los Angeles, exhibition catalogue, Centre de Recherche pour le développement culturel, Nantes, 1989.

Outside Cuba: Fuera de Cuba, exhibition catalogue, Office of Hispanic Arts, Mason Gross School of Fine Arts, Rutgers, State University of New Jersey/Research Institute of Cuban Studies, Graduate School of International Studies, University of Miami, Florida, 1989.

Chapter 6: Racially Based Art in Britain

Rasheed Araeen, *The Other Story: Afro-Asian Artists in Post-war Britain*, exhibition catalogue, Hayward Gallery, London, 1989.

Petrine Archer Shaw and Kim Robinson, *Jamaican Art*, Kingston Publishers Limited, Kingston, Jamaica, 1990.

Chapter 7: Minority Sexuality

Ross Bleckner, exhibition catalogue, Kunsthalle, Zürich, 1990.

Emmanuel Cooper, *The Sexual Perspective: Homosexuality and Art in the Last 100 Years in the West*, Routledge and Kegan Paul, London, 1986.

Melody D. Davis, *The Male Nude in Contemporary Photography*, Temple University Press, Philadelphia, 1991.

Allen Ellenzweig, *The Homoerotic Photograph: Male Images from Durieu/Delacroix to Mapplethorpe*, Columbia University Press, New York, 1992.

Della Grace, *Love Bites*, Editions Aubrey Walter, London, 1991.

Lincoln Kirstein, *Paul Cadmus*, Imago Imprint, New York, 1984.

Jeff Koons, exhibition catalogue, San Francisco Museum of Modern Art, San Francisco, 1992.

Jeff Koons, *The Jeff Koons Handbook*, Thames and Hudson/Anthony d'Offay Gallery, London, 1992.

Edward Lucie-Smith, *George Dureau: New Orleans*, GMP, London, 1985.

Edward Lucie-Smith, *Harry Holland: The Painter and Reality*, Art Books International, London, 1991.

Edward Lucie-Smith, *Luis Caballero: Painting and Drawings*, Editions Aubrey Walter, London, 1992.

Robert Mapplethorpe, *Black Males*, Galerie Jurka, Amsterdam, 1980.

Richard Marshall, *Robert Mapplethorpe*, Whitney Museum of American Art, New York/New York Graphic Society Books, Little, Brown and Company, Boston, Mass., 1988.

John Russell Taylor, *Ricardo Cinalli*, Edizioni della Bezuga, Florence, 1992.

Tom of Finland, Benedikt Taschen Verlag, Cologne, 1992.

Douglas Blair Turnbaugh, *Street Show: Paintings by Patrick Angus (1953-1992)*, Editions Aubrey Walter, London, 1992.

David Wojnarowicz, *Close to the Knives: a Memoir of Disintegration*, Vintage Books, New York, 1991.

David Wojnarowicz, *Memories that Smell like Gasoline*, Artspace Books, San Francisco, 1992.

Chapter 8: Feminist Art

Christine Battersby, *Gender and Genius: Towards a Feminist Aesthetics*, Indiana University Press, Bloomington and Indianapolis, 1989.

Whitney Chadwick, *Women, Art and Society*, Thames and Hudson, London, 1990.

Gisela Ecker, ed., *Feminist Aesthetics*, Beacon Press, Boston, 1986.

Jean Franco, *Plotting Women: Gender and Representation in Mexico*, Columbia University Press, New York, 1989.

Germaine Greer, *The Obstacle Race: The Fortunes of Women Painters and Their Work*, Secker and Warburg, London, 1979.

Linda Kauffman, ed., *Gender and Theory: Dialogues on Feminist Criticism*, Basil Blackwell, Oxford, 1989.

Mary Kelly, *Post-Partum Document*, Routledge and Kegan Paul, London, 1983.

Sarah Kent and Jacqueline Morreau, eds., *Women's Images of Men*, Writers and Readers Publishing, London, 1985.

Nannerl O. Keohane, Michelle Z. Rosaldo and Barbara C. Gelpi, eds., *Feminist Theory: a Critique of Ideology*, University of Chicago Press, Chicago, 1982.

Joyce Kozloff, *Patterns of Desire*, Hudson Hills Press, New York, 1990.

Kate Linker, *Love for Sale: The Words and Pictures of Barbara Kruger*, Harry N. Abrams, Inc., New York, 1990.

John McEwen, *Paula Rego*, Phaidon Press, London, 1992.

Micheline R. Malson, Jean F. O'Barr, Sarah Westphal-Wihl and Mary Wyer, eds., *Feminist Theory in Practice and Process*, University of Chicago Press, Chicago, 1989.

Marco Meneguzzo, *Cindy Sherman*, Mazzotta, Milan, 1990.

Sylvia Moore, ed., *Yesterday and Tomorrow: California Women Artists*, Midmarch Arts Press, New York, 1989.

Linda Nochlin, *Women, Art, and Power, and Other Essays*, Harper and Row, New York, 1989/Thames and Hudson, London, 1991.

Arlene Raven, Cassandra Langer and Joanna Frueh, eds., *Feminist Art Criticism: an Anthology*, Icon Editions, New York, 1988.

Hilary Robinson, ed., *Visibly Female – Feminism and Art: an Anthology*, Universe Books, New York, 1988.

Roxana Robinson, *Georgia O'Keeffe: a Life*, Bloomsbury, London, 1990.

Jacqueline Rose, *Sexuality in the Field of Vision*, Verso, London, 1986.

Nancy Spero, exhibition catalogue, Institute of Contemporary Arts, London, 1987.

Nancy Spero, *Re-Birth of Venus*, Kyoto Shoin, Kyoto, 1989.

Chapter 9: Aboriginal and Maori Art

Aratjara: Art of the First Australians, exhibition catalogue, curated by Berhard Luthi and organised by the Kunstsammlung Nordrhein-Westfalen, Düsseldorf, in cooperation with the Aboriginal Arts Unit of the Australia Council, Sydney, DuMont Buchverlag, Cologne, 1993.

Michael Boulter, *The Art of Utopia; a New Direction in Contemporary Aboriginal Art*, Craftsman House, Roseville, Australia, 1991.

Wally Caruana, *Aboriginal Art*, Thames and Hudson, London, 1993.

Haeta Maori Women's Art Collective, Project Waitangi, Wellington City Art Gallery, *Mana Tiriti: The Art of Protest and Partnership*, Daphne Brasell Associates Press, Wellington, New Zealand, 1991.

Headlands: Thinking Through New Zealand Art, exhibition catalogue, Museum of Contemporary Art, Sydney, 1992.

Jennifer Isaacs, *Aboriginality: Contemporary Aboriginal Paintings and Prints*, The University of Queensland Press, 1989.

Sidney M. Mead, *Te Maori: Maori Art from New Zealand Collections*, Harry N. Abrams, Inc., New York, 1984.

Margie K.C. West, *The Inspired Dream: Life as Art in Aboriginal Australia*, Queensland Art Gallery, Northern Territory, Australia, 1988.

Chapter 10: Modern Africa and Asia

Africa Now: The Jean Pignozzi Collection, Groniger Museum, Groningen, The Netherlands, 1991.

Art from South Africa, exhibition catalogue, Museum of Modern Art, Oxford, 1990.

A Cabinet of Signs: Contemporary Art from Post-Modern Japan, exhibition catalogue, Tate Gallery, Liverpool, 1990.

"Contemporary Art: Synthesis and Polarities: East–West Visual Arts Encounter", Marg, Vol. 38, No. 4, Bombay, 1987.

A Critical Difference: Contemporary Art from India, exhibition catalogue, Aberystwyth Arts Centre in collaboration with The Showroom, London, 1993.

Warren L. d'Azvedo, ed., *The Traditional Artist in African Societies*, Indiana University Press, Bloomington and Indianapolis, 1973.

Ibrahim El-Salahi: Images in Black and White, exhibition catalogue, Savannah Gallery of Modern African Art, London, 1992.

Pierre Gaudibert, *Art Africain Contemporain*, Editions Cercle d'Art, Paris, 1991.

Nelson H. H. Graburn, ed., *Ethnic and Tourist Arts: Cultural Expressions from the Fourth World*, University of California Press, Berkeley and Los Angeles, 1976.

Gutai–Japanische Avantgarde/Japanese Avant-Garde, 1954-1965, exhibition catalogue, Mathildenhöhe, Darmstadt, 1991.

Orde Levinson, *The Complete Graphic Works of John Muafangejo, a catalogue raisonné 1968-1987*, Struik Winchester, Cape Town, 1992.

Makonde: Wooden Sculpture from East Africa from the Malde Collection, exhibition catalogue, Museum of Modern Art, Oxford, 1989.

Moderne Kunst aus Afrika, exhibition catalogue, Staatlichen Kunsthalle, Berlin, 1979.

Marshall W. Mount, *African Art – the Years since 1920*, 2nd revised edition, Da Capo Press, New York, 1989.

Fumio Nanjo and Peter Weiermair, *Japanische Kunst der Achtziger Jahre*, Frankfurter Kunstverein/Editions Stemmle, Schaffhausen, 1990.

Roland Oliver, *The African Experience*, Weidenfeld and Nicolson, London, 1991.

Vinayak Purchi, *Arts of Transitional India, 20th century*, Popular Prakashan, Bombay, 1988.

Chéri Samba: a Retrospective, exhibition catalogue, Provinciaal Museum voor Moderne Kunst, Ostende/Institute of Contemporary Arts, London, 1989.

Susan Vogel, *Africa Explores: 20th Century African Art*, The Center for African Art, New York/Prestel, Munich, 1991.

Maude Wahlman, *Contemporary African Arts*, Field Museum of Natural History, Chicago, 1974.

Sue Williamson, *Resistance Art in South Africa*, David Philip, Cape Town and Johannesberg, 1989/Catholic Institute for International Relations, London, 1990.

Gavin Younge, *Art of the South African Townships*, Thames and Hudson, London, 1988.

Conclusion

Robert Hughes, *Culture of Complaint*, Oxford University Press, New York and London, 1993.

Picture Credits

The author and publishers would like to thank the following for their kindness in providing illustrations or granting permission for their use (any uncredited illustrations are from private collections):

page 6: Visual Arts Library, London
page 8: Benny Andrews
pages 11, 13: Visual Arts Library, London
pages 14-15: Musée de l'Homme, Paris
pages 17 to 22: Visual Arts Library, London
page 25: Benny Andrews
page 26: University Art Museum, University of California at Berkeley
pages 28-9: Marti Kolin Gallery, Santa Monica
page 30: Gallery Simonne Stern, New Orleans
page 31: McKee Gallery, New York
page 33: © ADAGP, Paris and DACS, London 1994/photo: Visual Arts Library, London
pages 34-5: © ADAGP, Paris and DACS, London 1994/photo: Didier Imbert Fine Arts, Paris
pages 38, 39: © ADAGP, Paris and DACS, London 1994/photo: Edimedia, Paris
page 40: © ADAGP, Paris and DACS, London 1994/photo: David Heald © The Solomon R. Guggenheim
 Museum, New York
pages 42-3: © DACS 1994/photo: Visual Arts Library, London
pages 44 to 49: Visual Arts Library, London
page 51: Hayward Gallery, London/photo: Marcus Leith
page 52: Visual Arts Library, London
page 54: Centre Georges Pompidou, Paris/photo: K. Ignatiadis
page 56: © DACS 1994/photo: Visual Arts Library, London
page 58: Tate Gallery, London/photo: Stefan Erfurt, Wuppertal
pages 60-1: Visual Arts Library, London
page 62: Michael Werner Gallery, New York and Cologne
page 64: Ester Hernandez
page 66: Rebecca Hossack Gallery, London
page 68: Visual Arts Library, London/photo: Edward Lucie-Smith
page 69: Daniel Saxon Gallery, Los Angeles
pages 70 to 72: Visual Arts Library, London
page 73: © DACS 1994/photo: Visual Arts Library, London
page 74: Visual Arts Library, London
page 76: Rasheed Araeen
page 78-9: Balraj Khanna
page 80: Rasheed Araeen
pages 81, 82: Tu Stern/photo: Miki Slingsby
page 83: Edward Lucie-Smith
page 85: Iqbal Geoffrey
page 87: Rasheed Araeen
pages 88, 89: Eddie Chambers
pages 90, 91: Keith Piper
page 92: Sokari Douglas Camp
page 94: Flowers East Gallery, London
page 95: © DACS 1994
page 96: Louis K. Meisel Gallery, New York
page 97: © Tom Wesselmann/DACS, London/VAGA, New York 1994/photo: Visual Arts Library, London
page 98 top: Visual Arts Library, London
pages 98 bottom, 99: Glyn Vivian Art Gallery, Swansea/Harry Holland
page 100: Jeff Koons
pages 102-3: Raab Boukamel Galleries, London
page 104: Edward Lucie-Smith
page 105: James Corcoran Gallery, Santa Monica
pages 106, 107: Visual Arts Library, London

page 108: Marlborough Fine Art, London
page 110: Tradhart, Slough
page 111: Philip Graham Contemporary Art, London
page 113: Tom of Finland Foundation, Los Angeles
page 114: Estate of Robert Mapplethorpe
page 117: Raab Boukamel Galleries, London
page 118: Max Protech Gallery, New York/Estate of Robert Mapplethorpe/photo: Geoffrey Clements, New York
page 120: Delmas Howe
page 121: Ricardo Cinalli
pages 122, 123: George Dureau
pages 124, 125: David Pearce
page 127: Luis Caballero
page 128: Michael Leonard
pages 130, 131: Civilian Warfare, New York/photo: Visual Arts Library, London
page 132: Douglas Blair Turnbaugh and Editions Aubrey Walker, London
page 133: Derek Lawson
page 135: Visual Arts Library, London
page 136: Nancy Fried
page 137: Della Grace
page 138: Fine Art Society, London
page 140: Laura Carpenter Fine Art, Santa Fe
page 142: photo: Kevin Noble
page 144: Visual Arts Library, London
page 146: Carolee Schneemann/photo: Dianne Nilsen
page 147: Ronald Feldman Fine Arts, New York
page 148: Waddington Galleries, London
pages 150-1: Through the Flower, Santa Fe/photo: Donald Woodman
page 153: Edwina Sandys
page 154: Arts Council of Great Britain
page 155: Visual Arts Library, London
page 157: Mary Boone Gallery, New York
page 158: Metro Pictures, New York
page 159: The Eli Broad Family Foundation, Santa Monica
page 160: Angel Row Gallery, Nottingham
page 162: Marlborough Fine Art, London
page 165: Fischbach Gallery, New York/photo: Plakke/Jacobs
page 168: National Art Gallery, Wellington, New Zealand/photo: L. Maiden
pages 171 to 174: Corbally Stourton Contemporary Art, London
pages 176-7: Museum of South Australia
pages 178-9: Corbally Stourton Contemporary Art, London
page 181: New Zealand Board for Tourism, London
page 183: Brooke-Giffend Gallery, Christchurch, New Zealand/photo: Edward Lucie-Smith
page 184 top: Museum of New Zealand, Te Papa Tongarewa
page 184 bottom: Edward Lucie-Smith
page 186: Musée d'Art Contemporain, Lyon
pages 188, 189: Visual Arts Library, London
page 191: Corbally Stourton Contemporary Art, London
page 193: Annina Nosei Gallery, New York
page 194: Contemporary African Art Collection/Claude Postel, Paris
page 196: Museum voor Volkenkunde, Rotterdam
page 197: Visual Arts Library, London
page 198: Savannah Gallery of Modern African Art, London
page 199: Luhring Augustine Gallery, New York
pages 200-1: Annely Juda Fine Art, London/photo: John Riddy
page 203: Camden Arts Centre, London

Index

A

aboriginal art 169
Abstract Expressionism 29, 45, 47, 50, 53, 72, 84, 170
Acme Gallery, London 88
Africa Explores: 20th Century African Art exhibition (1988) 187, 192, 195
Africa Now exhibition (1991-2) 187
African American Art 6, 9, 39, 206
African American Expression 39
African sculpture 15, 186
Afro-Asian artists 77
Afro-Caribbean artists 84, 86, 206
Afterimage magazine 167
AIDS 103, 116, 119, 128-9, 131, 133
Akpan, S. J.
 Portrait of a Seated Chief 186
Amaral, Tarsila do 197
 Abaporu 75
American Minimalists 32
American social realist tradition 20, 24
âmes maudits 57, 130
André, Carl 160
Andrews, Benny 24
 New York, New York 25
 Outsider, Inside 8
Angus, Patrick 133-4
 All the Love in the World 133
Anthropophagism 197
Anti-Slavery League 10
Araeen, Rasheed 77, 82, 84, 93
 How Could One Paint a Self-Portrait 76
Aragon, Louis 43, 45
Aratjara: Art of the First Australians exhibition (1993) 175
Art and Craft School, Rorke's Drift, Natal 187
Art Deco 20
Art Gallery of New South Wales, Sydney 175
art negrè 16
Art of Revolution, 1959-1970 (intro. Susan Sontag) 67
Artforum magazine 34, 152, 167
Artrage magazine 149
Australian Aboriginal art 169, 175, 180, 185, 207
awelye 172
Azaceta, Luis Cruz 75
 Question of Color 72

B

Bachardy, Don
 Bob Newman 104
Bacon, Francis 88, 126
 Two Figures in the Grass 109
Balthus 163
Bangladeshi artists 78
Bardon, Geoffrey 170

bark painting 169
Barnes, Albert 19
barrios 67, 71
Basquiat, Jean-Michel 32, 36
 Untitled 33
 in collaboration with Andy Warhol, *Felix the Cat 34*
Baudrillard 145
Bauhaus 41, 48-9
Bearden, Romare 8, 23-4
 Sermons: The Walls of Jericho 20
Bellmer, Hans 158
Bencomo, Mario 73
Besant, Annie 47
Beuys, Joseph 32, 59, 63, 130, 161
 Free University for Creativity and Interdisciplinary Research 60
 Kassel Documenta 5 (1972) 60
 Kassel Documenta 6 (1977) 60
 Organization for Direct Democracy through Referendum 60
 We Are the Revolution 56
Bischoff, Elmer 134
black art 77, 89
Blake, Peter 87
Blaue Reiter 41
Blavatsky, Mme Elena P. 41, 47
 The Secret Doctrine 47
Bleckner, Ross 131
 8122+, As of January 1986 131
 Trophy paintings 131
Bo Diddley (Ellas McDaniel) 31
body painting (*awelye*) 172
Bolshevik regime 41-2
Bonnard, Pierre 133-4
Bosch, Hieronymus 23
Boucher, François 50
Bowling, Frank 87-8
Boyce, Sonia 93
Brancusi, Constantin 23, 31-2
Braque, Georges 16, 23
Breuer, Marcel
 Whitney Museum of American Art, New York 49
British Museum, London 86
British National Art Library 137
Brooks, Romaine 138-9
Broude, Norma and Garrard, Mary D.
 The Expanding Discourse: Feminism and Art History 143
 The Power of Feminist Art: The American Movement 143
Bruegel the Elder, Pieter 20
Buddhism 47, 77
Bulatov, Eric 27

C

Caballero, Luis 129
 Untitled 126
Cadmus, Paul 109, 115

Night in Bologna 106, 109
calavera (Mexican skeleton figure) 64
Calder, Alexander 31
Caldwell, John 101
California Institute of the Arts, Valencia 156
calligraphy 202
camp 103
Caravaggio, Michel Angelo 144-5
Carracci studio 104
Caruana, Wally 180
Catherine the Great of Russia 50
Cavafy, C. P. 109, 111
Centre Georges Pompidou, Paris 55
Cézanne, Paul 15
Chadwick, Helen 159
 Piss Flowers 160
Chadwick, Whitney 145, 161, 167
 Women, Art and Society 143, 164
 Women Artists and the Surrealist Movement 143
Chambers, Eddie 89-91
 How Much Longer 88
 Untitled 89
Chandra, Avinash 78
 Untitled (1961) 80
 Untitled (1987) 82
Charles V 170
Chartres cathedral 50
Chatwin, Bruce
 The Songlines 169
Chavannes, Puvis de 12
Chavez, Cesar 67
Chicago, Judy 155-6, 166
 The Birth Project 145
 The Dinner Party 145, 149, 150, 152-3
Chicano Art: Resistance and Affirmation, 1965-1985 exhibition 65
Chicano community, USA 65
Chicano Movement 65, 67-8, 130, 206
China 202
Chinese calligraphy 23
Chinese ink painting 198
Cicciolina, La (Ilona Staller) 101, 103, 147
Cinalli, Ricardo
 Hercules Farnese 120, 123-4
Civil Rights Movement, USA 23, 67, 149
Clay, Cassius (Muhammad Ali) 36
Cleaver, Eldridge 90
Clemente, Francesco 167
Cogniet, Léon 104
 Academic Study of a Male Nude 104
Cold War 43, 45
Colombia 126
Communism, Communist Party 41-5, 156
Company School art 202
Conceptual Art 50, 53, 59

confrontation of a given space 58-9
Congresso de Artistas Chicanos en
 Aztlan
 We Are NOT A Minority 68
Contemporary Arts Center, Cincinnati
 116
Contemporary Black Artists in America
 (1951) exhibition 87
Corcoran Gallery of Art, Washington
 116
Cotton, Shane 185
 Metrocharts III 183
Courbet, Gustave
 Le Sommeil 135, 139
crafts 145, 152, 172
Cranach, Lucas 198
Cruising (film) 112
Cuban art-in-exile 71
Cuban Modernists 75
Cubism 16, 20
Cultural Revolution 198
cunt art 147

D
DAAD (Deutscher Akademischer
 Austauschdienst) 116
Dadaism 53, 57
Damon, Betsy
 The 7000 Year Old Woman 135
Dan tribe, Sierra Leone
 Carved wooden mask 18
David, Jacques Louis 63, 120
Davis, Gene 27
Davis, Stuart 45
Deitch, Jeffrey 36
Derrida, Jacques 145
Deutscher Akademischer
 Austauschdienst (DAAD) 116
Diaghilev, Serge 38
diddley bow 31
Diderot, Denis 50
Diebenkorn, Richard 134
Documenta IX 189
Douglas, Aaron 19
Douglas Camp, Sokari 197
 Lady with Pouch 93
Douglass, Frederick 20
Dreamings 177
Dreamings (Australian Aboriginal art)
 169-70
Drummer magazine 115
Ducanson, Robert S. 10, 12
Duchamp, Marcel 53
Dureau, George
 John Simpson 122
 Wrestling Satyrs 123
Dworkin, Andrea 101, 103

E
Eakins, Thomas 10
Ecole des Beaux-Arts, Paris 104
El Lton *68*
El-Salahi, Ibrahim 197
 Mother and Child 198

Encyclopedists 50
Engonu, Uzo 196
 Lone Eater 197
Ensor, James 129
Erlebacher, Martha Mayer 166
 A Man and a Woman 164
erotic illustrators 112
eroticism 146
Estrada Courts Housing Project, East
 Los Angeles 68
Ethnographical Museum, Trocadero,
 Paris *15*
Expressionism 80, 155

F
face-painters (limners) 10
Fascism 40
feminist art 143, 149, 159, 161, 206
feminist movement 7, 27, 68, 75, 99,
 101, 135, 141, 145, 172, 205
fetishes 27, 98
Fetting, Rainer
 Desmond Sitting 116
First Futurist Manifesto 39
Flash Art International magazine 167
Fletcher, Don, see Pearce, David
Fourmile, Henrietta 172, 175
Freud, Lucien 99
Freud, Sigmund 145
 Civilization and Its Discontents 47
Fried, Nancy 135
 Self-Portrait 137
Frink, Elisabeth 149
 Running Man 148
Fritscher, Jack 115
Fuente, Larry
 Liberty 71
Fuentes-Perez, Ileana
 The Inevitable Exile of Artists 72
Funakoshi, Katsura 198
 Exhibition view 200
 Staying in the Water 200
Futurism, Futurists 12, 39

G
Gallucci, Ed 112
Garvey, Marcus 89
Gauguin, Paul
 Carved Coconut-shell Money-box 12
gay art, see homosexual art
Gentileschi, Artemisia 145
 Judith Decapitating Holofernes 144,
 145
 Self Portrait as the allegory of
 Painting 145
 Susanna and the Elders 145
Gentileschi, Orazio 145
Geoffrey, Iqbal
 But the King had no Clothesline 84
Géricault, Theodore 63, 104
German Expressionism 41
Ghana 189, 195-6
Gilbert and George 103
Gilliam, Sam 27-8, 36

Ugutsu 29
Glasgow School 78
Gluck (Hannah Gluckstein)
 Medallion 139
Gober, Robert 131, 133
Golden, Thelma 9
Goldsmiths' College, London 78
gollywog 90
Gontcharova, Natalia 41
 Design for *The Golden Cockerel 38*
Gonzalez, Julio 83
Gorbachev, Mikhail 27
Gotzius, Hendrick 123
Goya, Francisco de 20, 126
 Disasters of War 126
 The Execution of Madrilenos on the
 Third of May 44
Grace, Della 138
 Photograph from Love Bites 137
graffiti 34, 76, 129
Grant, Lyonel 185
 Figure 184
Graves, Michael 49
Great Georges Community Cultural
 Project, Liverpool 149
Greer, Germaine 142-3
 The Obstacle Race 141, 164
Greuze, Jean Baptiste 50
Grimm, Melchior
 Correspondance littéraire 50
Gropper, William 20
Grosz, George 20
Grumley, Michael
 Hard Corps: Studies in Leather and
 Sado-Masochism 112
Guerin, Pierre-Narcisse 104
Guggenheim International Award 78
Guggenheim (Solomon R.) Museum
 48-9
Gutai Group in Japan (Osaka) 197

H
Haiti 20
Hall, Radclyffe 138
 The Well of Loneliness 138
Haring, Keith 34, 129
Harlem Renaissance 19-20, 23
Hartley, Marsden
 Painting No. 47, Berlin 106
Hausa of West Africa 190
Hayden, Palmer 23
 The Janitor Who Paints 19
Hayward Gallery, London 77, 82
Hegel, George 77
Heller, Nancy
 Women Artists: An Illustrated History
 143
Heresies magazine 137, 147
Hernandez, Ester 71
 Sun Mad 64
High Performance magazine 167
Hinduism 47, 77
Hirschfield, Magnus
 Sittengesichte der Nachkriegzeit 138

Hockney, David 87, 102, 109, 112, 133, 163, 166, 202
Man Taking a Shower in Beverly Hills 110
Two Boys Aged 23 and 24, 111
Hoet, Jan 189-90
Holland Day, F. 115
Holland, Harry 99
Triptych 98
homosexual (gay) art 103-4, 119, 124, 133, 205-6
Honey Ant Dreaming (Papunya) 170
Hong Kong 202
Hotere, Ralph 185
The Black over the Gold 183
Hovenden, Thomas 10
Howard University 19
Howe, Delmas 124
Hero I - The Birth 120
Rodeo Pantheon 119
Hudson River School 10
Hughes, Robert
Culture of Complaint 205
Huysman, J. K. 12

I
icons 41
Immendorff, Jörg
Self love doesn't stink 62, 63
Indian art 77
Indian mysticism 84
Ingres, Jean Auguste
Le Bain Turc 141
Institute of Contemporary Art, London 154
Islam 77
Italian Futurism 40
Italian nationalism 40
Izquierdo, Maria 75

J
Japan 197, 202
Japanese American art 65
jazz 18
John D. and Catherine T. MacArthur Foundation Grant 29
Johns, Jasper 88
Johnson, William Henry 19-20
Jones, Allen 99
Table Sculpture 98
Judd, Donald 32
Jung, Carl Gustav 84

K
Kahlo, Frida 71, 75
The Dream 70
Kahuklwa, Robyn
He purapura i ruia mai i Rangiatea 168
Kake (Finnish, butch) 112
Kamakura period 198
Kandinsky, Vassily 47
Red Oval 41
Kanou, Lourdes 137

Kapoor, Anish 82-4
Kassel Documentas 60-1, 189, 202
Kelly, Mary 155
Documentation VI, Post Partum Document 154, 155
Kenya 190
Khakhar, Bhupen 202
Yayati 202, 203
Khanna, Balraj 78
Regatta 78
Kiefer, Anselm 62-3
The High Priestess/Zweistromland 61
Killapaninna Lutheran Mission (Australia) 179
Kirby, John 134-5
Two Men Running Away 94, 134-5
Kitaj, R. B. 87
kitsch 103
Kollwitz, Käthe 20
Kooning, Willem de
Women 80
Koons, Jeffrey 36, 99, 102, 167
Fait d'hiver 103
Ushering in Banality 103
Wolfman 101
Koons Retrospective (1992) 101
Kossi, Agbah
Mamy Wata Figure 195
Kozloff, Joyce
Patterns of Desire 141
Pornament is Crime Series No. 4, Smut Dynasty Vase 143
Kozloff, Max 45
Krenov, James 31-2
Kruger, Barbara
Installation 156
Kwei, Kane 195
Mercedes Benz-Shaped Coffin 196

L
Laaksonen, Touko, see Tom of Finland
Lacan 145
Lam, Wilfredo 75, 161
Overture to Eleggua 73
Lanchester Polytechnic 89
Larionov, Mikhail 41
Lawrence, Jacob 8, 20, 23
Migration of the Negro 20
The Vaudeville Actors 23
They Also Found Discrimination 6
They Arrived in Pittsburgh 20
Toussaint L'Ouverture 20
Lawson, Derek 141
A Salon discussion Between the Young Men of Avignon and a Crucifixion 133
Queer Nudes 134
Leadbeater, Charles W. 47
Lee, Spike 37
Lempicka, Tamara de 139
Leonard, Michael 126
Vanitas 126, 128
Leonardo da Vinci 36, 104
Les Magiciens de la Terre 54, 55, 192, 195

lesbian art 135-6, 141
L'Humanité newspaper 44
Ligon, Glenn 116
Notes on the Margin of the Black Book 119
limners 10
linocut 187
Lippard, Lucy R. 129, 155
Lissitzky, El 41
Locke, Alain 19
Long, Richard
Installation view of *Walking in Circles 50*
River Avon Circle, River Avon Mud Hand Circles, Magpie Line 50
Lopez, Yolanda M. 71
Los Angeles County Museum of Art 141
Louis, Morris 27
lubok (folk art prints) 41
Lunacharsky, Anatoly 41
Luxemburg, Rosa 156

M
machismo 126, 205
Magic Realism 106, 109
Mailou Jones, Lois
Les Fétiches 16
Makonde carvers 190, *191*
Mammen, Jeanne 138
Mamy Wata (Mother Water) 192, 195
Mamy Wata 195
mana (sacredness) 7, 83-4, 204
Mantegna, Andrea
Dead Christ 129
Mao, Chairman (mausoleum) 202
Maori art (New Zealand) 180, 185
Maori carvings 12, 183-4
Mapplethorpe, Robert 34, 112, 115, 119, 126, 129, 138, 156
Black Males 115-6
Man in Polyester Suit 115
Phillip Prideau 114, 115
Marx, Karl 41, 61, 156
Mendieta, Ana 160
Untitled 140
merae (Maori meeting house) 183
Mexican muralists 20, 45, 67
Michelangelo 104
Minimal Art 50, 58, 84, 160
minority art 7, 9, 75, 205
Minority Rights Award, Britain 86, 152
Miró, Joan 78
Mistry, Dhruva 82
Diagram of an Object 83
Moderna Museet, Stockholm 32
Modernism, Modern Movement 9, 12, 15, 23, 29, 39, 42, 48, 53, 57, 65, 104, 169, 183, 202, 207
Mondrian, Piet 23, 47
Monroe, Marilyn 158
Moody, Ronald 86
John the Baptist 87
Morimura, Yasumasa
Playing with Gods: No. 3, Night 198

Playing with Gods series 198
Mother Water see Mamy Wata 192
Motherwell, Robert 84
Muafangejo, John 187-9
 *An interview of Cape Town
 University in 1971* 187
 Lonely Man, Man of Man 188, *189*
 Shiyane Home 189
Mullins, Edwin 82
Museé du Luxembourg 10
museum boom 49
museum culture 7, 17, 55, 206
Museum of Modern Art, New York 20
Muybridge, Edweard 109

N
Naifeh, Steven 106
Namibia 187
Napangardi, Eunice
 Bush Banana Dreaming 175
Nash, Paul 82
Nathwadara painting 202
National Farmworkers' Association 67
National Gallery of Australia, Canberra
 180
National Gallery of Jamaica 91
National Gallery, London 84
Native American art 65
Navajo sand-paintings 170
Nazism 62
Neel, Alice 155
Neo-Classicism 104, 120
Neo-Expressionism 75
Neo-Romanticism 82
New Art Examiner magazine 167
New Functionalism 195
New Generation exhibition (1964) 88
New Guinea *15*
New Masses periodical 44
New Orleans World's Fair (1983) 31
New York/New Wave Exhibition, P.S.1,
 Long Island 34
Newton, Huey 90
Nga Hau E Wha National Merae (Maori
 meeting house) *180*
Nietzsche, Friedrich, Wilhelm 12
nihilism 57
Nochlin, Linda 141
 *Why are there no great women
 painters?* 141-2
Noland, Kenneth 27
Notarius, David 159

O
Olcott, Henry Steel 47
Oldenburg, Claes 32
Olitski, Jules 88
Orozco, José Clemente 20, 45, 67
Other Story, The exhibition (1989-90)
 77, 82, 84
Outside Cuba: Fuera de Cuba
 exhibition (1987-9) 71, 75

P
Pacheco, Maria Luisa 75
paintings as public statements 63
Pakistani artists 78
Pan-African movement 89
Papunya paintings 170-1, 175
Paris Salon (1897) 10
patriarchy 143
Pattern Painters 156
Pearce, David 124
 Torso 124
 (as Don Fletcher), *Andy 124*
Pelaez, Amela 75
Penitente art 68
perestroika 27
performance art 41, 147, 161, 167
Perry, Regenia A. 19
Petyarre, Ada Bird, *Women's Dreaming
 179*
Philadelphia Academy of Art 10
Philadelphia Museum of Art 10
Philip II of Spain 170
Philips Collection, Washington, D.C. 20
photography 119, 156
Physique Pictorial magazine 109-10
Picasso, Pablo 15, 83
 Guernica 43
 Les Demoiselles D'Avignon 16, 95,
 133-4, 141
 Massacre in Korea 43, 44, 63
 The Voyeur 95
Pierre et Gilles, *Le Garcon Papillon
 (Kevin) 102*, 103
Piper, Adrian 156
Piper, Keith 89, 91
 Exotic Signs 91
 The Black Assassin Saints 90
Pissarro, Camille 12
Platt Lynes, George 115
political activism 40
Pollock, Jackson 106, 170
Pop Art 45, 53, 58, 68, 87-8, 95-6
Portuguese Art Since 1910 exhibition
 (1978) 163
Portuguese Revolution 162
Posada, Jose Guadalupe 64
Post-Painterly Abstraction 50, 88
pre-Modernist period 10
pseudo-minority 7
psychoananalysis 47
pulquerias 67
Puryear, Martin 31-2, 36
 Empire's Lurch 31

R
Ramos, Mel 95
 *Camilla, Queen of the Jungle Empire
 96*
rasquashismo 71
Rego, Paula 161, 166
 The Cadet and his Sister 163
Reutersward, Carl Frederick 32
Reuther, Pastor Johann 179
Rewiri-Thorsen, Kura 185

Cast No Shadows 184
Ribalta, Francisco 126
Ribera, Jusepe 126
Rickey, Carrie 152
Rickey, George 31
Rimbaud, Paul
 Une Saison en Enfer 130
Rimsky-Korsakov,(*The Golden
 Cockerel*) 38
Ringgold, Faith 155-6
Ritts, Herb 119, 138
 Duo 119
Rivera, Diego 45, 67
Robusti, Marietta 143-4
rock-carving 169
Rocky 68
Romantic Movement 57
Rothko, Mark 47, 50
 Blue, Orange and Red 46
Rotorua carving school 183, 185
Rousseau, Douanier 202
Royal Acadamy of Arts, London 163
Royal Academy, London, Summer
 Exhibitions 86
Royal College of Art 87
Royal Society of Portrait Sculptors 86
Rubens, Sir Peter Paul 144
Ruskin, John 77
Russia-Japan war (1904-5) 41
Russian avant garde 40-2
Russian Constructivists 156
Russian primitivist style 38
Rustin, Jean 99
Rutgers University, New Jersey 71

S
Saar, Betye 90, 155-6
 The Liberation of Aunt Jemima 27
sado-masochism (S&M) 101, 112, 115,
 124, 126
Salle, David 167
Salons, French 50
Samba, Chéri 192, 195
 The Art of Do-Nothings 193
San Francisco Museum of Modern Art
 101
sand paintings 169-70
Sandys, Edwina
 Christa 152
São Paulo Bienal (1959) 126
São Paulo Bienal (1969) 161
São Paulo Bienal (1976) 163
São Paulo Bienal (1989) 31
Schapiro, Miriam 147, 155-6
Schnabel, Julian 167
Schneemann, Carolee
 Interior Scroll 147
 *The Delirious Arousal of Destruction
 147*
Scott, John 29, 36
 Breeze Window for Mom 31
Serpentine Gallery, London 88
Serra, Richard, *Weight and Measure 58*
sex and gender 164

sex, sexual imagery 95
Shahn, Ben 20, 24
shamanism 56, 59, 63, 161
Sherman, Cindy 167
 Untitled Film Stills 156, *158*
 Untitled (No. 264 - Woman with
 Mask) 159
shetani (spirit) carvings 191
Shtenberg Brothers 156
Siqueiros, David Alfaro 45, 67
Slade School of Fine Art 87, 197
slavery 20
Sleigh, Sylvia 141, 148, 164
Social Sculpture 59
Sonsbeek 91, 93
Sontag, Susan 67
South Africa 90, 187
South Australian Museum, Adelaide 180
souvenir art 190, 195
Souza, Francis Newton 78
 The Goddess Kali 80
Spanish Civil War 43
Spender, Stephen 111
Spero, Nancy 156
 Torture in Chile 155
Spiral Group 23
Stackelhaus, Heiner 59
Stael, Mme de
 De l'Allemagne 62
Stalin, Joseph 42, 45
Staller, Ilona (La Cicciolina) 101, 103,
 147
Stevens, May 155-6
Stewart, Paddy Japaljirri
 Yam and Bush Tomato Dreaming
 173
Stompers Gallery, New York 109
strip-cartoon 129
Sudan 197
Sugar Ray Robinson 36
Super Realism 98
Surrealist Movement 43, 47, 159, 163
Sutherland, Graham 82
Sutherland Harris, Ann 141
Swedish Royal Academy, Stockholm 31
Symbolist movement 12

T
Tanner, Hanne 10
Tanner, Henry Ossawa 12, 15
 An Old Couple Looking at Lincoln
 10
 Raising of Lazarus 10
 The Banjo Lesson 10
 The Thankful Poor 10
Tantrism, art of 80, 83-4
Tanzania 189
Tate Gallery, London 63
Tatlin, Vladimir 41
Tenebrist School 145
Teraoka, Masami 71
 What are you looking at? 65, *66*
Theosophical Society 47
Theosophy 41, 47

Third Text magazine 77
Tickner, Lisa
 The Spectacle of Women: Imagery of
 the Suffrage Campaign 143
Times Square Show (1981) 34
Titian 170
Tjapaltjarri, Tim Leura
 Wild Potato Bush (Yam) Dreaming
 171
toas 177, 179-80
Tom of Finland (Touko Laaksonen) 110
 Untitled 112
Tony Shafrazi Gallery, New York 36
Torero, Marlo 68
Toulouse-Lautrec,Henri de 134
Towards a Worldwide Commune, mass
 performance, Petrograd 41
trade routes 16
transgressive art 7, 57, 99, 103, 152
transvestism 94, 134
Treaty of Waitangi (1840) 180
Tschuya, Tilsa 75
Tubman, Harriet 20

U
ukioye prints 65
University of Miami 72
University of Science & Technology,
 Kumasi, Ghana 189
Utopia women's batik group 172

V
vaginal imagery 152
Valadez, John
 The Wedding 69
Valconover, Francesco 144
Venice Biennale (1968) 32
Venice Biennale (1992) 82
Victoria & Albert Museum, London 86,
 137, 166
video 167
Vietnam War 67, 149
Virgin of Guadalupe 68
Vogel, Susan 196
 About the Here and Now 192
voyeurism 95, 101

W
Wagstaff, Sam 115
wakas (Maori ceremonial canoes) 183,
 185
Wakemba of Kenya 190
Walpiri tribe (Australia) 172-3
Warhol, Andy 32, 34, 36, 112, 115-6
 Green Coca-Cola Bottles 53
 in collaboration with Jean-Michel
 Basquiat, *Felix the Cat 34*
Washington Color School 27
Weber, Bruce 119, 138
Wesselmann, Tom
 Great American Nude series 95
 Great American Nude No. 70, *96*
West Africa 190
White Smith, Gregory 106

Whitechapel Art Gallery, London 88
Whitney Biennial (1993) 9, 36, 116
Whitney Museum of American Art 48-9,
 87
Wilding, Faith 147
Wilke, Hannah
 So Help Me Hannah 147
Williamson, Sue
 Resistance Art in South Africa 187
Willing, Victor 161, 163
Wojnarowicz, David 129, 133
 Close to the Knives 129
 Just a Little Bit of the Tin Drum
 Mentality 131
 Untitled 130
Women Artists' News magazine 137
Women Painters: 1550-1950
 exhibition (1976) 141
Women's Art magazine 159
Women's Art News magazine 167
Woodley, Karen 149-52
World War I 41, 53, 57
World War II 43, 59, 62, 77
Wright, Frank Lloyd
 Solomon R. Guggenheim Museum,
 New York 48

Y
Yonyu, Huang 198
Yuendumu paintings 172-3

Z
Zade 68
Zaire 189-90, 192
Zambia 189
Zapilote 68
Zeng, Fan 198, 202
Zubaran 23